Deconstructing the Elements with 3ds Max
Third Edition

Dedication

To my family and close friends, no matter how near, far, or on any plane of existence.

Deconstructing the Elements with 3ds Max
Third Edition

Create natural fire, earth, air and water without plug-ins

Pete Draper

Autodesk®
Media and Entertainment
Techniques

Focal Press
Taylor & Francis Group

NEW YORK AND LONDON

First published 2006
This edition published 2009 by Focal Press
70 Blanchard Road, Suite 402, Burlington, MA 01803

Simultaneously published in the UK by Focal Press
2 Park Square, Milton Park, Abingdon, Oxon OX14 4RN

Focal Press is an imprint of the Taylor & Francis Group, an informa business

Library of Congress Cataloging-in-Publication Data
Application submitted

ISBN: 978-0-240-52126-8 (pbk)

Typeset by diacriTech, Chennai, India

Contents

Foreword ix

Acknowledgments xi

 Equipment xii

About the author xiii

Introduction xv

 Why 3ds Max? xv

 3ds Max Versions xv

 Your level of experience xvii

 You are only as good as your reference material! xvii

 Format xviii

 Structure of each tutorial xix

 The online digital assets xx

 The video tutorials xxi

 Tutorial support xxi

FIRE — 1

1 Ball of fire 3

2 Sun surface – extreme UV solar imagery 20

3 Angle grinder 42

4 Afterburner 60

WATER — 81

5 Ice aggregation 83

6 Icicles 96

7 Condensation 113

8 Soap bubbles 131

EARTH 151

9 Mountain weathering 153
10 Atoll 177
11 Snow drifts 191
12 Mars 206

AIR 219

13 Bubble stream 221
14 Large bubbles 242
15 Galaxy 262
16 Ray of dusty light 290

APPENDICES 305

The next step and further reading 307
Plugin solutions 309
Index **311**

COMPANION WEBSITE – Contents

Brand new video tutorials include:
Electrical sparks
Fire strip
Swimming pool caustics
Paint spillage
Bucket of water
Whirlpool
Geode
Island
Snowscape
Contrail
Barn tornado
Foam

All 3ds Max support files for each video tutorial as well as for each chapter included!

Brought to you from the Second Edition of this book:

FIRE

Candle
Match
Gas hob
Oil fire
Flamethrower
Tunnel explosion
Fireworks
Coals
Solar flare

Video tutorials

Atmosphere entry
Lava fountain
Lightning
Wood fire

WATER

Lemonade
Calm seas
Stormy seas
Underwater
Moving surface water
Rain
Hailstones
Snowflakes
Lava lamp
Glacier

Video tutorials

Waterfall

EARTH

Volcanic terrain
Lava
Grass and dirt
Grasses
Frozen wastelands
Mountain
Asteroids

AIR

Cigarette smoke
Tornado
Eruption
Pyroclastic flow

Video tutorials

Clouds
All 3ds max support files included!

Foreword

I first met Pete Draper in 2004 at the Animex International Festival of Animation located at Teesside University in England. Within minutes of meeting him, it's as if we'd been friends all our lives. I saw in him many of the same qualities I see in myself. Besides being good-natured, friendly guys, we both share a great love of movies and visual effects. We're self-taught, "learn it as you go" kind of guys, and we both got our start with the DOS version of 3D Studio. My career took me to companies that tend to use proprietary software, but when I do work on a project in 3ds Max, Pete is my "go to guy" when I get into trouble. Plus he's pretty good in a bar fight.

When Pete told me he was writing a 3ds Max book on visual effects, I was intrigued. I knew he'd already written dozens of articles for *3D World* magazine as well as several other publications, and I'd seen him giving workshops at Animex. It was clear that this man knows what he's talking about. When I finally got a copy of his book, I was blown away. He'd decided to take on some of the most challenging elements of CG effects that even seasoned effects veterans dread. On top of that, he taught the reader how to create them without the aid of costly 3rd party plugins as well as presenting the information in a clear-cut, step-by-step process that not only tells you what to do but also explains each step in a easy-to-understand language. One of my favorite parts about his tutorials is that he stresses the importance of getting good photographic reference. This is so important and yet so many people I've met don't think they need it. There are so many different places to get reference from, that there is no excuse not to have it. I've learned early on in my career that good reference is the key to creating realistic visual effects, and it's great to see that at the forefront of Pete's lessons.

Having read and learned from the earlier version of this book myself, I can promise that you'll find this a great learning tool and an invaluable reference. If you follow Pete's formula of gathering and analyzing your reference, breaking down the event into its core components and then building up the effect from the individual pieces, you'll have a great foundation for reconstructing your own elements.

Tom Martinek
Digital Supervisor, Industrial Light & Magic

Acknowledgments

Many thanks to my immediate family for their constant love and support: Mum (Diana), Dad (Russell), sister (Esther), and new bro' Garath. See? Told you I'd bung you in by name! Also to the rest of my family – way too many to mention as we "roll that deep."

Close friends Andrew Hawkes and Caroline Baylon, Chris Hawkes, Ash Hall, Tiffany John, Laura James, and Carol Baker for the friendship and putting me up/putting up with me "oop north" while I cursed, cursed, and cursed again at my computer while writing this book! Hope I didn't scare the cats too much …?! Andrew Dymond, Sue Dymond, Jonathan Brown (congrats on the engagement!), and Chris Harnwell for keeping me (in)sane in Bristol! Chris Ollis (www.intertwined.co.uk) and Allan Johnson for being good mates and all-round movie and games banter – good luck with the new show guys! Robert James, Matt Jones, Gav, and Owen Thomas and everyone else from the Taunton Massive, even though we're no longer … err … "massive" anymore.

Many thanks to everyone who contributed to this new edition: the guys at the NASA Goddard Space Flight Center and the SOHO/Trace teams (www.nasa.gov/nssdc.gsfc.nasa.gov), NOAA (www.noaa.gov), USGS (www.usgs.gov), iStockphoto (www.istockphoto.com), Bristol International Airport's Fire Safety Training staff, Ash Hall (www.a-hall.com), Laura James (www.flickr.com/photos/22682131@N08/), Leonard Tan for the awesome underwater footage, and Detonation Films (www.detonationfilms.com) for the blowey stuffy uppy footage. Also cheers to Allan McKay (www.allanmckay.com) for good online banter and generally being an all-round top chap, and Charley Carlat (www.charleycarlat.com), Anselm von Seherr – Thoß (www.3delicious.com), Kai Stavginski (www.aearon.de), and Jefferson D. Lim (aka "Galagast") for the use of their scripts.

Also I can't go any further without saying cheers to the Animex and Red Stick guys: Chris Williams at the University of Teesside (www.animex.net) and Stacey Simmons at LSU (www.redstickfestival.org) and all the awesome people I've met (so far) in this business: Rachelle Lewis (www.rachellelewis.com), James Gentile, Ed Hooks (www.actingforanimators.com), Stuart Sumida (margaritas on me next time!), Curtis Jobling, Hans Rijpkema, Mark Walsh, Dan Lund, Tony West,

and above all Tom Martinek (www.mrfusion.org) for the awesome Foreword! Also cheers to Badger, Graham, and Nikki for being splendid chaps and for not getting too annoyed when we refuse to go back to the hotel 'cos we're having too much of a good time …! The USA tour cometh soon!

Cheers to the guys who wrote the testimonials on the back cover: Gary M. Davis – Autodesk/visualZ (www.visualz.com), and Allan McKay – Catastrophic FX (www.allanmckay.com), … many many thanks for the awesome words! Also many thanks to Jim Thacker and the guys over at *3D World* magazine (www.3dworldmag.com) for not bitching too much when I'm late with copy due to being snowed under with this project! Many thanks also go out to Cris Robson over at 3D-Palace (www.3d-palace.com) for hosting my website stuff and for understanding why I couldn't make it over to Maxterdam this year. Damn you deadlines and the need to eat … damn you!! Many thanks also to Jean-Marc Belloncik at Autodesk for an awesome job on the tech checking (sorry, but I'm still calling it a "panel," so naaah!) … couldn't have done it without you!

Finally, thanks to Laura Lewin, Simon Cotton, and David Bowers at Focal Press for not going mental when copy was a tad late, thanks to my hectic schedule!

Anyone I've kind of forgot, really really sorry! … it's a bit of a late night and my fingers hurt!

Equipment

All photos shot by the author were taken using an Olympus E510 digital camera. All film-based photos taken by the author were shot with either a Nikon or Canon film SLR and scanned using an Epson Perfection 3200 Photo scanner and Silverfast software.

All footage filmed by the author was shot using Panasonic and Sony digital camcorders, and color-corrected and edited as necessary in Autodesk Combustion and AVID Express Pro HD.

About the author

Pete Draper is a UK-based visual effects animator and 3D artist who has been in the industry for well over a decade and whose work has seen the large and small screens. Having held such posts as Lead and Senior Artist, Head of Media, and Director of Visual Effects, Pete now works as a freelance VFX gun for hire.

He writes for several publications, notably for *3D World* magazine, providing tips, tricks, reviews, and tutorials for 3ds Max and other animation and graphics tools. In addition to the previous two editions of this book, Pete has also contributed to 3ds Max 4 Magic and 3ds Max 6 Killer Tips besides the numerous papers available in his own website.

Pete's work covers a wide range of disciplines, from visual effects through to reconstructions, commercials, and in-house training. Due to his expertise in this field, he was nominated for the Autodesk Masters award in 2007, and is currently an external examiner for Teesside University, England.

He can be found producing animated media for film, TV or interactive media, static imagery for print, writing for various online or print-based publications, or speaking at workshops around the country. Pete tries to keep his caffeine levels down, but it really isn't working well

For examples of Pete's work and free articles he has written, please visit his website www.xenomorphic.co.uk.

Introduction

Why 3ds Max?

Okay, this is a question a lot of you might be asking. Why should I use 3ds Max above all other products out there? And to be honest, I don't have a reason at all. There are numerous products out there, each having its pros and cons, prices and deals, license costs, feature sets, stigmas, and so on. I guess the main reason I use 3ds Max is it being brought up in the DOS versions; so it was a natural progression to move onto the (then) new Windows version – 3D Studio Max 1.0. I've used most of the products out there in my time in the industry, but I still keep coming back to 3ds Max, mainly due to my familiarity with its intuitive interface, workflow, architecture, modeling toolkit, excellent particle system, and so on. But that's just my own history. You've obviously got an interest in the software and are reading this book for you want to further your knowledge of the software and put time and effort into it. If you do just that, then you'll find that using the software can be a rewarding experience, especially when you create and animate something that has never been seen before, but only in your mind. It's also billed as the software with the largest registered install base; this will more than likely go up substantially as time passes. Because of this number, the knowledge base is huge, which you can find in many of the Max-related support boards, newsgroups, IRC channels, and websites available to the Max community, none more so than Autodesk's own support forums over at www.area.autodesk.com, which includes users worldwide, beta testers, and Autodesk's own developers. It's a great community and I'm proud to be a member of it.

3ds Max Versions

With each version of 3ds Max comes a batch of new toys to play with, some more useful than others when dealing with recreating natural effects. For example, in 3ds Max 6 we had Particle Flow and Mental Ray added to the base kit, and in later versions Cloth and Hair have been added, the latter being ideal for creating grasses. As with any tool, we'll use any feature as and when required, not putting ourselves out of the way to utilize new tools if not necessary. For example, it's of

least use in spending an epoch in creating a Mental Ray material and tweaking GI lighting settings, caustics, etc., if we could produce a similar result with the standard Scanline renderer which in some circumstances render faster. However, if we're looking for a feature that is not possible with the Scanline renderer or is easier and quicker to be produced and/or rendered using Mental Ray (such as multiple pass motion blur), we shall use it instead. It's all about using the tools available to us. In addition, there are other tools such as the new Pro Materials, architectural materials and objects, dynamics in the form of Reactor, scene management tools, modeling amendments, and object type additions. Again, we'll use these as and when required. The tutorials in this book have been designed for 3ds Max 2009 onwards, although your interface setup may be slightly different from those screenshots (for example, I've turned off the Viewcube navigation system out of personal preference). As there are two versions of 3ds Max 2009 out there, there may be slight differences not noted in the supporting documentation, such as some maps with Use Real-World Scale enabled by default (and disabled in the Media & Entertainment version); I've tried to ensure any options like this be disabled/enabled so that if you're using Design we're all on the same page. If I've missed one or two, then I apologize in advance – please post it in the support forum and I'll get these changed/commented on as soon as possible! Although a lot of the theory behind the tutorials could be transferred across to the earlier versions, however, the majority of the tutorials require the accompanying digital content to start with to ensure we're all using the same unit scale setup (else your results may differ from mine!). As these digital assets have been created with 3ds Max 2009, previous versions of the software won't be able to open the scene files; however, you should still be able to follow the tutorial for the most part with your version of the software (you may need to re-create the base assets, but that should be pretty straightforward for you), or download the trail version of 3ds Max from the Autodesk website. Additionally, it might be worthwhile pointing out that the majority of scene files can be "regressed" by Borislav Petrov (aka Bobo)'s BFF script over at www.scriptspot.com/bobo, though obviously newer features such as the Pro Materials obviously won't translate back; so you'll need to use an equivalent setup.

As a quick disclaimer, by the time this book hits the shelves, the 3ds Max 2009 Creativity Extension would already be out, which includes a wealth of new particle tools to play with. This makes one or two steps in the tutorials, particularly the Galaxy tutorial, redundant due to the Initial State operator being able to replace the script used in this particular tutorial. However, as a fair few of you

won't be on the subscription program, I've deemed it necessary to include the "original" scripted version until this book is updated with the Creativity Extension included in the software as a core feature (in the next main release). It also gives a good example of scripting Particle Flow which, if you're serious about particles, you should really look into … once you've finished this book, of course!

Your level of experience

With a product of the size of 3ds Max, no single publication is going to turn you into a 3ds Max guru overnight. The software is absolutely huge and growing with each passing version. It, therefore, takes time to learn the full extent of its toolkit; so before you contemplate tackling the tutorials in this book, you should at least have read the excellent manual provided by Autodesk, and gone through the tutorials bundled with the software. I cannot stress this enough as you should be able to follow the tutorials in this book without any problem. By going through the documentation, you'll gain experience as to where feature 'X' or item 'Y' is located and what its basic operation is, so that the main content of this particular publication can be spent teaching you how to use these elements, either individually or combined, to create dramatic effects, rather than telling you how to find them, access them, and use them. If you've not looked at the tutorials which ship with the software, or don't know how to transform (move, rotate, or scale) an object, link one object to another, bind an object to a Space Warp, open up and access materials and maps, change shaders, hide/unhide/freeze/unfreeze objects, add modifiers, or copy and paste modifiers, now is the time to put this book down and work through them as it tells you everything you need to know before you start with your first tutorial in this book.

You are only as good as your reference material!

Believe it or not, this is the case with almost every medium in the artist's world – be it working with oils, ceramics, pixels, or polygons. If you're trying to simulate something that exists in the real world, then you've to source as much reference materials as humanly possible to get as much information about the thing you're trying to create. Elements are one of the hardest things to create in CG, especially if they need to be animated (examples include landslides, water,

air (smoke), and fire). The main reason behind this is that we see these elements in some shape and form every single day; so any slight discrepancy or flaw in the scene is going to stick out like a sore thumb. In visual effects this can ruin the rest of the scene as the main attention of the audience is on the problem element and not on the (possibly) more important aspects of the scene, such as the hero object/character. So it's important we grab as much reference materials as possible and study it until our eyes bleed. Each aspect of the effect should be scrutinized over and over again until you understand how and why an effect behaves, reacts, or shades the way it does. Using this knowledge we'll begin to lay out our scene. If we've understood the effect correctly, it'll then simply be a matter of adding one sub-effect (e.g., shape) on top of another (e.g., animation) on top of another (e.g., additional animation) on top of another (e.g., further animation) on top of another (e.g., material effects), and so on, until our overall effect is complete. This way of working runs true for any type of medium in the art world: start off with the basic features and build up layers until you've the final result. The format and writing of this book holds true to this methodology, calling on a large amount of animated and still reference materials that accompany it. Hopefully, by the end of your first tutorial you'll begin to see the world slightly differently.

Format

As there are four elements in nature, this book is divided into four sections – Fire, Water, Earth, and Air, with each element further broken down, such as Earth: Snow drifts; Air: Water bubbles; Fire: Fireball; and Water: Bucket of water, for example. Within each tutorial we'll analyze each individual effect and break it down into its core components: how it moves, its color and tone, its shape and form, and whether any third-party item enhances or even creates the effect. To do this, we need to analyze as much reference materials as possible of the element we're trying to simulate so as to get as realistic an effect as possible; this material is included as a digital asset to accompany this book, and should be viewed at given points when following the tutorial (additional reference materials may have been included but not called on directly in the text, but they should also be viewed if possible to gain a further understanding of the effect). Once the analysis of the effect is complete, we'll either start constructing our scene from scratch, or load in a pre-constructed scene (depending on the scene's complexity and/or relevance with respect to creating the effect) to add our effect to.

Structure of each tutorial

To keep a form of consistency, we're going to adhere to a certain format throughout the book. This will take on the form of the following:

Introduction – A summary of what we're going to achieve, what tools we're going to use, and what the final result should look like.

Analysis of effect – A comprehensive breakdown of the effect using some reference material to give you a better understanding of the effect and tell you what tools in 3ds Max can create this effect. Now I stress that I'm in no way a geologist, oceanographer, climatologist, or any other such scientist; so the analysis of the reference material is purely derived from scrutinizing the images and footage and from reading up on the effect while researching and sourcing the material. If you're experienced in a specific field and you feel I've gone way off the mark in one of the analysis sections, please let me know by posting a message in this book's support forum mentioned later.

Walkthrough – Starting from either a pre-constructed scene or from a blank canvas, we'll gradually build up our effect, referring to our reference material as necessary as we progress through the construction process. This process is split up into sections, and each section consists of three main parts: firstly an introduction to the section – explaining what we're going to accomplish; secondly detailing the process – noting which settings to use; and finally extra information about which parts of the section do the overall effect and, if there are limitations, how we can get around them. These parts are laid out logically; so each screenshot (or part thereof) has instructional and informative text accompanying it so you don't get lost. The screenshots show the settings in action and any other information, such as gradient design, which relies more on illustration than description; this is mentioned in the text, but the screenshots are there to illustrate things that would be too difficult or confusing to write out, such as curve settings, etc. The full screen is shown in the screenshot thumbnail for a good reason – changing one setting in 3ds Max can affect other elements right across the UI. For example, adding an operator to Particle Flow (left-hand side of screenshot) can drastically change the way a particle system behaves (right-hand side of screenshot). To illustrate this properly, the full screenshot has to be used. However, in some instances there may well be not much to show apart from, say, adding an operator or two. This may make the screenshot aesthetically boring, but it's still an important step towards the final effect and to keeping

things consistent, besides showing the reader every single piece of information possible. If you feel your eyes are straining trying to read the screenshot in this book, worry not as there are full-sized versions included as digital assets.

Taking it further – How successful was the emulation of the effect, and what pitfalls should we look out for when creating and rendering the scene? How do we enhance the effect – either by tweaking or modifying the scene, using a third-party solution, or compositing the effect into another scene or in pre-shot footage? This section also gives suggestions on how to expand on the scene – if there may be a certain effect (not covered in the tutorial) to occur after the main effect, here you'll find suggestions and hints on how to create it and what areas to look into.

Note – Because of the very nature of tutorials, repetition of information or notes is unavoidable. This is because of the way tutorials are read. You'll more likely jump into a specific effect that interests you rather than read the book from cover to cover. Therefore, some notes will have to be repeated as you may have skipped reading them in a previous instance.

The online digital assets

The online assets contain as much reference materials I sourced for each tutorial, and are structured in a way you can find reference relating to a particular tutorial within one folder group. Within each group there are several subfolders containing the Source – the 3ds Max files and maps, plus any other asset, and Reference folders – materials for you to peruse in the Images and Movies folders (if you're trying to emulate the effect in moves, distorts, etc.) to get a better understanding of how the effect works so that you can emulate it more convincingly. Several such reference files have not been called upon in the main text, but they should also be viewed as these demonstrate additional circumstances where this effect occurs, provide further examples of the effect, or suggest ways of new adaptations for you to try. Within each main tutorial folder, there is also a folder containing all the full-sized screenshots used in this book, which you can use instead of having to view the thumbnail versions in the book as they're too small to make out a specific step. The reference materials have mostly been personally filmed and photographed by the author where available; each sample has been compressed to a decent size for download – images have been resized

and JPEGs compressed, and animations have been converted from DV or HDV to WMV as this now yields a better image quality than standard MPEG. Images and footage have also been sourced from third parties and are used with permission. To keep things consistent, all images and movies have been resized to a generic size.

The video tutorials

In addition to the reference materials, full-sized screenshots, and resulting 3ds Max files, there are extra tutorials in the form of videos. These tutorials were originally planned as going to be in print, but due to the scale of each tutorial and the limitation in page volume, it soon became clear that squeezing them all in is impossible without compromising on tutorial quality and explanation, which I wasn't prepared to do. These video tutorials adhere to the same format as the tutorials in the book, with the "Introduction," "Analysis," etc., but in this case I'm taking you through each step while demonstrating it all on-screen in the 3ds Max interface and calling on the reference material throughout.

Tutorial support

Should you have any problems using the tutorials in this book, a forum has been set up for you to post your questions to the author. Please visit **www.deconstructingsupport.com**

Fire

Creating a fire to look realistic is one of the most difficult tasks in CG, and we normally have to resort to a plugin solution to get the effect look right, but still the effect would look artificial because we haven't analyzed the motion of the flame we're trying to emulate. Fire comes in all shapes and sizes and behaves differently depending on the combustible material, exposure of the camera it's being filmed on, or viewed with the naked eye. In this section we've got a wide selection ranging from a "simple" VFX gas flame test (the kind you see in plugin product demos!), to sparks, to something a little larger!

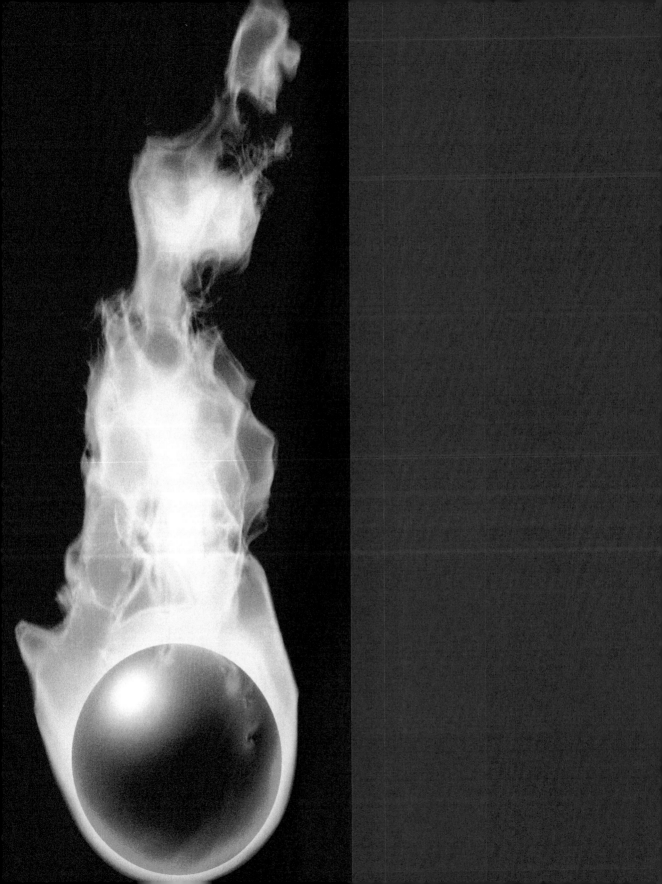

1 Ball of fire

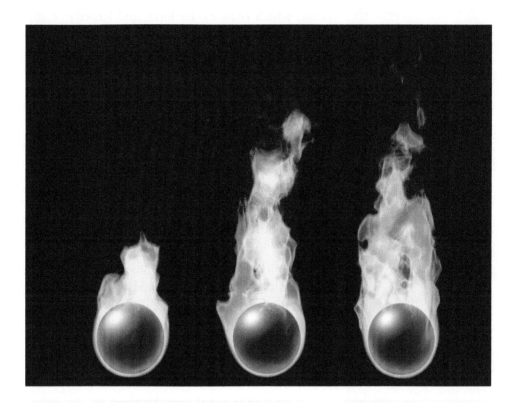

Introduction

In this tutorial we're going to tackle one of the most common simulations performed with fluid dynamics, that of a metal ball emitting fire. There are several reasons behind this – from the amount of "fuel" the simulation has, its explosive properties, color, and whether or not the system is set to generate smoke. In our system we're going to simulate this type of effect using 3ds Max's native kit, namely Particle Flow, with multiple systems to affect each aspect of the flame shape. The resulting particles will then be surfaced with a Blobmesh Compound Object with a material assigned before rendering.

Analysis of effect

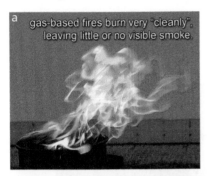
gas-based fires burn very "cleanly", leaving little or no visible smoke.

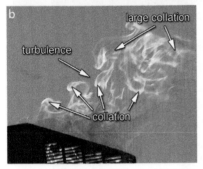
large collation

turbulence

collation

sporadic flames get torn off from the main flame pattern due to turbulence and fuel dissipation / combustion.

smaller gas jets force the gas out and thereby the flame, resulting in an elongated flame pattern.

(a) For this particular type of fire effect, we'll base our simulation on a gas-fuelled fire, specifically a non-oxygenated fire and one with a large emission point, which reduces the force and ferocity of the flame. As this flame is gas-based, it leaves very little or no smoke, and as a result it's, aesthetically, very clean burning. The flame is a trademark yellow-orange color with a white core (depending on camera exposure) and a subtle orange perpendicular effect with a fluid-like waveform pattern. (b) This pattern has three main parts – the initial influence being the collation of fire plasma into small pockets that make up the distinctive internal detail of the flame; the second influence breaks up this uniformity and adds larger masses of collation which are then torn off by turbulence (the third influence). It's this turbulent motion that gives this large body of flame its distinctive shape, folding over itself and interacting gracefully with the external environment. (c) Additionally, as the gas burns, we see a occasional lick of flame at the top, with some parts being "torn off" or detached from the main body of the flame. (d) The resulting flame design appears much smoother (aesthetically) than in any other fuel source (wood, oil, etc.).

Okay, first things first. Tutorial number one and we're encountering our first major challenge: the effect we're trying to simulate is totally based on fluid dynamics, that of the motion of flame in relation to its surrounding medium: air. Unfortunately, at this current time of writing, we don't have a fluid system native to the software (20 quid said that by Christmas we've got one, just to put egg on my face!), though there obviously are some excellent plugin solutions out there (see the Appendix for

more information on this). However, we can create a convincing result using the base software. Due to its motion effect, we're obviously going to use a particle system to generate the dynamics of the flame system; however, simply emitting the particles from a single source and exerting a Wind Space Warp on them isn't going to be enough, purely because the Space Warp in question doesn't simulate the desired turbulent motion. It's, however, good enough in this instance to affect the entire simulation to suggest a subtle external force to break up uniformity, creating a light breeze on the flame causing it to distort somewhat and also to be used to drag the particles vertically. The main body of simulation will lie in multiple particle systems. The initial Flame system will be used to position and scatter particles around the Geosphere primitive in the scene, with an SDeflector preventing these particles from intersecting the geometry as they pass around the surface. These particles will be attracted to one another within a small threshold radius, producing collations of particles. These particles will then be affected by a reduced number of particles born from the same location(s), which will produce larger collations and also interact with the main body of the system. Finally, to break up the effect and to design the turbulent refined patterns as seen in the reference material, a time-offset instance of the large influence particles will chase the flame particles, causing them to displace, simulating air rushing in, and producing loops and arcs akin to the reference. The simulation aside, the main crux of the design is shading the particles correctly. Actually we aren't going to render the particles but surface them using a Blobmesh Compound object, which will have a material assigned that uses fog density based on object thickness to drive the brightness of the flame as it progresses through the animation. In the "Taking it further" section, I've adapted this material even further, creating the falloff effect around the edges of the flames. Once you've finished this tutorial, feel free to have a look at this section and the accompanying Taken Further 3ds Max scene file.

Walkthrough

PART ONE: First we'll load the start scene and add a basic Space Warp before designing our initial particle system.

1 Open the *01_Ball_O_Fire.max* file included with this tutorial and accept any file unit change if prompted. In the Top Viewport, create a Wind Space Warp and relocate it to the origin – XYZ coordinates (0 cm, 0 cm, 0 cm). Navigate to the Modifier tab in the Command bar and set Turbulence to 1. Set its Frequency to 5 and Scale to 0.01

Information: Don't forget to accept any file unit change so that any inputs we give can return uniform outcomes. Otherwise you may experience different results from that in this tutorial. We've added some Turbulence to the Wind Space Warp to simulate external forces not generated originally from the fire itself. The Scale value has been set low so that the resulting waveform is quite large (yes, you read that right …!). I've mentioned about relocating the Wind Space Warp to the origin as we're using the Turbulence setting; the resulting pattern is based on its position in the scene, so by ensuring that it's at the origin we'd get virtually the same resulting effect.

2 Still in the Top Viewport, create an SDeflector Space Warp and relocate it to the origin as before. Set its Diameter to 6 cm so that it's exactly aligned with the Geosphere primitive in the scene. Set the SDeflector's Bounce value to 0.

Information: This SDeflector will be used to sculpt the particles around the Geosphere primitive in the scene so that

the particles that are born from the PF Source 01 icon in the scene (which is set slightly larger than the SDeflector to give the particles a chance to interact with the surface, else it's possible that some or all of them pass right through it) flow around its surface. The Bounce value is set to 0 so that the particles simply travel over its surface, not bounce off it.

PART TWO: With the Space Warps set up, we'll use the existing Particle Flow icon to build our flame system.

3 Select the PF Source 01 icon in the scene and click on its Particle View button in the Command bar. In Particle View, rename the PF Source 01 icon to PF Source Flames. Click on the Render operator in this event and set its Type to Phantom.

Information: We're using Phantom as the particle position and shape size need to be visible to the renderer so that the Blobmesh object we'll create later on can derive its surface; however, we don't want the particles to be visible in the render.

4 Drag out a Birth operator to the Particle View event display, wire its input to the output of the PF Source Flames event, label the event Flame Shape, and set its Emit Stop value to 300 (the length of the sequence). Set its Amount value to 60 000. Add a Position Icon operator to the event, and in the Location group, choose Surface. Add a Shape operator to the event and set its Size value to 0.3 cm.

Information: We need a fair amount of particles to create a nice effect, hence cranking up the value. We've changed the Location group to Surface so that the particles are simply born over the surface of the Particle Flow icon, not within it, else they'd be born inside the Geosphere! The Shape operator drives the size of the particles referenced by the Blobmesh object, though they won't be rendered.

5 Add a Keep Apart operator to the event and label it KA Flames. Set its Force value to −1 cm and set Accel Limit to 20 cm. In the Range group, set Core Radius to 0.2 cm and Falloff Zone to 0.8 cm. In the Scope group, choose Selected Particle Systems and choose PF Source Flames in the list (the only one currently available).

Information: This initial Keep Apart operator has a negative Force value, thus attracting the particles instead of repelling them. This particular operator

makes the flame particles simply attract each other, creating small collations (derived from the Core Radius and Falloff Zone values) and folds in the geometry when surfaced, thus generating small detail in the resulting flame; when the particles collate together, the resulting surfaced geometry will be wider, yielding a brighter color as derived from a material we'll design later on.

6 Copy the PF Source Flames root event three times. Label the first copy PF Source Small Influence, the second copy PF Source Large Influence, and the third copy PF Source Turbulence. Back in the Flame Shape event, add another Keep Apart operator and label it KA Small Influence. Set its Force to −1 cm and Accel Limit to 25 cm. In its Range group, set Core Radius to 0.2 cm and its Falloff Zone value to 3 cm. In the Scope group, choose Selected Particle Systems and choose the PF Source Small Influence in the list.

Information: We've set up root events at this stage so that we can get the Keep Apart operators built up in the original system, referencing these new root events (systems). The second Keep Apart operator to be added drags the original Flame particles upwards, creating additional folds in the geometry. The particle system that drives this will have a reduced number of particles so that the attractions are defined as in the reference material.

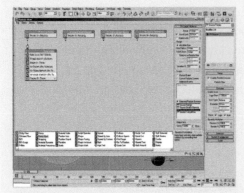

7 Add another Keep Apart operator and label it KA Large Influence. Set its Force to −1 cm and Accel Limit to 20 cm. In its Range group, set Core Radius to 0.4 cm and its Falloff Zone value to 4 cm. In the Scope group, choose Selected Particle Systems and choose the PF Source Large Influence in the list.

Information: As said before, this new Keep Apart operator affects the motion of the Flame particles further by attracting them towards the particles in the named system, thus resulting in the flame to appear to fold and spiral as the multiple Keep Apart operators fight for influence.

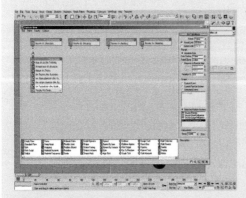

8 Add another Keep Apart operator and label it KA Turbulence. Leave its Force at 1 cm (note the positive value 1 cm this time as opposed to −1 cm previously) and Accel Limit to 20 cm. In its Range group, set Core Radius to 1 cm and its Falloff Zone value to 2 cm. In the Scope group, choose Selected Particle Systems and choose the PF Source Turbulence in the list.

Information: This final Keep Apart operator is unlike others in that it has repulsion instead of attraction. The system it references will have a time offset, a clone of the Large Influence system but with a 5-frame offset and a negative influence to simulate air rushing in behind the flame, partially displacing it.

9 Add a Force operator to the event and add the Wind01 Space Warp to its Force Space Warps list. Set the Influence value to 610. Add a Delete operator to the event and set it By Particle Age. Set the Life Span value to 50 and Variation to 5. Add a Collision test to the event and add the SDeflector to its Deflectors list.

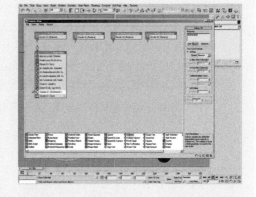

Information: The Wind, as mentioned earlier in this tutorial, is added simply to introduce an illusion of external air turbulence from wind, someone breathing, closing a door… take your pick…! The Collision test loads in the SDeflector so that the particles flow over the surface instead of passing through the Geosphere geometry.

10 Ensure you're at frame 0 and instance the Flame Shape event. Label this new event Flame Small Influence. Make the Birth operator unique and set its Amount value to 350. Remove the Shape operator and make the Delete operator unique. Set its Life Span value to 100 and Variation to 0. Wire the input of this new event to the output of the PF Source Small Influence event.

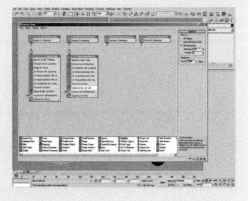

Information: You must ensure you're at frame 0 as you may have particle updates while duplicating a lot of particles affected by multiple Keep Apart operators. Also ensure you amend the settings before wiring to prevent any system lag if you aren't at frame 0. This new event has the same particle emission points, yet a reduced particle count as mentioned before, for

the Flame particles to be attracted to, creating small collations of particles/fire. The Shape operator has been removed as we don't need it in this system, but only in the original one. We've made the Delete operator unique so that the trailing Flame particles are continuously dragged vertically at the top of the flame, creating licks of flame and also ensuring that the flame doesn't try to slow down and attract particles beneath it.

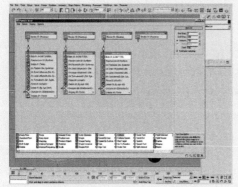

11 Instance the Flame Small Influence event to create a new event and wire the input of the new event to the output of the PF Source Large Influence event. Label this new event Flame Large Influence. Make the Birth operator unique and set its Amount value to 150.

Information: Same deal as before, but with an even lesser amount of particles as this system is going to deal with a larger influence on the Flame particles.

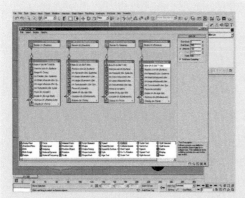

12 Instance the Flame Large Influence event to create a new event and wire the input of the new event to the output of the PF Source Turbulence event. Label this new event Flame Turbulence. Make the Birth operator unique, and set its Emit Start to 5 and Emit Stop to 305.

Information: This time, even though the majority of the system is identical to the previous one, we've set a time offset so that this new system is "chasing"

the previous one. When used within a KA Turbulence operator in the Flames system, it displaces out the particles behind the Large Influence particles, creating the wind to rush in and displace the flame.

13 Make the KA Turbulence operator in this event unique and label it KA Turbulence Chase. Set its Force value to −1 cm (changed from 1 cm) and choose the PF Source Large Influence system in its Scope group's Selected Particle Systems list. Save the scene, turn off the Autobak feature in your preferences, and click on the Play Animation button to run the simulation. If you face problems like particles suddenly disappearing, see the "Information" section below. In the screenshot, I've also made each Display operator unique and assigned it a color and shape to distinguish the systems.

Information: This Keep Apart operator has had its Force value changed back to a positive value, resulting in an attraction to the Large Influence system. This will, in turn, displace the Large Influence particles along with other particles in the other systems, creating a turbulent effect. We're playing through the sequence to view the simulation to ensure no particles suddenly disappear. Usually this problem occurs with multiple Keep Apart operators dealing with a lot of particles due to the Keep Apart operator's brute force method. The sequence is already set to play every frame consecutively, and if any problem arises (i.e., the system hangs), click back immediately at frame 0 on the Timebar (eventually) so that the system updates and returns to frame 0. We've turned off the Autobak feature so that 3ds Max doesn't attempt to Autosave part way through the playback

sequence or once the sequence has been completed, else it will try to re-run the simulation and attempt another Autobak save at the end and so on and so on... (depending on the time interval between saves you've set in your preferences). To get around the issue of disappearing particles (should you experience it), set a new Seed value in the Position Object operator and re-run the simulation. Worst case scenario, drop the amount of particles in the Flame system, even by just 1000, and re-run the simulation. Actually, to tell you the fact, the Force operator's Influence value was originally set at 600, but I found the Keep Apart operators were failing, so I simply amended the value to 610, which worked. If this value doesn't work for you, just drop it down between 590 and 610; even very small changes can result in the particle positions being recalculated. NOTE: We're running the simulation to ensure particles don't disappear at render time. You can check this in the Viewport as the percentage of particles visible in the Viewport is set the same value as that in the render, plus the Integration Step settings are also the same.

PART THREE: With the particle system now designed, we'll surface the particles before designing a Flame material and assigning it to the geometry.

14 Return to frame 0 and enable the Autobak feature. Save the file for safety. Add a Blobmesh operator to the scene. Set its Render and Viewport Evaluation Coarseness values to 40 and enable Off In Viewport. Click on the Pick button and choose the PF Source Flames icon in the scene (with the button depressed, click on the Select By Name icon in the scene if you've trouble clicking on the icon in the Viewport). Click the Pick button again to turn it off.

Information: Make sure you return to frame 0, else you'll surface the resulting Blobmesh at the full extent of the amount of particles in the scene which may slow things down a touch. We've turned off Show In Viewport to speed up Viewport performance. The Evaluation Coarseness value has been increased to bring down the amount of polygons that the Blobmesh will generate, thereby speeding up the surfacing operation; we've set both Render and Viewport to the same value so that if you may decide to view the geometry in the Viewport (by re-enabling Show In Viewport) you can see exactly what you'll get at render time. The reduced mesh density will obviously result in surfacing inaccuracies, but we'll refine the mesh next. As there are multiple PF Source icons in the scene, it's much easier to use the Select By Name feature to assign the relevant object to the Blobmesh. Ensure you turn the Pick button off afterwards, as mentioned above, else you'd accidentally select another object in the scene and add it to the Blobmesh as well!

15 Add a Cap Holes modifier to the Blobmesh01 object. Add a Turbosmooth modifier. Finally add a Relax modifier and set its Iterations value to 50. Turn off Keep Boundary Pts Fixed. Open the Material Editor and add a Raytrace material to a free sample slot. Label the material Flames.

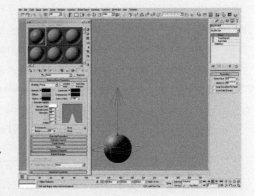

Information: Due to the low mesh density of the Blobmesh, set in Evaluation Coarseness, an occasional hole in the geometry may pop up, which will result in a black mark in the resulting render. Adding a Cap Holes modifier fixes this problem. The Turbosmooth modifier refines the mesh ready for the Relax modifier; the Turbosmooth adds more polygons for the Relax modifier to work on, resulting in a smooth result, which takes only a fraction of the time it'd take to create the same amount of polygons with the Blobmesh object alone! We need these extra polygons to effectively relax and smooth out the main mass of the geometry without losing finer detail of single particles.

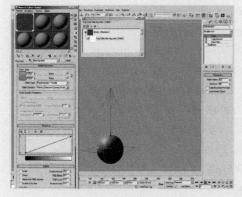

16 Set its Transparency color to white and set the Index of Refr value to 1. Set the Specular Level and Glossiness values to 0. Expand the Extended Parameters rollout, and in the Advanced Transparency group, enable Fog. Set its Start value to 1 and End value to 600. In the Fog's Map slot, add a Falloff map and label it Flame Fog Color. Set the Front color swatch to RGB 255,148,93 and the Side color to RGB 255,115,65. Expand the Output rollout and set its Output Amount to 3. Assign this material to the Blobmesh01 object in the scene.

Information: The flame material simply uses the Raytrace material's Fog element to create a smooth texture, with its intensity derived from mesh thickness. This is ideal for our flame effect as the thicker the flame, the brighter it gets, and the thinner the geometry, the lower the intensity. However, we don't want the material to reflect its environment; therefore, we've set the Index of Refraction of the object to 1. We've cranked up the Output value of the Falloff map, which sets two colors – one for the facing geometry and the other for the perpendicular – the sides of the flame, to brighten up the end result. The Fog parameters have been set as such so that the outer edge of the geometry isn't fogged (inset by the Start value of 1 and the inner (End) value set to 600) – a value much higher than the thickness of our geometry as it currently stands, but useful to have in case you decide to amend the scene later on. Should you find the flame too bright for your needs, try increasing this End value to drop down its attenuation.

17 Label a Standard material in a new sample slot Metal Ball. Set its Diffuse color to RGB 55,55,55 and set Specular Level to 100 and Glossiness to 15. Assign this material to the Geosphere01 object in the scene. Render off the scene.

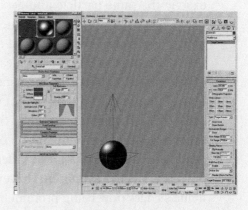

Information: The material assigned to the Geosphere in the scene is just a basic material to simulate a dark metal sphere (hence a large highlight). If you need a more accurate representation, try adding a Raytrace map to its Reflection map slot; the beauty of flame geometry is that it'll be reflected within the Raytrace map!

Taking it further

The end result of this tutorial does work quite well for emitters of this size; however, for larger surfaces and bigger fires a lot of additional work is required. This is due to the amount of heat the "fire" emits, thus affecting turbulence in the air. Additionally, changing the size of the fire requires a change to the amount of fuel, which obviously changes the resulting shape of the fire (see the reference material for examples). For this you'll need to amend the influence systems, plus potentially add additional systems to get the end result look right.

One way to get the end result look a bit more effective would be to speed up its motion; obviously it's currently way too slow and needs speeding up considerably. You could do this in the comp simply by ramping up the playback speed of the footage. If you want this effect in 3ds Max, you'll need to amend the Keep Apart operators so each has more strength over the adjacent particles, and also turn up the Force operator's Influence value, thus dragging the particles upwards faster. We'd have to increase the Keep Apart operators' influence, else the wind may simply drag the influential particles up, not giving the flame particles any chance to catch up!

An additional way is to tweak the assigned material slightly, which I've added as the Taken Further scene included with this tutorial. In this example, using

exactly the same particle and geometry setup, I've simply added a prominent falloff effect to the inner edge of the material. This is achieved by adding a Falloff map to its Transparency map slot and designing the Mix curve to inset the falloff edge a little so that it coincides with the reference material. The brightness of this edge is derived from an instanced version of the map used in the Fog slot in the Luminosity slot. The Output value of this map was dropped down a touch due to the resulting intensity of a (now) partially opaque material being applied onto the fog, which resulted in an overly bright flame. This falloff effect is pretty subtle but does make a lot of difference to the end result, giving the shape of the flame a better definition. However, it isn't without problems. Because of the flame's edges now being prominent, irregularities in the adaptive geometry of the Blobmesh due to the high Adaptive Coarseness values are now visible, even with the Turbosmooth modifier applied. Thankfully, adding some motion blur tends to cure this problem as the particles at the peak of the flame are moving so fast that the falloff effect blends nicely. Ideally the falloff effect should also be linked to the thickness of the geometry, stronger in intensity where the geometry is thick and very transparent where the geometry is thin.

Additionally, even if you decide to keep the material design and speed of the flame as it's, adding a touch of motion blur will make a lot of difference. There are three main ways to achieve a good result – one by using Object Motion Blur (which may take a while and result in artefacts), secondly by using multiple-pass motion blur (set in the Camera), and thirdly by using the Scene Motion Blur feature in the Video Post. One type of motion blur is missing in this list – Image Motion Blur. Obviously this type can't be used as the polygon count is dynamic from one frame to the next, which would result in a blurry mess!

Although this flame color and shape is loosely based on a gaseous fire, you may want to amend the system somewhat by adding some smoke into the fire as the flame licks extinguish. This is actually pretty easy; instead of killing the particles off with a Delete operator, you can send them to another event after the same amount of time they're made renderable (HINT: change the Render operator's Type to Geometry and make the initial event non-renderable in its Properties). The type of particle required for the smoke could be set as a scaling facing particle (Shape Facing operator) or a nice rotating Sphere (Shape operator/Shape Instance operator), and use billboard particles and/or lots of falloff to ensure the geometry edges aren't visible. As these additional particles will interact with the shaded Blobmesh (i.e., they overlap), you may find that the fogging effect applied to the Blobmesh flame geometry is brightened by a fair amount. To get around

this, I'd suggest compositing the smoke separately, else you'll find that your flame is too bright in places and/or suddenly gets brighter as the smoke particles kick in (even if the smoke particles are very dark!). You could try rendering both out in one pass, but you'll more than likely need to amend the Output value of the Falloff map used to control color distribution in the assigned material. Personally, I'd composite the effect as the result is less hassle, plus you can always amend smoke color and density later in the comp!

No matter how much we tweak and amend this system, it has to be said that even at this early stage in the book, (currently) there's no proper native solution to make this type of effect, that is to say there isn't a native fluid system for 3ds Max, so you'll have to resort to a plugin or a third-party solution. However, there's no reason why one couldn't script the motion effectively with a bit of time and effort. Fluid dynamics calculations aren't exactly easy, though if you know MAXScript you should be able to code a system that affects particle positions over time based on surrounding fluid/air viscosity. For more information on computational fluid dynamics and for some very good CG references and examples of dynamics, check out Ron Fedkiw's site at http://physbam.stanford. edu/~fedkiw/.

2 Sun surface – extreme UV solar imagery

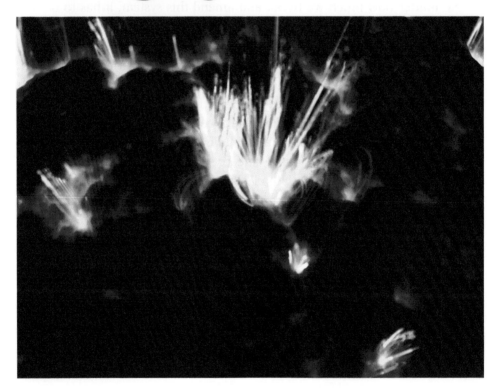

Introduction

Even though we've already got a tutorial based on sun (in the accompanying electronic book), this particular tutorial tackles the effect in greater detail using a different method of generation and a different particle system to produce the effect. There are a couple of aspects which are identical, namely the way the particles find their target, and even though the particle system is much more simplified, it produces a much better result due to constant searching for destination targets (or "gravity wells") akin to the real thing.

Analysis of effect

(a) As mentioned in the introduction, this tutorial has some similarities with the Solar Flare tutorial in the accompanying e-book; so therefore the analysis is going to be exceptionally similar, though based on TRACE reference material, concentrating on their Extreme Ultraviolet images instead of the Ultraviolet ones in the Solar Flare tutorial, namely in the 171 Å passband (1-million-degree emission). Obviously if we base our tutorial reference on visible light images, we wouldn't see a great deal and/or much visible detail for us to simulate. The surface material in these images is quite monochromatic, largely consisting of brighter emission points, yet surface texture can still be distinguished from the trails as noisy indentations in the surface. (b) The emissions (often called "Cooling Loops") are fired off at varying angles and widths, speed and spread, although (relatively consistently) the higher the emission, the greater the range of spread (additional loops) that is present. That isn't to say that smaller loops have less detail; in fact some smaller loops have as much detail as the larger ones, it's simply that they find a closer attraction point. (c) The emission points also attract the loops back down, which are constantly being attracted to the adjacent points, thus affecting the direction and shape of the loop. The colors of the loops appear uniform in this type of reference material; obviously, depending on the amount of post-processing these images have had, the color may be slightly more yellow than orange, yet the luminance values appear consistent. (d) That's to say that the loops are considerably brighter at their point of origin and at the point they return to the surface than at the precipice of the loop shape. The animation of the reference depends largely on the ferocity of the sun spot and the time intervals the TRACE satellite took the images; almost fluid-like explosions can erupt across the surface, disrupting the adjacent loops and emission points. See the movies in the reference material for examples.

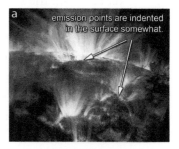

Image courtesy TRACE/
Lockheed-Martin/NASA

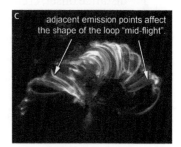

Image courtesy TRACE/
Lockheed-Martin/NASA

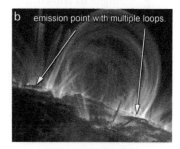

Image courtesy TRACE/
Lockheed-Martin/NASA

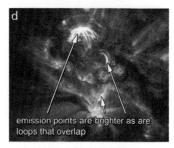

Image courtesy TRACE/
Lockheed-Martin/NASA

For this tutorial we're going to concentrate on a constant stream of emissions, yet break up the sequence with a finite stream life so that the surface texture is constantly changing. We won't make the streams as fast as those in the reference; however, we can always speed up the resulting sequence to emulate this! The surface texture itself will be set up with a basic displacement that can be driven by a Cellular map. This map can be used in several different guises, not only in renderable surface but also to control the emission areas, target areas, velocity of the particles, and their direction. Though the emission points on the renderable surface can be inset akin to the reference material, so as to get the stream angles to travel outwards from these points, we'll use negative displacement, thus creating bulges in the emitter geometry. This will, therefore, direct the particles outwards from the emission point. The speed of these particles can be determined from the Cellular map; at the "hottest" areas (white), the particles travel at their full velocity set within a Speed By Surface operator in Particle Flow, whereas darker grayscale values will have lesser velocities, resulting in smaller loops. Again, the Cellular map drives the loop's target. To accomplish this, we'll use a Find Target test which is pointed to another piece of geometry in the scene, which has its parts "cut out" by the Cellular map, leaving only relevant faces for the particles to find. The particles themselves will be emitted and randomly spawned with a slight distance offset, creating additional streams akin to the main "parent." To achieve a more realistic loop as opposed to the one in the supplementary book's Solar Flare tutorial, this tutorial uses a feedback technique to find the nearest target. That's to say that the particles try to find their target, then are passed to a new event, and after four frames they try to find their nearest target again; because of their velocity, they may have traveled out of the influence of the original target and a new target may be pulling them towards it. This thus creates the breakup of uniformity we see in the reference material. These particles pass through this feedback loop until they reach a target and/or (for safety) hit an SDeflector object positioned underneath the surface to prevent any particles from missing the target geometry and looping back around! The particle's material will be shaded akin to the reference material by point sampling the RGB values, with brightness around the emission and target points (and where streams overlap) generated by using Additive Transparency. To blend these particles until no individual particles are distinguishable, we'll use mental ray's motion blur which yields a nicer result and doesn't take as much time to render a large frame offset as the Scanline renderer; moreover, we'll use a high Shutter Duration value, which overlaps and causes the particles to appear as one long loop instead of being fragmented.

Walkthrough

PART ONE: Loading the start scene and setting up the geometry.

1 Open the *02_Sun_Surface_Start.max* file included with this tutorial. Accept any unit change that may pop up. In this scene we've several objects to work with – a Plane primitive object, Camera, PF Source icon, and an SDeflector. Select the Plane01 object in the scene and label it Surface_Renderable. In its Plane base level, set the Length and Width Segs values to 100.

Information: By accepting the unit change dialog panel we ensure we're all working with the same unit values as we're going to deal with procedural maps and particle velocity values; if you were to use a different unit setup, then your results would differ from that in this tutorial and cause further problems down the line. The Plane01 object (now renamed Surface_Renderable) has had its Length and Width Segs values amended so that we've enough polygons to add detail to it later on.

2 Add a UVW Map modifier to the Surface_Renderable object. Add a Bend modifier to the stack and set its Angle value to 60. Set the Bend Axis to X. Add another Bend modifier to the stack and set its Angle value to 60. Set the Bend Axis to X. Go to the Gizmo sub-object level and rotate the modifier 90 degrees clockwise in the Top Viewport as illustrated.

Information: Even though the base Plane object has mapping already assigned to it, it's best to add it here so that you can tweak it later on, should you need. It's also been added at this stage underneath any deformation modifiers so that the mapping gets deformed too. If it were to be added further up the stack, the results may be different – they'd be planar projected onto a deformed surface which will appear stretched. The Bend modifiers have been added simply to create a slight curve in the geometry to give the indication of a spherical surface.

3 Add a Displace modifier and set the Strength value to −100. In this modifier's Map group, enable Use Existing Mapping. Clone this object and label the new object Surface_Speed. Add an XForm modifier to the stack between the UVW Mapping modifier and the first Bend modifier. Go to its Gizmo sub-object level, and in the Front Viewport, relocate the Gizmo 10 units vertically down along the Y-axis.

Information: The Displace modifier will be used later to create surface detail by adding a map to it, which we'll design shortly. The Surface_Speed has an XForm modifier further down the stack to offset the geometry without affecting the Bend modifiers; if we'd simply moved the object itself, the polygons wouldn't line up, and it's possible that the emission points of the particles wouldn't appear to emit from the corresponding (renderable) surface deformation and shading. The particles to be born later and emitted

will have their speeds set underneath the visible renderable geometry (this object will be made non-renderable later on), and so it appears that the loops are being emitted from under the surface, not on top of it, for the most part anyway; due to surface deformation, there may be one or two streams that start slightly above the renderable deformed surface, but due to the sheer number of streams and motion blurring added later on, this is negligible.

4 Navigate to the Displace modifier in this new object and set its Strength value to 50. Set the Decay value to 0.75 and enable Luminance Center. Set the Center value to 1. Add a Relax modifier to the stack. Clone this object as an instance and label the new one Surface_Emitter.

Information: As we want the particles to spread outwards from the emission points, the Displace modifier has had its value amended to a positive value so that the result will be an outward bulge. The particles will travel along the direction of the polygon normals, thus spreading them outwards. The Relax modifier has been added to smooth out any sharp edges resulting from displacement that'd affect the particles' motion and direction. We instance the object so that we can assign a different material to the object which will, in turn, affect the particles' motion or emission independently.

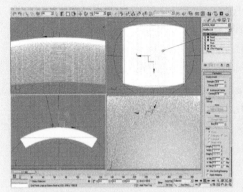

5 Copy the Surface_Emitter object (not instance) and label the copy Surface_Target. In the base Plane object, set the Length and Width Segs values to 300. Add a Push modifier above the XForm modifier and set its Push Value to −5. In the Displace modifier, amend the Strength value to 30 and set Decay to 0. Set Luminance Center's center value to 0.75. Remove the Relax modifier.

Information: As we're going to remove the pieces of geometry, increasing the amount of detail in the base primitive allows for a greater "cut out" accuracy generated by the Vol. Select modifier we'll add next. The Push modifier has been added to offset the geometry behind the emitter objects (once the maps have been added to the Displace modifiers), so that the particles don't reach their target immediately after birth! The Relax modifier has been removed as we no longer need it due to geometry optimization which we'll add next.

6 Add a Vol. Select modifier to the stack and enable Face in the Stack Selection Level group. In the Selection Method group, enable Invert. In the Select By group, choose Texture Map. Add a DeleteMesh modifier to the stack. Add a Mesh Select modifier. Add an Optimize modifier and set its Face Thresh value to 90.

Information: The Vol. Select modifier will select polygons based on the map information we'll add shortly; so at present this has no effect. This selection is then passed up the stack and the resulting polygons deleted, restricting the visible surface the particles can find. The Mesh Select modifier merely clears the sub-object selection so that the Optimize modifier can work on the entire geometry; this was added to speed up particle calculations, else the system will have to attempt to work out the positions for thousand more particles than necessary! If you think particle accuracy has been compromised, then feel free to reduce the Face Thresh value to put polygons back later on. Note that as we haven't dropped any maps in the Vol. Select modifier, the entire geometry is deleted. This will be resolved shortly.

PART TWO: Setting up displacement maps to deform the scene geometry and to drive selection to remove polygons from the Surface_Target object.

7 Open the Material Editor. In a new sample slot, create a Cellular map and label it Surface Control. Set Source to Explicit Map Channel. Swap the Cell Color and the second Division Color so that the Cell Color is black and the second Division Color is white. Set Size to 0.125 with a Spread of 1. Enable Fractal and set Iterations to 10.

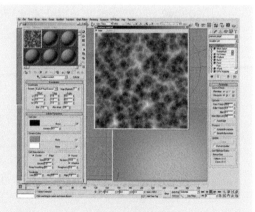

Information: This Cellular map pretty much drives everything in this scene, from surface deformation and shading through to particle emission and speed. It simply creates a sporadic cellular texture with white cracks, with Fractal being enabled to add additional fine detail.

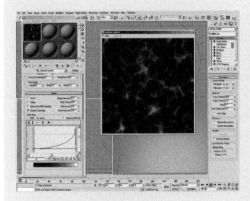

8 Expand the Output rollout of the Surface Control map and turn on Enable Color Map. Relocate the point at position (1,1) to (1,1.3). Select both points, right-click and set Point Type to Bezier-Corner. Design the curve as illustrated, ensuring the handle for the point at position (0,0) doesn't go below 0; zoom closely to the handle to ensure this.

Information: The Output simply adds more control over color distribution in the Cellular map. At this point we've to be very careful about the Bezier handles – I could seriously suggest zooming closely to the handle to ensure it doesn't dip below zero. This is because even a slight nudge below zero can affect the curve towards (0,0) and result in a bad selection of polygons, errors in displacement, particle emission and speed issues, and problems in the renderable material as they'll have to deal with negative values. Better to be safe than regret later on!

9 Instance this map into the Map slot of the Displace modifiers in the Surface_Renderable, Surface_Speed (and therefore Surface_Emitter), and Surface_Target objects. Create a new Output map in a new sample slot, label it Surface Target Selection, and instance the Surface Control map into its Map slot.

Information: By instancing the map into the Displace modifiers, you can immediately see the effect – the Surface_Renderable object deforms inwards where there's white, and the Surface_Emitter and Surface_Target objects deform outwards very subtly (i.e., smoothed out, thanks to the Relax

modifier). We're also using this map to drive the Vol. Select selection, but because the map doesn't have that much solid white in it, we're going to crank it up a touch.

10 Expand the Output rollout of the Surface Target Selection map, turn on Enable Color Map, and set the point at position (1,1) to (1,10). Select both points in this curve and set their point type to Bezier-Corner. Design the curve as illustrated, ensuring the handles don't dip below 0.

Information: Same deal as before with regard to the handles – we don't want negative values! This Output map simply increases the values of the map while still keeping the dark areas and without affecting the main Cellular map itself (and therefore not affecting the displacement).

11 Instance this Output map to the Texture Map slot in the Surface_ Target's Vol. Select modifier to set the Sub-Object Face selection and then delete the relevant polygons set by the other modifiers above the Vol. Select modifier in the stack.

Information: Immediately we see the selection affected by the assigned map; remember that we've selected using the white areas of the map, but inverted the selection in the modifier. The resulting selection is then deleted using the Delete Mesh modifier.

PART THREE: Next we'll set up the materials assigned to the objects in the scene that drive the overall effect, including the material assigned to the Surface_Renderable object.

12 Create a new material in the Material Editor and label it Surface Speed. Instance the Surface Control map into the Diffuse slot of this material. Assign this material to the Surface_Speed object in the scene. Create a new material and label it Surface Emitter. Add an Output map to its Diffuse slot and label it Surface Control Multiply. Instance the Surface Control map into the Output map's Map slot. Still in the Output map, expand its Output rollout and turn on Enable Color Map.

Information: The Surface Speed material simply drives the speed of the particles being emitted from the Surface_Emitter geometry; the Cellular map can be used as-is for this, but we need to tweak the intensity of the Surface Emitter, else we won't have enough particles; this is applied with an Output map, akin to what we did earlier with the selection.

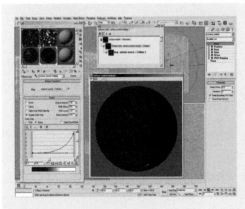

13 Relocate the point at position (1,1) to (1,5). Add a point to the curve at position (0.2,0). Right-click this new point and set it to Bezier-Corner. Drag out the Bezier handles as illustrated, again ensuring that the handle doesn't go below 0. Assign this material to the Surface_Emitter object in the scene.

Information: Same deal as before, but this time ensure there are no low grayscale values generating odd sporadic loop in the middle of nowhere! This can be achieved by clamping off the curve by adding the extra point and setting it to a height of 0.

14 Select the Surface_Speed, Surface_Emitter, and Surface_ Target objects in the scene. Right-click in the Viewport and select Object Properties in the resulting menu. In the resulting panel, turn off Renderable and click OK to close the panel.

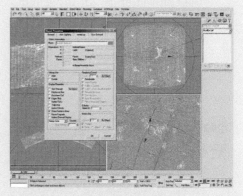

Information: We don't want to see these objects in the scene, so they've had their Renderable properties disabled. You could always hide the geometry, though we need to call them later on when assigning particle properties.

15 Back in the Material Editor, label a new material Surface Renderable. In the Shader Basic Parameters rollout, set the Shader type to Oren-Nayar-Blinn. Set the Self-Illumination value to 100. Add a Mix map to the Diffuse slot and label it Surface Color Mix. Add an Output map to the Mix Map's Mix Amount slot and label it Surface Color Control. Instance the Surface Control map to the Map slot in the Output map.

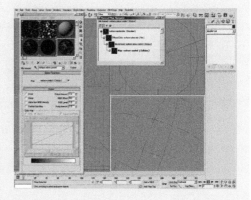

Information: Here we've the main design of the material assigned to the Surface_Renderable object. Its construction is pretty straightforward, again using the Cellular map throughout the scene to control the mixing of colors in the Surface Color Mix map. The Oren-Nayar-Blinn shader is used to create a nice matted and smooth texture akin to the reference. The Mix map will have colors assigned later on, replacing the default white color of the Cellular map, and the Output map has been added to amend the color strength of the Cellular map as before (without affecting the Cellular map itself).

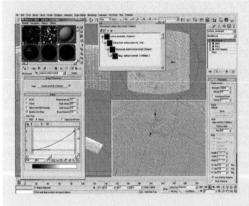

16 Expand the Output rollout of the Surface Color Control map and turn on Enable Color Map. Set the point at position (1,1) to (1,2), right-click the point at position (0,0), and set it to Bezier-Corner. Design the curve as illustrated. Back up in the Surface Color Mix map, and set the Color #2 swatch to RGB 255,140,62. Expand the Output rollout and set Output Amount to 2.25. Assign this material to the Surface_Renderable object in the scene.

Information: The Surface Color Control map is there to amplify just the white areas of the Cellular sub-map, which is then applied to the Surface Color Mix map, controlling the intensity of the orange color we've just inserted into its Color #2 swatch. Its Output Amount has been increased to 2.25 to intensify the color further in the hot areas defined in the Surface Color Control sub-map.

PART FOUR: Finally we'll set up our particle system to drive the overall loop effect and reference the scene geometry to control emission, velocity, and particle targets.

17 Select the PF Source 01 object in the scene, and in the Modifier tab of the Command panel, click on the Particle View button. Add a Material Static operator to the PF Source 01 root event. Go to the Material Editor and label a new material Flare Loop. Set the Diffuse color to RGB 255,118,52 and set the Self-Illumination value to 100. Set Opacity to 6. Expand the Extended Parameters rollout and set Advanced Transparency to Additive. Instance this material into the Material slot in the Material Static operator in Particle View.

Information: The Material Static operator has been added at this level so that it affects every subsequent event in the particle system. This can be useful instead of having to add it to every event in the system we create. The assigned material has a pretty low opacity value, but bear in mind that due to Additive transparency, the resulting particles appear bright because of the amount of particles present in the scene and the fact that they overlap.

18 Drag out a Birth operator to the Particle View event display to create a new event. Label the event Birth Positions. Wire the input of this new event to the output of the PF Source 01 event. Set the Birth operator's Emit Stop value to 300 and Amount to 6000. Add a Position Object operator and the Surface_Emitter object to its Emitter Objects list. In its Location group, enable Density By Material. In the If Location Is Invalid group, enable Delete Particles.

Information: The Birth operator simply sets the duration of the sequence (the entire 300 frames), and the Amount is the original amount of particles added to the system before they're distributed and spawned later on. The Position Object operator scatters the particles across the Surface_Emitter object based on its assigned material, thanks to the enabled Density By Material option. If the system has a problem determining the positions, it normally drops the particle at a random position on the emitter geometry. We don't want this, so the Delete Particles option is enabled.

19 Add a Shape operator to the event and set Shape type to Cube. Set Size to 7. Add a Scale operator to the event and set Scale Variation to 50 for all three axes. Turn off the Particle system by clicking on the lightbulb icon in the PF Source 01 root event.

Information: The particles need to be pretty small, hence the low Size value in the Shape operator. The Scale operator in this event will set the stream width of the loops as the Spawn tests to be introduced later on will inherit these values. We've turned the particle system

off because we're going to add multiple Spawn tests to the system. If you aren't at frame 0, it may result in the Spawned particles spawning themselves because the test doesn't send the particles out of the event. Therefore, turning it off is purely for safety.

20 Add a Spawn test to the event. Set Spawnable % to 20 with Offspring to 10 and Variation to 100. In the Size group, set the Scale Factor and Variation values to 75. Add a Send Out test to the event.

Information: The Spawn test is introduced to create multiple particles from a fraction of the overall birthed particles. These will then be sent to another event where they're offset (moved) to create a bit of a spread. The amount of child loops (smaller in width) is determined by the Offspring and Variation values. The Delete Parent option has been disabled to ensure the original loop still renders. As this parent particle won't be passed out of the Spawn test, a Send Out test is added to send this parent particle to the next event, so that the child particles once offset can join them.

21 Drag out a Speed operator to the Particle View event display to create a new event. Wire the input of this new event to the output of the Spawn test in the previous event. Label the new event Stream Spread Offset. In the Speed operator, set its Speed and Variation values to 100. Set Direction to Random 3D. Add an Age Test to the event and set it to Event Age with a Test Value of 1 and Variation of 0.

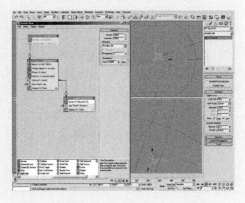

Information: This event simply offsets the child particles generated by the Spawn test in the previous event by moving them randomly with a high Variation value to remove any uniformity. These particles stay in this event for 1 frame only before being outputted to the next event (rejoining their parents).

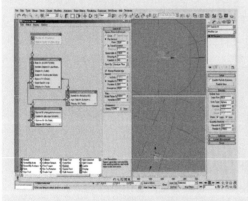

22 Drag out a Speed operator to the Particle View event display to create a new event and label the event Stream Emitters. Wire the outputs of the Birth Positions' Send Out test and Stream Spread Offset's Age Test to the input of this new event. Set the Speed operator's Speed value to 0. Add a Delete operator to the event and set it to Particle Age with Life Span of 120 and Variation of 60. Add a Spawn test to the event and set it to Per Second. Set the Rate value to 20.

Information: The Speed operator's value is set to 0 to kill the speed of the child particles in the Stream Spread Offset event. The particles in this event are now in situ to emit the streams (via the Spawn test), but we want the emitter particles to exist only for a finite lifespan to add some animation to the scene; therefore, the Delete operator has been introduced to remove them after a short while. The Spawn test creates multiple particles per second from the original particle's position, inheriting the Spawn values set earlier in the system. As the particle's speed has been killed earlier on, we don't need to worry about setting the Speed parameters in this test.

23 Drag out a Speed By Surface operator to the Particle View event display to create a new event and label the event Stream Direction. Wire the output of the Spawn test in the Stream Emitters event to the input of this new event. Set the operator's Speed value to 650 and add the Surface_Speed object to its Surface Geometry list. Enable Speed By Material. Add an Age Test to the event, set it to Event Age, and set its Test Value to 4 with a Variation of 0.

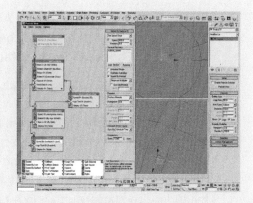

Information: Here's the main crux of the animation. As with the Position Object operator, the speed of the particles is influenced by its assigned material – white values travel at the full value (650) and black values have no velocity. Because the child stream particles have been offset, their velocities are slightly different from that of the parent. Also, they're slightly further across the deformed geometry that drives the speed, so they will be directed along a slightly different trajectory. To get larger spreads, try amending the Displace modifier's Strength value (after we've finished the tutorial of course!). The Age Test keeps the particles in this event for four frames to give them a chance to get cleared off the surface before they're influenced by the target geometry, which we'll add next.

24 Drag out a Rotation operator to the Particle View event display to create a new event and label the event Stream Search01. Wire the output of the Stream Emitters event's Age Test to the input of this new event. Set the Rotation operator's Orientation Matrix to Speed Space Follow. Add a Find Target test to the event. In its Control By Speed group,

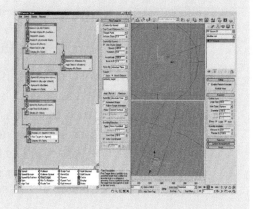

set the Speed value to 400 and Accel Limit to 200. In the Target group, enable Mesh Objects and add the Surface_Target object to its Mesh Objects list. Choose Closest Surface from the Point drop-down list.

Information: The Rotation operator ensures the particles are always facing their direction of travel. This isn't always necessary; however, it adds to the smooth contour of the stream when rendering a large image and/or being closer to the surface. It takes little time to calculate (the proverbial "drop in the ocean" in the scheme of things!), so it's worthwhile adding. The Find Target test is the other most important item in this system – directing the particles back down to the surface and targeting the closest remaining geometry in the Surface_Target object. This test's values have been amended so that the particles appear to have some mass, i.e., they don't suddenly turn on a hairpin to travel to their targets!

25 Add a Collision test to the event and add the SDeflector to its Deflectors list. Instance the Age Test from the Stream Direction event to this event. Instance the entire Stream Search01 event and label the new event Stream Search02 (if it doesn't do it automatically). Wire the output of the Age Test in the Stream Search01 event to the input of this new event, and the output of the Age Test in the new event to the input of the Stream Search01 event as illustrated.

Information: The Collision test is added as a failsafe "catch-all"; the Find Target particles will occasionally miss their targets and have to loop back around to attempt to hit them again. The SDeflector ensures, if they miss then they're deleted, so we don't get any adverse loops. The Age Test is the duration the particle has to find its target; after the four frames are set within the test, the particle will search for its next closest target; this may be the same point or one slightly different, simulating the loop in real life. Note that the value 4 was derived to speed up particle calculations; ideally the value

should be 1, however this will slow the system down. Alternatively, if you want to speed the system up, try increasing this value, but be aware that this can result in corners being visible in the loop as the particle changes direction.

26 Drag out a Delete operator to the Particle View event display to create a new event and wire the outputs of both Find Target tests and the Collision tests of both Stream Search01 and Stream Search02 events to the input of this new event. Ensure you're at frame 0 and turn the particle system back on. Select the root event of the particle system, right-click and select Properties. Enable Object in the Motion Blur group and click OK.

Information: This event simply removes all the particles once they either successfully find the target geometry or come into contact with the SDeflector object in the scene which is positioned and vertically scaled to be just under the geometry. We're specifying motion blur here so that we don't need to motion blur the entire scene, but only the geometry that needs it (the particles).

27 Open the Render Setup panel and change the renderer from Scanline to mental ray. Navigate to the Renderer tab and go to the Camera Effects rollout. Turn on Motion Blur by clicking on the Enable button, but turn off Blur All Objects. Set the Shutter Duration (frames) value to 4 and set the Shutter Offset (frames) value to 0. Go to the Indirect Illumination tab and turn off Enable Final Gather. Finally specify a new output file and path to render to and render off the sequence.

Information: Again, we're using mental ray because of the quality of the motion blur as opposed to Scanline's which would take considerably longer to get the same effect. By default we're motion blurring the entire scene due to the default setup in mental ray; however, we can confine this to just the particles by turning off Blur All Objects in the Camera Effects rollout in the Render Setup panel's Renderer tab.

Taking it further

The particle counts setup for this scene has been designed for moderate spec'd systems; so if you've a system running the 64-bit version of 3ds Max or an absolute ton of memory, try dropping the opacity of the particles down and cranking up the system's Birth Amount. Additionally, you may also want to look into increasing the initial Spawn operator (that produces stream-widening emission particles) and the Spawnable % value and/or the Offspring. You may also want to look into emitting more particles from more locations; to do this you'll obviously need to tweak the Emission material's Diffuse map so that there's more white applied to the material and hence more particles. This will produce more defined and detailed scenes at the expense of render times. Alternatively, if you don't have a higher spec machine but still want to output these detailed systems, try using lots of render passes with different Seed values inputted into the Position Object operator and composite them together in your favorite compositor.

The Taken Further scene included with this tutorial has a couple of different items added to it, including Volumetric Lights. These are designed to exaggerate the surface detail as they're restricted to areas around the surface. However, these volumetrics (illustrated in the opening image of this tutorial) are rendered off in a separate pass and composited in, purely due to render times; rendering off transparent particles and volumetrics with a ton of Motion Blur takes a substantial amount of time, though a single volumetric pass and the original sequence composited together takes a fraction of the time. You can also tweak "illumination" strength in the comp, plus add additional glows and detail that would take a while to set up in 3ds Max. Compositing is your friend!

There are downsides, however, if you want to apply some motion to the scene. This is due to the high amount of motion blur we've applied – if you apply camera motion to the scene, then you'll find that the particles blur in the direction of the

camera's motion too; however, if you simply want to add a subtle pan and/or dolly into the scene, you can add this as a 2D effect in a compositor easily. However, if you want to do a full 3D rotation in a larger scene, you'll need to increase the amount of particles in the individual streams (this may mean reducing the over-all number of emitted particles, but increasing the amount in the Spawn Rate test) and then reduce the Motion Blur value in the Render Setup panel to a single or half-frame value. To get the amount of streams back to their normal amount, you'll have to render off several passes and composite them together. Unless you've got a 64-bit workstation with the power of a small fusion reactor that is ...!

3 Angle grinder

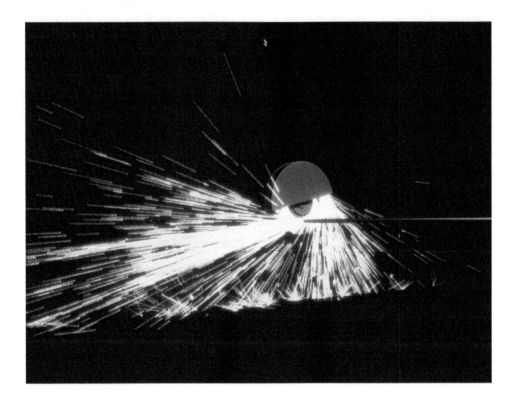

Introduction

In this tutorial we're going to concentrate on creating an effective array of sparks, specifically those emitted from grinding metal. Now you may think it's a pretty straightforward procedure; however, depending on the way sparks are generated, they behave totally differently. For this particular tutorial we're going to deal with creating an angle grinder effect; so the things we need to concentrate are emission rate, adhesion to the grinder itself, and emission velocities. However, the spark itself has its own properties governing its shape and lifespan. More on that in the "Analysis of effect" section.

Analysis of effect

(a) An angle grinder generates sparks using a fast-rotating disc with a textured surface which, when applied to a metal object, generates friction and therefore heat to produce hot fragments, resulting in glowing sparks. These sparks are derived from either metal-against-metal or ceramic-against-metal, with the sparks themselves having defined characteristics and motion. (b) The motion is difficult to be seen due to the speed of the sparks, but with close scrutiny (by slowing down and/or frame advancing the reference footage), we can see that, initially, the fragments of hot metal are adhered to the rotating discs which, after a brief time, are ejected outwards. However, some fragments adhere to the disc more than others, resulting in they travelling around the disc (leaving bright trails) and being flung out at intervals. (c) This produces a distinct distribution pattern, with most fragments being ejected around the contact point, and a small percentage of the adhered fragments being ejected further around the disc as it rotates. As most angle grinder equipment comes with a safety guard, these sparks interact with the interior of the safety guard and the disc itself, ricocheting off each other before being ejected to the side of the disc or at the far side of the safety guard. The spark lengths are determined by the shutter speed of the camera taking the image/footage, which, in frame counts, can be quite high. This obviously varies from footage to footage depending on the amount of exposure and, therefore, dictates the brightness of the spark. (d) However, one thing is consistent – if the image is in focus then each spark is exceptionally thin in diameter. These types of sparks also have a violent explosive death by exploding into three or four sparks as can be seen in the reference footage. It's this property that makes the system look convincing, resulting in a long spark trail with several small branches at the end due to camera exposure

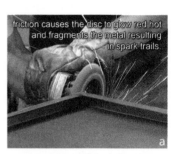

Image courtesy of iStockphoto, Hans Caluwaert, Video # 6222080

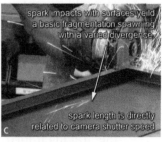

Image courtesy of iStockphoto, Hans Caluwaert, Video # 6222080

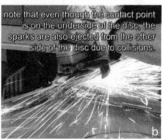

Image courtesy of iStockphoto, Hans Caluwaert, Video # 6222080

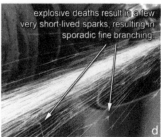

Image courtesy of iStockphoto, Jorge Viamonte, Video # 3370749

over a frame or two. Not every spark dies this way, in fact only a sporadic few out of the entire ejection mass or when they come into contact with an adjacent surface.

Obviously we're going to deal with a particle system for this simulation; however, it isn't simply a case of placing particles on a disc and having the disc rotate like a Catherine Wheel firework. Initially we need to simulate the varied contact between the metal and the rotating disc which will, in this case, be set up by an animated particle rate. These emitted particles will then be adhered to the rotating disc using a Shape Mark operator, which will then be tested for age with a short variation due to the speed of the disc – a few frames will suffice. After this the particles will have their particle ages reset and then flung out using their inherited speed and direction. To get a degree of variation in the distribution akin to the reference material, we'll set up a couple of additional Spawn tests – one to set a relatively large divergence of around 25 degrees and the other to produce additional particles with a 2-degree divergence from this 25-degree spread. These particles will be tested for interaction with the disc and safety guard (throughout), and will have a small lifespan which relates to the material assigned to the entire system and change of color depending on the life of the particle. Once the particle has been ejected from the disc, a small amount of it will be sent out to another event to produce particle explosion trails. Any ground impacts will spawn additional particles, which will be deleted once a single frame creates a short burst of intensity akin to the explosion particles. The entire trailing system will be produced by Object Motion Blur with the Scanline renderer, using multiple samples and Glow Render Effects to produce brightness. However, due to the limitations of the Glow effect, we'll have to render out the effect larger than the default render output sizes used in the rest of this book. See the "Taking it further" section at the end of this tutorial for more information on this.

Walkthrough

PART ONE: First we'll load the startup 3ds Max scene and set up the Space Warps used to design particle interactions with the scene before designing the material to be applied to our sparks.

1 Open the *03_Angle_Grinder_Start. max* scene included with this tutorial and accept any file unit change if prompted. In the Top Viewport, create a Gravity Space Warp. Create a Deflector Space Warp to encompass the scene as illustrated. Set its Bounce value to 0.35, Variation and Chaos to 25, and Friction to 10. Move the Deflector01 Space Warp 500 units down in the Z-axis so that it's well below the base of the grinder.

Information: Don't forget to accept the file unit change if prompted when loading the scene; we're dealing with particle systems which require specific values to be entered, so if you're using a different unit setup, you may get results different from those in this tutorial. The Gravity Space Warp has been introduced to drag the particles back down to "earth," and the Deflector Space Warp prevents them from going below the base of the scene. We've set a touch of Bounce, with some Variation and Chaos to randomize particle deflection directions (so the surface isn't "perfect"), and added a bit of Friction to slow the particles down a touch.

2 Create a UDeflector Space Warp and label it UDeflector_Grinder. Click on its Pick Object button in the Basic Parameters rollout and choose the Grinder_Deflector object in the scene. Set Bounce to 0.5, Variation to 10, and Chaos to 5. Copy the UDeflector and label the copy UDeflector_Guard. Click on its Pick Object button and choose the Guard_Deflector object in the scene.

Information: As we want the spark particles to interact with the guard, they will obviously bounce off this object and back onto the disc; therefore, we need to set up two UDeflectors to add these objects into our particle system later on. We're using non-renderable low-poly-proxy geometry for our deflectors to keep particle calculation times down. This is because the particle system provided has a very low Integration Step for the Viewport and Render though the particles are moving very fast; therefore, we need a very fine sub-frame calculation on their position to prevent any particle leakage and to get some nice sub-frame arcs in the motion, thanks to the gravity and deflector interaction.

3 Open the Material Editor and label a new Standard material in a free sample slot Sparks. Set its Material ID Channel to 1. Add a Particle Age map to its Diffuse map slot and label it Spark Life Color. Set the Color #1 swatch to RGB 255,235,170. Set the Color #2 swatch to RGB 255,182,117 and set its Age #2 value to 35. Set the Color #3 swatch to RGB 255,140,65 and set its Age #3 value to 65. Expand the Output rollout and set the Output Amount value to 5. Back up at the

top of the material, enable Self-Illumination, and instance the Diffuse map into its Self-Illumination map slot.

Information: A pretty heavy step but straightforward. Here we're simply setting up a self-illuminated material that sets the particle color, and therefore its self-illumination color, based on its age. We've also cranked up the Output Amount value to brighten up the particle color as we'll be using Object Motion Blur, which would otherwise result in a dull image, else the Glow Render Effect we'll add later on may not pick up the color of the particles as well.

PART TWO: With the material and Space Warps set up, we'll now use them in our established particle system.

4 Open Particle View. In the PF Source 01 root event, add a Material Dynamic operator to the event and instance the Sparks material to its material slot. Add a Force operator to this event and add the Gravity Space Warp to its Force Space Warps list. Add a Delete operator to the event and set it to By Particle Age, and set Life Span to 2 with a Variation of 3. Add a Collision test to the event and add both UDeflector Space Warps to its Deflectors list.

Information: We've added all these operators to the root event of the system as illustrated so that they govern the entire system in every single event we'll add next. The Force operator introduces the Gravity to the system to bring the particles back down to the Deflector01 object (which will be added later on). The Delete operator adds a lot of random variation to its lifespan, causing the particles to die on birth or within a few frames. This operator also governs the color distribution of the material assigned to the system through the Material Dynamic operator. As we're using the Delete and Material Dynamic operators throughout the system, there will

be no break in color design, such as lifespan color restarting, etc., unless we introduce it. The UDeflector Space Warps have been added to enable interaction with the disc and its safety guard. As mentioned earlier, the PF Source 01 has a refined Integration Step (not as refined in the Viewport as in the Render though, so particle positioning will be different in the Render than in the Viewport) to increase particle accuracy – necessary for these fast-moving particles!

5 In the Birth event, add a Position Object and a Metal_Pipe_Emitter object to its Emitter Objects list. Add a Shape Mark operator to the event. Click on the button in the Contact Object group and choose the Grinder_ Mark object in the scene. In the Size group, set the Width and Length values to 5. Ensure the Surface Offset value is set to 0.001. Add an Age Test to the event and set it to Event Age. Set Test Value to 1 with a Variation of 3.

Information: The Birth operator already has an animated Rate value set up which decides when the metal pipe should come into contact with the rotating disc. The Shape Mark operator simply forces the particles to adhere to the disc upon emission from the Metal_Pipe_Emitter object in the scene. We've used a small amount of Surface Offset to ensure the particles don't fight against the geometry of the rotating disc for position; they'd have to be placed in exactly the same location as the size of the disc, which may have caused flickering in the resulting render. A slight offset removes this issue. The Age Test has been added to determine when the particles should be flung out from the disc; as the disc is rotating very fast, we don't need a high Test Value or Variation, else the particles will go more than once around the disc!

6 Add a Shape operator to the event display to create a new event. Label the event Loose Sparks and wire the input of this event to the output of the Age Test in the Birth event. In the Shape operator, set its type to Cube and set the Size value to 1.5. Add a Spawn test to the event and rename it Spawn-Restart Age. In this new test, enable Delete Parent, and in its Speed group, set Divergence to 0.

Information: The Shape operator gives the particles ejected from the disco some 3D size, which will be picked up better in the resulting motion blur than simply ejecting the Shape Facing particles. The new Spawn test simply restarts the age of the particles, so we must kill any Divergence as this will be set up in the next step. We've reset particle age for two reasons – firstly due to the lifespan set up in the root event of the Delete operator; by this time the particles may have reached the end of their lives and will fall short of showing any trails. The other reason is due to the material assigned to the particles, which has been derived from the particle's life.

7 Add another Spawn test to the event and label it Spawn-Spread Divergence. Set the Spawnable % value to 15 and Offspring to 4 with a Variation of 100. In its Speed group, set Variation to 10 and Divergence to 25. Add another Spawn test to the event and label the new test Spawn-Slight Offset. Set Spawnable % to 5 and Offspring to 2 with a Variation of 100. In the Speed group, set the

Inherited % value to 80 with a Variation of 40 and Divergence of 2. In its Size group, set Scale Factor to 50 and Variation to 50.

Information: In this step we're setting up two Spawn tests. The first one creates the initial spread of particles with a decent amount of random offspring but with little speed variation as we don't need slow-moving particles! The second test creates some additional particles which are spawned with low divergence, creating small groups of particles close to one another, akin to the reference material. On a side note, it's little tweaks like this that make explosive effects convincing as the spread isn't uniform; there's always a fair amount of random collation scale and distribution, which is what these two Spawn tests have added.

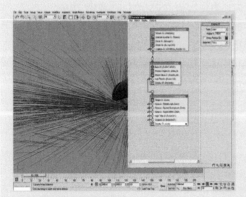

8 Add an Age Test to the event and set it to Event Age. Set Test Value to 2 with a Variation of 1. Add a Collision test to the event and add the Deflector01 object in the scene to its Deflectors list. In the Display operator, set Type to Lines for visual reference in Viewport.

Information: The Age Test has been added to pipe out the particles after a couple of frames or so to another event, which will check to see if they need "exploding" into the branching sparks as mentioned in the "Analysis of effect" section. The Collision test has been added to check for interaction with the Deflector01 object in the scene (i.e., the ground). We've set the Display operator to Lines so that we can see a representation of the length of the trails over a 1-frame duration in Viewport.

9 Add a Split Amount test to the event display to create a new event and label the new event Split for Explosions. Set the Ratio value in the Split Amount test to 30. Instance the Collision test from the Loose Sparks event to this new event and wire the input of the new event to the output of the Age Test in the Loose Sparks event.

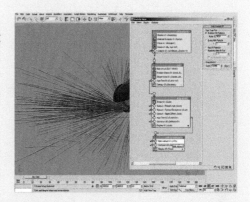

Information: Here we've introduced a Split Amount test to determine what percentage of the particles are going to be sent to another event to branch off into the exploding particles – 30% of the total amount. To check for collisions with the Deflector in this event, we've instanced the Collision test from the previous event.

10 Add another Split Amount test to the event display to create a new event and label the event Ground Collision. Wire the input of this new event to the output of the Collision test in the Loose Sparks event and also to the output of the Collision test in the Split for Explosions event. Set the Ratio value to 80.

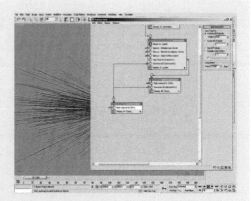

Information: This event governs what may happen to the particles when they hit the Deflector01 Space Warp in the scene. We've added the Split Amount test into the event so that 80% of the particles can be sent to another event which will in turn delete them, resulting in a fair amount of particles being deleted by ground impact, akin to the reference material.

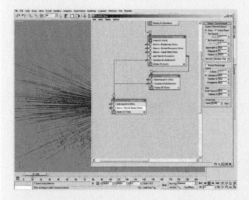

11 Add a Spawn test to the event and label it Spawn-Ground Impact. Enable Delete Parent and set the Spawnable % value to 50. Set Offspring to 15 with a Variation of 100. Turn off Restart Particle Age, and in its Speed group, set the Inherited value to 85 with a Variation of 35 and Divergence of 90. In the Size group, set Scale Factor to 50 and Variation to 25.

Information: Here we've simply added some additional particle spawning for 50% of the (remaining) particles in the event, creating multiple branching upon impact with smaller "fragment" particles. We've turned off Restart Particle Age so that the colors of the particles defined in the assigned Material Dynamic operator don't "reset" as mentioned earlier.

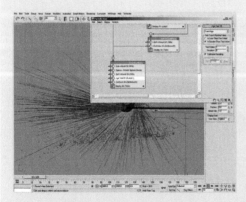

12 Instance the Split Amount test from the Split for Explosions event to the Ground Collision event. Add an Age Test to the event and set it to Event Age. Set Test Value to 1 with a Variation of 0. Instance the Collision test from the Loose Sparks event to the Ground Collision event.

Information: Here we've added a Split Amount test to send 30% of the particles into another event which will define the spark explosions, resulting in a number of impact-branched particles also spawning explosive trails. The Age Test has been added to ensure the life of the particles in this event is only for one single frame; however, due to the speed of the particles and the influence of the Gravity Space Warp, they may travel back down between the frames. Therefore, we need to ensure they don't pass through the "ground," hence instancing the Collision test across to this event.

13 Add a Delete operator to the event display to create a new event, label the event Killer and wire the outputs of the first Split Amount (80%) and Age Test in the Ground Collision event to the input of the Killer event.

Information: Here we've just set up a basic event that deletes the particles once they enter the event, which will be used to remove the particles from the scene before the original Delete operator (in the root event of the system) gets chance to delete them based on their age. In this step we're also wiring up the event to the output of the Split Amount so that the majority of the particles are deleted as they hit the Deflector01 Space Warp and that the remaining particles are deleted after a single frame.

14 Instance the first Split Amount (80%) from the Ground Collision event to the event display to create a new event. Label the new event Second Ground Collision and wire the input of this new event to the output of the Collision test in the Ground Collision event. Add a Send Out test to the event. Wire the output of the Split Amount test in this new event to the input of the Killer event.

Information: As mentioned in the last step's "Information" section, we're checking for additional sub-frame ground impacts. As before, we're removing 80% of the impact particles by piping them to the Killer event (and thereby deleting them). The remaining particles will be sent across to the event we'll set up next, which creates small branching trails.

15 Add a Spawn test to the event display to create a new event and label the event Spark Explosions. Wire the outputs of the Split Amount (30%) tests in the Split for Explosions and Ground Collision events and the Send Out test in the Second Ground Collision event to the input of this new event. Set the Spawnable % value to 40 and Offspring to 4 with a Variation of 100. Turn off Restart Particle Age. In its Speed group, set the Inherited value to 10 with a Variation of 10 and Divergence of 75. In the Size group, set Scale Factor to 75 and Variation to 25. Add a Send Out test to the event.

Information: We've set the Spawnable % value to 40 and not 100% as this event also works with collision particles coming off the ground (Deflector) impacts, so we need only a select few particles spawning the spark explosions, not all of them. We've added a Split Amount test into the Split for Explosions event so that we've a higher percentage sent to the Spark Explosions event than that desired to be exploded, but only a percentage of these produces explosion as set up in the Spawn test. We've turned off Restart Particle Age as before so that there isn't any break in particle color, and that the Delete operator in the root event still governs their lifespan. As the majority of the particles in this event aren't spawned, we needed to add the Send Out test, else they will just stay in the event.

16 Instance the Age test from the Ground Collision event to the event display to create a new event and label the new event Explosion Lifespan. Wire the input of this new event to the output of both tests in the Spark Explosions event. Wire the output of the Age test to the input of the Killer event. Instance either of the

Collision (Deflector01) tests to the Explosion Lifespan event and wire its output to the input of the Ground Collision event.

Information: This event holds the particles for one frame before they either collide with the Deflector01 Space Warp or are deleted. This results in the original particle drawing a trail with trademark branching. We've piped both the tests from the Explosion Lifespan event into this event so that the non-spawned trails are also tested for age and removed if necessary.

17 Select the root PF Source 01 event, and right-click and choose Properties in the resulting menu. In the resulting Properties dialog, turn off Receive Shadows and Cast Shadows. In the Motion Blur group, enable Object. Click OK to confirm and close the dialog.

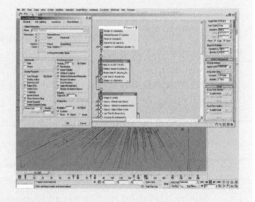

Information: As we don't want the sparks to cast or receive shadows, we've to turn them off in the root event (this obviously governs all other events further down the flow). We've done it at a stage where the system has been fully built, because if we were to do it earlier on, any new event that we've created would have had the default properties, namely casting and receiving shadows enabled and motion blur disabled.

PART THREE: With the particle system set up, we'll finish off the scene by adding some Render Effects and setting the Motion Blur parameters before rendering.

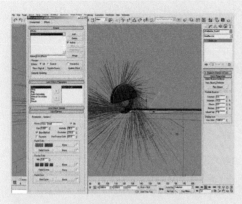

18 Open the Environment and Effects panel, and in the Effects tab, add a new Lens Effects effect to the Effects list (say that three times as fast!). In the Lens Effects Parameters rollout, add a Glow element to the right column and rename it Glow-Small in the Glow Element rollout. Set Size to 0.001 and Intensity to 90. Set Use Source Color to 90 and set the first Radial Color swatch to RGB 255,95,65. In its Options tab, enable Material ID.

Information: Here we're adding the main Lens Effect effect which contains the Glow element; however, to get the nicest result with a decent falloff, we'll use three Glow elements. The first one is kept as tight as possible to the shape of blurred particles. We're using a fair amount of the original particles' color to derive a glow color, yet throwing in a small percentage of defined color to give it a bit of extra warmth. We've enabled Material ID in the Options tab (which defaults to 1) to correspond with the Material ID we've set up in the Sparks material earlier in the tutorial.

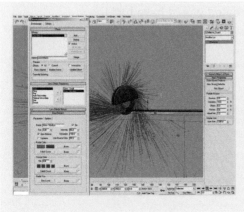

19 In the Lens Effects Parameters rollout, add another Glow element to the right column and rename it Glow-Medium in the Glow Element rollout. Set Size to 0.01 and Intensity to 60. Set Use Source Color to 80 and set the first Radial Color swatch to RGB 255,95,65. In its Options tab, enable Material ID.

Information: Here we need similar settings as in the Glow-Small element, but painstakingly we've to repeat the majority of the settings instead of being able to just copy and edit as this facility doesn't currently exist, so a load of number crunching. For this case we're going to use a slightly bigger Size value and reduced Intensity and Source Color influence.

20 In the Lens Effects Parameters rollout, add a Glow element to the right column and rename it Glow-Large in the Glow Element rollout. Set Size to 0.05 and Intensity to 70. Set Use Source Color to 50 and set the first Radial Color swatch to RGB 255,95,65. In its Options tab, enable Material ID.

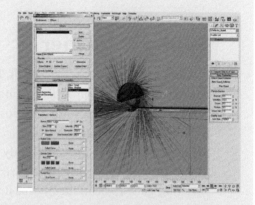

Information: ... and the same as for the larger glow; this time with an even less Source Color influence but a slightly higher Intensity to cover the entire Spark area (overlaying the other two Glow elements).

21 Open the Render Setup panel and set Output Size to a medium-sized image, such as 1600 × 1200. In the Renderer tab's Object Motion Blur group, set the Samples amount to 30 and render off the scene.

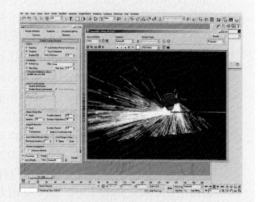

Information: We're using Object Motion Blur for two main reasons. First, the speed of the particles and their amounts will result in the image being smeared a lot had we used Image Motion Blur, especially around the disc and Deflector impact sites, which will

result in an incorrect blur. Secondly, the Glow Render Effect would only apply itself to a single particle, not to the blur, resulting in an incorrect result. The Object Motion Blur doesn't have these drawbacks due to its multiple-sample method – the particle motion is portrayed accurately and the Glow is applied for every sample. The Object Motion Blur will result in a longer render time. We're rendering out to a larger-than-normal image size due to the influence of the Glow; more about this in the "Taking it further" section.

Taking it further

It does produce an effective result, but bear in mind that we're using a higher resolution image to produce a smaller resolution sequence that is consistent with the rest of the tutorials in this book. The reason for this is simply the size of the Glow effect; in the reference material, any "glow" the ejected material may have is confined pretty tightly, so we don't want a big blobby glow of our own. However, rendering out the sequence at a smaller resolution will cause the resulting glow to be ineffective as it will appear too big, even with very very low settings. We've temporarily got around this issue by simply increasing the size of the rendered image and applying a very low glow size to brighten up the sparks (dulled down by motion blur sampling). However, all this is immaterial in a production pipeline where we wouldn't bake out the glow in the render anyway – the sparks are rendered out as a separate pass and any effects added in a compositor will have much more control over glow distribution. If you've access to a compositor (e.g., Combustion), I'd seriously advise you look into this process as it will save you a lot of heartache with rendering in the long run!

That aside, try adding this effect to some of your own scenes, specifically shots of metal against metal or metal against wall, such as a car's exhaust dragging along the ground or a car clipping a wall. These types of sparks also find applications in pyrotechnic effects, specifically tearing metal debris; try placing some non-renderable particles on debris surfaces which spawn additional particles inheriting the original trajectory and then tie that into the system we've already built. Think what type of sparks these are, how they're made, and therefore how long they will live. Don't forget, the effect needs to have a lot of "energy" for it to be convincing; the spark trail durations are generated by camera shutter speeds, so you'll have to work out how long (in frames)

and how fast the particles should travel to make the effect convincing in your own scenes.

Finally, due to the limitation of the amount of samples available to us in the Scanline renderer, we'll see individual samples in the resulting render. Unfortunately, this can't be avoided with this particular renderer as the upper amount is clamped off at 30 samples. However, you can get around this by removing the Object Motion Blur and using Multi-Pass Motion Blur in the scene's Camera as you can add more samples, but bear in mind that the Glow can be applied multiple times which, when using this method, will result in the Glow being quite dull in comparison with the result of Object Motion Blur. The best solution would be to either use this multiple-pass method and apply the glow in post or use the mental ray renderer that has a much better control over motion blur samples.

4 Afterburner

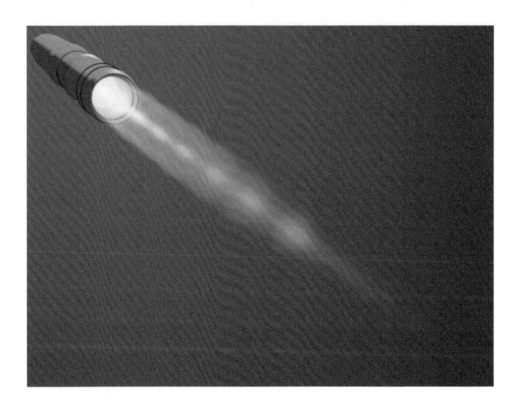

Introduction

In this tutorial we're going to create a realistic afterburner effect. Quite simple, you may think; however, fire is virtually impossible to photograph accurately, i.e., it represents exactly what we see with the naked eye. Herein lies the problem: we're basing our scene construction on an image which has been captured as a specific exposure depending on whether it was taken at night or during the day. Therefore, we'll study several images with different exposures to glean as much detail as possible about the emissions, color, shape, and intricate formations within the flame.

Analysis of effect

(a) As mentioned in the introduction, this type of effect is visibly different depending on whether you view the afterburner during the day or at night; however, we can pick up different detail at each lighting scenario. (b) The shape of the afterburner consists of two main elements: the cone and the thrust jet. The cone itself is exactly a conical-shaped formation emitted from the afterburner nozzle which is akin to a blue gas flame, in the way it has an internal cone with little opacity that builds up to full intensity (which is quite transparent in daylight) and quickly tails off to be transparent. (c) The jet itself is an elongated "beam" of fire which contains rays of varying densities within its structure. It's shaded slightly more yellow-orange and, again, isn't that opaque in daylight; however, at night it does stand out quite prominently. (d) The thing that makes up the visible "trademark" effect of the afterburner is the "Shock Diamonds." This is a formation derived from internal shockwaves, resulting in a collation of waves at regular intervals, called "Mach Disks." The diamonds themselves are slightly visible and orange in hue, whereas the Mach Disks, a collation of diamonds, are more intense; due to the collation effect they tend to build up and fade away with attenuation akin to inverse square. The internal illumination of the engine itself doesn't appear to be all that bright due to the flame in daylight being oxygenated (blue); however, any internal illumination can be attributed to heat as illustrated in the reference material; the metal gets so hot that it glows with an intense ferocity.

Disclaimer: At the time of this writing, no afterburner movies could be made available for reference due to copyright reasons, but there are

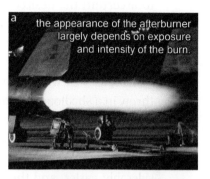
a the appearance of the afterburner largely depends on exposure and intensity of the burn.

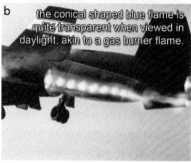
b the conical shaped blue flame is quite transparent when viewed in daylight, akin to a gas burner flame.

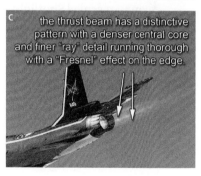
c the thrust beam has a distinctive pattern with a denser central core and finer "ray" detail running thorough with a "Fresnel" effect on the edge.

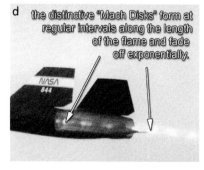
d the distinctive "Mach Disks" form at regular intervals along the length of the flame and fade off exponentially.

several out there on video sites such as YouTube. It's worthwhile viewing these to ascertain the desired animation of the flame, specifically the phase detail within the thrust jet. It's also worthwhile viewing engine manufacturer websites such as Rolls Royce and Pratt & Whitney for their media release images and footage.

In 3ds Max we'd normally construct geometry to create such an effect and throw in a shedload of motion blur to blur out any visible contours in the geometry so that it looks more realistic. However, in this case we're going to forego the geometry route and use a ton of lights to generate the desired system. This actually works a lot nicer as we can control the intensity of each element considerably easier, and then link the entire lot to a single Dummy object which will pulse with a Noise controller, giving the impression that the flame has a bit of oomph (technical term). The intensity of the Mach Disks, however, can be controlled by a simple expression. Okay, this is getting a bit too advanced where we could simply set a single value in its Multiplier field, but it opens up the scene for adaptation later on; you can then simply animate the position of these disks, and the Multiplier value will automatically increase or decrease depending on the distance of the light to the engine. We'll have some additional lights thrown in for good measure, namely the core of the Mach Disks and main afterburner cone – a scaled Spotlight with attenuation to drive the transparent interior cone. Now I must admit that I didn't come up with this spotlight method myself to create the cone shape – it was someone else who'd a brainstorm over in the scifi-meshes.com forums a fair few years ago; unfortunately I couldn't find out who it originally was; so if it was you then my apologies (and please let me know on the support forum so credit is where credit is due). All in all we'll be using numerous lights for our afterburner system; this sounds a little excessive but they'll be confined with attenuation and will (for the most part) not cast shadows, keeping render times down.

Walkthrough

PART ONE: First we'll load the start 3ds Max scene and set up the initial lights to create the cone and thrust beam.

1 Open the *04_Afterburner_Start.max* scene included with this tutorial and accept any file unit change if prompted. In the Back Viewport (change the Front Viewport to display the Back), create a Free Spotlight at the origin (XYZ coordinates 0,0,0) and label the light Spot_Cone. Using non-uniform Scale, set the X and Y scale values of this object to 6.5 in the numerical entry fields at the bottom

of the interface and relocate the light to XYZ coordinates 0,−20,0 as illustrated.

Information: In this base scene we've a basic stand-in object for an afterburner, plus an Omni light for the sun and a standard Skylight with a blue environment as background. We're creating the first light in the Back Viewport so that it results in orienting the light in the direction we want: directly down the length of the engine. We've scaled the light as we'll make use of its Attenuation feature to create the cone; however, we want the cone to be elongated, hence we'll scale the light across its diameter, not along its length, and then set a high attenuation value to give us the desired result. We've relocated the light so that the start of the attenuation cone is outside of the engine.

2 In the Shadows group, enable On. In the Intensity/Color/Attenuation rollout, set the Multiplier value to 15 and set the color to RGB 97,92,185. In the Decay group, set Type to Inverse Square and set the Start value to 75. In the Near Attenuation group, enable Use and Show and set the Start value to 450 and the End value to 500. In the Far Attenuation group, enable Use and Show and set the Start value to 650 and the End value to 750.

Information: To ensure no clipping or overlaps in the resulting volumetric lighting, we've enabled Shadows purely for safety. The light is set to a blue hue, point sampled from the reference material. The Near Attenuation will create the interior cone, building up the intensity of the light (and therefore the volumetric) before the Far Attenuation values fade it out. We're using Inverse Square Decay to get a nice realistic falloff to our flame cone effect.

3 In the Spotlight Parameters rollout, enable Show Cone and set the Hotspot/Beam value to 158 and the Falloff/Field value to 165. In the Advanced Effects rollout, turn off Specular. In the Shadow Map Params rollout, set Bias to 0.01 and Sample Range to 20.

Information: Here we see the cone taking shape, thanks to the wide angle of the Falloff/Field value. We don't want this light to emit any specularity from its source, hence disabling this feature for this light. We've tightened the accuracy of the Shadow Map by dropping the Bias back to 0.01 (bringing it tightly up against the surfaces that cast the shadows) and blurred it a fair bit by increasing the Sample Range. This will also affect the quality of the volumetric light.

4 In the Back Viewport, create a Free Direct light at the origin of the scene (coordinates XYZ 0,0,0) and label it Direct_Jet_Beam. Set the Multiplier value to 75 and set the color to RGB 255,133,43. Set the Decay type to Inverse Square and the Start value to 130.

Information: Again, this light has been created in the Back Viewport so that the orientation of the light is as desired. Here we're using a pretty strong intensity (and a high Decay Start value) as we don't want the light to fade out too prematurely.

5 In the Near Attenuation group, turn off Show (this option may be on by default from creating the previous light), and turn Use on in the Far Attenuation group. Set the Start value to 130 and the End value to 1500 in the Far Attenuation group. In the Directional Parameters rollout, set the Hotspot/Beam value to 30 and Falloff/Field to 42. In the Advanced Effects rollout, turn off Specular.

Information: Here we've set the Far Attenuation value to clamp off the light at the end of its (visible) decay so that 3ds Max doesn't calculate the light beyond this point; without attenuation, the software would calculate the light's decay to infinity. Again, we don't want specularity to emit from the light, so this feature is disabled.

6 Copy the Direct_Jet_Beam light and rename the copy Direct_Mach_Disk01. Relocate this light to XYZ coordinates 0, −60, 0 (use numerical entry if necessary). Set its Multiplier value to 50. In the Decay group, set the Start value to 7. In the Near Attenuation group, enable Use and Show and set the Start value to 0 and the End value to 10. In the Far Attenuation group, set the Start value to 20 and the End value to 30. In the Directional Parameters rollout, set the Hotspot/Beam value to 43 and the Falloff/Field value to 45 (it should update to 45 by default unless you've different values set up in your software preferences).

Information: As we've a lot of original parameters already set up in the Direct_Jet_Beam light (such as its position and color), we need to simply clone and edit the copy. Here we're using the Attenuation values (Near and Far) to create a volumetric cylinder that fades in and out over 10 units, creating a Mach Disk effect.

7 Copy the Direct_Mach_Disk01 light and label the new light Omni_Mach_Disk_Core01. In the Light Type group, choose Omni from its drop-down list. Reposition the light to XYZ coordinates 0, −75, 0 so that it's right in the middle of the attenuation of the Omni_Mach_Disk01 light as illustrated. In the Near Attenuation group, turn off Use and Show. In the Far Attenuation group, set the Start value to 7. Again

using the non-uniform Scale, scale the Omni light by setting the Z-scale to 200 (a scale factor of 2) to elongate the light as illustrated.

Information: The Z-scale isn't scaling the light vertically as per usual because the light was originally created in the Back Viewport, and so it has been rotated automatically by 3ds Max. Here we're copying the light and changing its Type to an Omni light, which is repositioned to exaggerate the Mach Disk we've already established. Scaling the light creates a slight overlap of Omni lights (once we duplicate them later on), which will result in an elongated volumetric effect akin to that in the reference material.

PART TWO: With the initial lights set up, we'll create and assign a projector map to the Jet Beam light before setting up the volumetrics for the other lights.

8 In the Material Editor and in a free sample slot, create a Mix map and label it Jet Beam. Add a Gradient Ramp map to its Color #2 slot and label the map Jet Ring Color. Set Gradient Type to Radial, and in the Noise group set Amount to 0.1 Set Size to 3 and choose Fractal as the noise type. Navigate to frame 300 and turn on Auto Key. With the Default In/Out Tangents for New Keys flyout set to a linear type (next to the Set Key button), set the Phase value to 0.25. Turn off Auto Key.

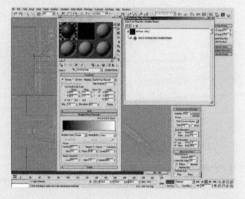

Information: Using the Mix map we can simply blend a black color (which will add fine detail into the resulting volumetric rays) with a Gradient Ramp map that has a strong core and outer ring intensity, which we'll set up next. The map also has a touch of animation to it, but not much; the main bulk of detail animation will be set up shortly with a map used to blend the colors/maps together in the Mix map. We're using a Linear keyframe type so that the animation doesn't ramp up or ramp down again, which would look odd!

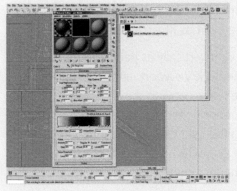

9 In the gradient, remove the flag at position 50 and set the flag at position 0 to RGB 255,215,43. Set the flag at position 100 to RGB 130,68,22. Add flags to positions 18 (RGB 255,133,43), 25 (RGB 130,68,22), and 40 and 60 (RGB 20,10,0 for both). Add additional flags to positions 78 (RGB 130,68,22), 82 (RGB 255,133,43), 86 (RGB 255,215,43), 90 (RGB 255,133,43), and 95 (RGB 130,68,22) so that the resulting gradient appears as illustrated.

Information: Here we've created a simple gradient so that there's a great deal of intensity at the core and at the outer areas of the gradient. A lot of number crunching I know, but it'll give a nice Fresnel-type effect when rendered, again akin to the reference material.

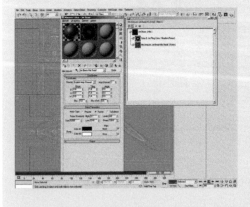

10 Add a Noise map to the Jet Beam map's Mix Amount map slot and label the map Jet Beam Mix Detail. In the Coordinates group, set Source to Explicit Map Channel. In the Noise Parameters group, set Noise Type to Fractal. Set Size to 0.025, High to 0.7, Low to 0.45, and Levels to 4. Enable Auto Key at frame 300 again and set Phase to 100 (you should still have the linear keyframe tangent type enabled from before). Turn off Auto Key.

Information: Here we've a more detailed animation of the beam – a fast animated Noise map with a very fine detailed texture applied; when rendered the end result will appear as if the rays are rushing out of the engine while still being maintained in the overall pattern (generated by the Gradient Ramp map). However, something is amiss.

11 Copy the Jet Ring Color Gradient Ramp map to the Color #1 slot of this map and rename it Jet Ring Core Mix. Reset the gradient, remove the flag at position 50, and set the flag at position 0 to white and that at position 100 to black. Add a flag to position 8 and set it to white, and add a flag to position 25 and set it to black. Instance the Jet Beam (Mix map) to the map slot in the Direct_Jet_Beam light's Projector Map group.

Information: … and the fact is that the core should be more solid and not as broken up as the rest of the beam. Copying and editing the Gradient Ramp map ensures there's no black in the core of the volumetric light, resulting in a solid beam in this area which overlaps the Omni light(s) running down the length of the beam.

12 Return to frame 0. Open the Environment and Effects panel and add a new Volume Light Atmospheric Effect. Rename the effect Volume Light-Jet Beam. In the Volume Light Parameters rollout, click on the Pick Light button and choose the Direct_Jet_Beam light in the scene. Set the Attenuation color to RGB 255,150,0 and enable Use Attenuation Color. Enable Exponential and set the Density value to 1.5.

Information: We're setting up the Volumetric Light effects and assigning lights at this stage and not later on, because as we clone the lights they'll automatically be assigned to their respective Volume Light effect! This makes life a little easier in the long run, especially with the amount of number crunching we'll have to do shortly. In this effect we're simply adding and setting the parameters for the main beam effect, which will use some attenuation color to help emphasize the beam's color saturation and also use the Exponential feature so that the effect blends correctly with the objects and other effects in the scene. Density has been dropped so that it isn't too intensive (otherwise it would occlude other effects in the scene!), akin to the reference material.

13 Add a new Volume Light Atmospheric Effect. Rename the effect Volume Light-Cone. In the Volume Light Parameters rollout, click on the Pick Light button and choose the Spot_Cone light in the scene. Set the Fog color to RGB 190,190,205, the Attenuation color to RGB 113,113,182, and enable Use Attenuation Color. Enable Exponential and set the Density value to 1.5.

Information: As before, we're simply assigning the correct light to the desired Volume Light effect. Here we're setting up the cone effect which uses a touch of extra color by tweaking the Fog and Attenuation colors. Exponential is used as before. Density has been dropped as before, for the same reason.

14 Add a new Volume Light Atmospheric Effect. Rename the effect Volume Light-Mach Disk Core. In the Volume Light Parameters rollout, click on the Pick Light button and choose the Omni_Mach_Disk_Core01 light in the scene. Set the Attenuation color to RGB 255,150,0 and enable Use Attenuation Color and Exponential.

Information: This time we're using a much denser light due to the intensity of the Multiplier value of the light. Bear in mind that we're going to use Expression controllers shortly to drive the Multiplier values of these lights, so what you currently see (with respect to their intensities in the render) isn't what you get at render time, apart from the beam and cone volumetrics.

15 Add a new Volume Light Atmospheric Effect. Rename the effect Volume Light-Mach Disk. In the Volume Light Parameters rollout, click on the Pick Light button and choose the Direct_Mach_Disk01 light in the scene. Set the Attenuation color to RGB 255,150,0 and enable Use Attenuation Color. Enable Exponential and set the Density value to 1.5.

Information: The final volumetric effect to be set up is the Mach Disk effect which, again, has quite a low density due to the expression controllers we'll set up next. You may notice that we're using consistent colors across the board for light and fog colors. This is actually intentional as you can see these colors consistently in the reference images included with this tutorial.

PART THREE: With the volumetrics set up, we'll now create the Expression controllers and duplicate the lights to create the Mack Disks along the length of the cone.

16 Select the Direct_Mach_Disk01 light and open Track View. Navigate to its Multiplier controller and assign a Float Expression controller to it. In the Expression Controller panel's Create Variables group, select Vector and add Engine into the Name field. Click on the Create button to create the Vector.

Information: Here we're replacing the existing controller with a Float Expression controller so that we can automatically set the Multiplier value based on the distance from the Engine object's pivot point. To do so, we initially need to create two Vectors. Firstly, we've to create the Vector for the Engine object.

17 With Engine selected in the Vectors list, click on the Assign to Controller button and choose the Engine object's Position Transform Controller as illustrated. Click OK to confirm and close the panel. Next, create another Vector called M1 and assign it to the Direct_Mach_Disk01 object's Position Transform Controller. In the Expression group, enter: 1000*(1/length(Engine-M1))

and click on the Debug button to ensure the resulting values are the same as in this screenshot (the resulting Expression value should be 50). NOTE: If you've positioned the light at a different location, then your Expression value won't be the same as in this tutorial. The explanation is in the "Information" section underneath.

Information: The Engine Vector is assigned to the Position Transformation coordinates of the Engine object, which yields a numerical value. The second Vector is labeled M1 (Mach Disk 1) and is assigned to the Position Controller of the light we're currently dealing with. The expression, therefore, derives a value by subtracting the positional values of each object. However, the further away the light is positioned, the higher the number will be. We actually want the reverse of that (or the inverse); therefore, the expression is inverted by dividing the resulting value of subtraction by 1. This result is multiplied by a generic value (1000) to increase the result of division to something higher than 1 that we can use in the scene.

18 Copy the Expression controller and select the Omni_Mach_ Disk_Core01 light in the scene. In Track View, navigate to its Multiplier controller and paste (copy) the Expression controller, replacing the existing controller. Open this new controller's Expression Controller dialog (by right-clicking on the controller and selecting Properties) and click on M1 in the Vectors list.

Edit the Name field in the Create Variables group to rename the vector M1a and click the Rename button to assign the new name. Click on the Assign to Controller button and choose the Omni_Mach_Disk_Core01 object's Position Transform Controller. Edit the Expression, replacing M1 with M1a as illustrated. Click on the Debug button to test the validity of the expression and close the Expression Controller dialog.

Information: As we've already set up the main gumph in the previous couple of steps, we can now simply clone the controller and paste it in the other Mach-oriented light and edit its parameters. The controller works exactly as before; however, this time we're referencing the position of the Omni light as opposed to the Direct light.

PART FOUR: With the initial expressions set up within the Mach Disk elements, we can now simply duplicate and edit the expressions for each subsequent light. A bit of boring and painstaking operation I know, but you've to take the rough with the smooth in CG!

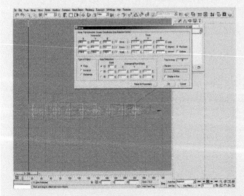

19 In the Left Viewport, select the Direct_Mach_Disk01 and Omni_Mach_Disk_Core01 lights. Open the Array tool (Tools menu: Array), ensuring you're still in the Left Viewport so that the axes don't change while performing the Array. In this dialog's Incremental section, set the X Move value to 80. In the Type of Object group, choose Copy, and in the Array Dimensions group, set the 1D value to 8. Test the result with the Preview button (as illustrated), and if the result is convincing, click on OK to close the dialog and generate the array.

Information: Here we've simply created a number of copies of the original lights at the distance interval we've set in the Array tool. We haven't used instancing in this occasion, else the Multiplier values would be instanced across, and we need these unique for each light.

20 Open up Track View and select the Direct_Mach_Disk02 light. Navigate to its Multiplier controller and view its Properties to bring up the Expression Controller dialog. Rename the M1 Vector M2. 3ds Max will automatically re-assign the Vector to the correct Transform Position Controller (this current light's). Edit the Expression to replace M1 with M2. Again, click on the Debug window

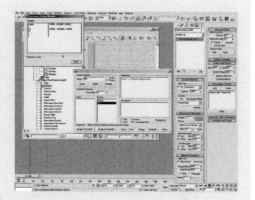

to confirm the Expression value. NOTE: If you've used different values in the Array process, then you can more than likely expect different Expression value results.

Information: Here we're going through the motions of editing one of the Direct light copies. For each Mach Disk Vector, edit the name (so that it's unique), and edit the expression itself to include this new Vector name. As mentioned before, the system has referenced and intuitively assigned the Vector to the correct controller. Technically, we don't need to rename each Vector, but it's good to get into the habit of doing this so that when you begin scripting you won't mix up with variable names passing from one script to the next and ending up with wayward results. Just like how you set names for objects and materials, etc., renaming is simple to do and will aid you in future should you (or anyone else) revisit the scene to see at-a-glance what each variable/material/object does from its name.

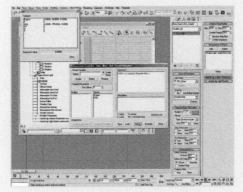

21 Select the Omni_Mach_Disk_ Core02 light. Navigate to its Multiplier controller and view its Properties to bring up the Expression Controller dialog. Rename the M1a Vector M2a. Edit the Expression to replace M1a with M2a. Again, click on the Debug window to confirm the Expression value as illustrated.

Information: ... let's work on its Omni counterpart. Same process as before, just editing it with the correct Vector name suffix. Whew ... got all that?

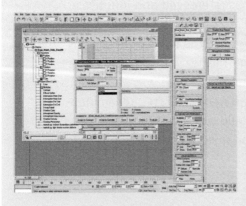

22 Now it's a painstaking task of replacing every single Mach Disk and Mach Disk Core light's Multiplier controller's Vector name (M3, M3a, M4, M4a, etc.). A longwinded procedure I know; if you want to jump ahead at this point, an Intermediary scene file is included with this tutorial which you can load and rejoin us at the next step.

Information: ... because we're now into "pain in the backside" territory – having to edit the rest of the controllers for the light clones. The resulting values can be tested by checking the Debug for each one, or simply performing a test render! Now you can understand why we set up the volumetrics earlier on – you should see a reduction in the intensity of light you've just edited as compared to the one before it!

23 Using non-uniform scaling, scale each Direct_Mach_Disk light so that it doesn't extrude past the outer boundary of the exterior attenuation boundary of the Spotlight as illustrated. NOTE: It's easier to perform this operation in a Perspective or Orthogonal Viewport and then checking for intersections in the Left Viewport. To make life a bit easier, you may want to reduce the light's Targeted value in the General Parameters rollout (as illustrated).

Information: As can be seen in the reference material, the size of Mach Disks has actually reduced, following the exterior contours of the cone. This step replicates this effect, else the cone would pass through the disks, yielding an unrealistic result in the render!

PART FIVE: Finally we'll set up internal lighting within the engine itself and link all of the lights to a pulsing Dummy object to simulate engine ferocity!

24 In the Top Viewport, create an Omni light at coordinates XYZ 0,10,0 and label it Omni_Engine_Ill01. Enable Shadows and set the Multiplier value to 3. Set the color to RGB 238,178,83, the Decay Type to Inverse Square, and Start value to 30. Turn off Show in the Near Attenuation group, enable Use in the Far Attenuation group, and set the Start value to 30 and the End value to 150. In the

Shadow Map Params rollout, set Size to 256 and Sample Range to 8. Still in the Top Viewport, instance this light three times down the length of the engine as illustrated (I've used spacing of 40 units) so you'll get four instances of the same light.

Information: As the lights were of pretty low intensity, they were instanced to totally illuminate the interior of the Engine object. However, they don't need to overly saturate the object with light and color, just to give an indication that the engine is running hot. We're using several versions of the same light to ensure there's an even fill of light throughout the engine; due to its internal detail a single light wouldn't fill the interior evenly, so many are required. As the Shadow Map Size value is quite low, these multiple lights won't significantly affect render times.

25 Still in the Top Viewport, create a Dummy object and position it at the origin of the scene. Open Track View and add a Position List controller to its Position controller, resulting in the Euler XYZ controller being nested within it. Add a Noise Position controller to the Available controller slot in the List controller.

Information: This object will be used to create a bit of pulsing animation in the lights, akin to a real afterburner (check online references for examples). We've nested the Noise controller within a Position List controller so that we can still animate the position of the lights overall. If we'd not done this, then the Noise controller would drive the entire positional information of the Dummy object (and therefore the animation of the lights' position) unless we linked it to another Dummy and animated its position that way. It has been built this way just for safety.

26 In the resulting Noise Controller dialog, set Frequency to 0.02 and Roughness to 1. Set the X and Z Strength to 0 and Y Strength to 10. Finally, at frame 0 select all the engine's lights and link them to the Dummy01 object in the scene (don't link the original scene lights to the Dummy!) and render off the sequence.

Information: The high Roughness value gives a pretty sharp pulsing effect to the overall position of the lights, yet the direction is limited to only one axis so that the pulsing effect is only along the length of the exhaust. This works well in the resulting render as the Spot light is set to cast shadows, which will fluctuate in size depending on its position. Same deal as with the internal illumination of the engine with the lights moving back and forth to give the same (apparent) pulsing in illumination.

Taking it further

Even though the end result does work quite well, thanks to the Volumetric light setup, we can vastly improve on the system, especially if we wish to animate the strength of the afterburner. Try wiring up the position and intensities to a slider so that the entire system can be animated by one simple animation control. This can be achieved with parameter wiring and/or expressions. Additionally, try using a script or expression controller to automatically calculate the intensity of the afterburner based on the parent object's (i.e., the jet fighter) velocity. You can also implement some additional time-offset to introduce a buildup of thrust before the main afterburner intensity kicks in, propelling the aircraft down the runway (for example).

Next, try amending the system so that it represents an afterburner when viewed at night; again, see the reference material for examples and amend the controllers that drive the Multiplier values of the lights accordingly so that

they're considerably brighter. You'll also need to amend the properties of the Volumetrics. However, bear in mind that if you could see the individual Shock Diamonds, then chances are you won't be able to see much of the plane due to the amount of illumination the flame kicks out; the "camera" should have a fairly high shutter speed/f-stop value to capture all of the detail in the flame without it blowing out the picture. Saying all that, obviously there's a bit of artistic license required here.

If you really want to throw caution to the wind, try amending the system to use the Parti Volume shader within mental ray. This will yield a much nicer and controllable effect than the standard volumetrics used in this tutorial, and will give rise to additional effects such as orange licks of flame in the cone and more effective attenuation, among others.

Finally, try linking the entire lot to an animated nozzle so that when the afterburner kicks in, the nozzle contracts and focuses the flame. As before, this can be achieved with parameter wiring and a touch of IK to get the correct linking system set up; this type of contraction nozzle appears to be quite complex; however, it's not all that bad if you break it down into one single system and then duplicate it around the entire circumference of the engine outlet. Flame on!

Water

At first glance, water effects may appear quite simple, and so most of the time it results in a failure. Water dynamics are exceptionally difficult to simulate, which is why research still continues into producing the most effective fluid dynamics system with existing systems being modified, new off-the-shelf solutions, and VFX houses developing their own in-house kit. In this section we'll concentrate on creating fluid simulations using the base kit. This, for the most part, requires a fair amount of particle wrangling to fake a fluid result, though it's possible with a decent reference material.

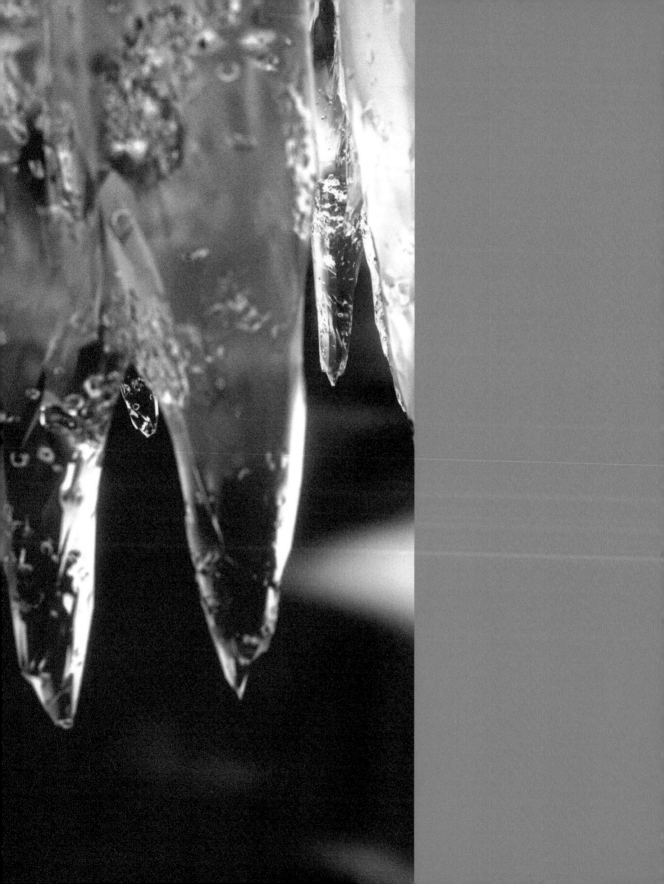

5 Ice aggregation

Introduction

In this tutorial we're going to simulate the aggregation of ice on a window. Now this could take on different forms – from ice crystallization through to hail collating on the glass surface. Either way, the results are pretty similar, just that the ice formation patterns can be more intricate than the resulting hail patterns. To simulate this effect we're going to produce an aggregation system which will check for "collisions" between particles; therefore, building up the resulting formation as one particle after another adheres to its neighbor.

Analysis of effect

frost forms in the corner of aircraft windows at high altitudes due to wind interaction and turbulence in these areas

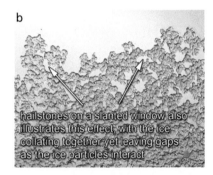

hailstones on a slanted window also illustrates this effect, with the ice collating together yet leaving gaps as the ice particles interact

the frost collation can be quite uniform...

... but it only takes one "seed" for other intricate patterns to grow, based on wind turbulence and condensation

(a) This type of effect is quite consistent in nature, from the ice formation we'll simulate in this tutorial through to snowdrift buildup and even coral formation. These types of effects are produced by a process called aggregation, which refers to the adherence of one particle on another over time. (b) This can be seen in detail in hailstones falling on a window, specifically that in the reference material, due to the angle of the glass (skylight window) forcing the hailstones to collate and adhere to each other. (c) The same applies to frost buildup on aircraft windows at high altitudes. Both effects, as with all others, rely on the matter which carries these particles, namely air (frost) or water (coral), distributing the particulate matter; therefore, the shape, strength, and turbulence of the matter have a direct effect on the resulting formation of the aggregate. (d) In this particular tutorial, we'll deal with a two-dimensional effect of frost on a window, yielding a fine fractal-based effect that is very tightly knit. For more detailed arm effects such as ice formation on cold surfaces, see the "Taking it further" section.

This type of effect is pretty straightforward in 3ds Max; however, we don't have any native particle/particle interaction system. It's pretty easy to be scripted, just by dropping a reference script in one event (static particles) and using a Script Test to check distances between the moving and static particles. However, this would result in pretty slow updates as there may be thousands of particles checking for distances, which bogs down the system somewhat; so we need another approach. There's another way to come over this problem, which involves using a Keep Apart operator with a pretty high Force value set so that when the particle gets within a threshold value of the main seed particle

(established in another system) it can be forced away at a high velocity. However, before it's relocated to the other side of the scene(!), the particle must be tested for velocity, and if it's over a certain threshold value, then it joins the seed particle in another group and its speed is set to 0, resulting in the particle "adhering" to the original. This new particle is then used in the Keep Apart operator for any subsequent particles adhering to this mass. The result is very effective, yet we need to ensure that our values are juxtaposed across the board; the size of the resulting particle should correspond to the distance checked in the Keep Apart operator, plus any additional forces (e.g., Wind) we apply to the traveling particles shouldn't influence the Speed Test, else we'll end up with uncontrolled aggregations popping up all over the place! To ensure this, we'll set the Speed Test's velocity checking value up in the thousands, which corresponds to the Force value we'll set for the Keep Apart operator. Finally we'll surface the particle mass with a Blobmesh Compound Object before assigning an Ice material to it and rendering from underneath, looking up at the sky (akin to the reference material), thanks to a .hdr map included with 3ds Max.

Walkthrough

PART ONE: Loading the start scene and setting up the Force Space Warps to be exerted on the ice particles, plus any additional collision objects.

1 Open the *05_Ice_Aggregation_ Start.max* file included with this tutorial. Accept any file unit change on loading. In the Top Viewport, create a Wind Space Warp. In the Modifier tab and with the Wind Space Warp still selected, set the Strength value in the Force group to 0. In the Wind group, set Turbulence to 1, Frequency to 10, and Scale to 0.05.

Information: As we're dealing with particle system values, we all need to work with the same units, else our results may differ. The Wind Space Warp has had its Strength value set to 0 as

we don't want any directional force set from it; it can be applied with a Speed operator within the particle system we'll design shortly; however, in your own scenes (after you've finished this tutorial of course!), you may want to bin the Speed and use the Force value. It's entirely up to you! The Turbulence, Frequency, and Scale values have been amended to generate a large, slow turbulent waveform that can break up particle distribution and create a more effective collation on the seed particle we'll design shortly.

2 Still in the Top Viewport, create a Gravity Space Warp. Create a Deflector Space Warp as illustrated to encompass the scene with a Width and Length of approximately 2500. Set its Bounce value to 0. Create an SDeflector Space Warp at the origin (XYZ coordinates 0,0,0) with a Diameter of 1000.

Information: As the particle emitter is currently located 10 units on the Z-axis in the scene, the particles should drop down and stay at Z = 0 so that they can all (potentially) interact with the seed particle. The emitter was set at this height as the Wind Space Warp could affect the particles in all three directions. If we've the particles born at Z = 0, there's a possibility that some may leak through the Deflector Space Warp that we've added as our ground interaction surface (with no bounce, so the particles don't bounce along!). Therefore, the Gravity Space Warp will drag the particles down until they hit the Deflector, with the Wind affecting them as they spread across

the Deflector. The SDeflector is a catch-all system to remove particles from the system when they're "out of bounds," i.e., since they no longer affect aggregation, they can be removed to save processing time.

PART TWO: Next, we'll set up the particle system to drive the aggregation effect.

3 Select the PF Source 01 icon in the scene, and in the Modifier tab, click on the Particle View button. Select the Render 01 operator in the root event and change its Type to Phantom. Label the event PF Source Frost Wind. Drag out a Birth operator to the Particle View event display and set its Emit Stop value to 500 (the length of the sequence). Choose Rate and set the Rate value to 5000. Wire the input of this new event to the output of the PF Source Frost Wind event and label the event Particle Wind.

Information: We're using Phantom as the Type in the particle system so that the particle information is passed to the renderer though the particles aren't actually rendered. Hence the Blobmesh object we'll introduce later on can derive their position and scale to surface the particles and generate a resulting mesh. We need a lot of particles to produce the desired effect, so crank up the Rate value to 5000. Rate has been chosen in case you want to animate the value later on. The particle system itself has its Integration Step set to Half Frame for collision accuracy.

4 Add a Position Icon operator to the event. Add a Speed operator to the event and set its Speed value to 100. Add a Force operator to the event and add the Wind01 Space Warp to its Force Space Warps list. Add another Force operator to the event and add the Gravity01 Space Warp to its Force Space Warps list.

Information: The Speed operator simply pushes the particles across the scene in the direction of the scene icon's arrow. Adding the Wind Space Warp now affects the motion of the particles in all three dimensions, while the Gravity drags them down. Currently, there's nothing to stop them from passing through the Deflector01 object as this object hasn't yet been incorporated into the system.

5 Drag out a Standard Flow to the event display and label the root event PF Source Seed. In the Top Viewport, relocate this object 250 units down along the Y-axis as illustrated. Select its Render event and change its Type to Phantom. Rename its child event to Seed Birth. In this new event's Birth operator, set Emit Stop to 0 and Amount to 1.

Information: This particle system is going to emit a single seed particle (set in its Birth operator) so that the other particle system will collide with it to start the aggregation effect. We've relocated the icon in the Viewport to give the other system's particles time to disperse with its Wind Space Warp. Again, this system isn't going to be rendered (nor is it going to be affected by Blobmesh); however, it still needs to be referenced by the other particle system, so therefore it's set to Phantom.

6 In the Position Icon operator, set Location to Pivot. Remove all operators from the event apart from the Birth and Position Icon operators. Add a Send Out test to the event. Drag out a Speed operator to the event display and label the new event Seed Particles, and wire the input of this new event to the output of the Send Out event. In the Speed operator, set its Speed value to 0. Add a Shape operator to the event and set its Size value to 1.25.

Information: We've set the Location to Pivot so we can accurately see where the seed particle is going to be born, nothing more. We need only the Birth and Position Icon operators for this event, so the rest of the operators are removed. This seed particle will then be sent to another event which is shared with the other particle system as the aggregate particles event. We've added a Speed operator to this event and set it to 0 so that the particle velocities set by the Keep Apart operator (and Force operators) in the other system are set to 0, else they'd ricochet off this seed particle!

7 Add a Keep Apart operator to the Particle Wind event. Set its Force value to 50 000 and turn off Accel Limit. In the Range group, set the Core Radius value to 2.5 and Falloff Zone to 0. In the Scope group, choose Selected Events and choose the Seed Particles event in its list of events.

Information: We've set the Keep Apart operator's Force value very high just to test

the speed of the particles at a high value. This will, therefore, exclude the low velocities set in the Speed and Force operators (as mentioned in the next step's "Information" section). The Core Radius coincides with the Size set for the Shape operator introduced earlier, and the Falloff value is set to 0 so that the particles can have a sudden rate of change of velocity and not a gradual one, thus colliding directly within the threshold radius we've set and don't stop some distance away from the seed particle/aggregation mass.

8 Add a Speed test to the Particle Wind event. Set its Test Value to 10 000. Wire the output of this test to the input of the Seed Particles event. Add a Collision test to the event and add the Deflector01 Space Warp to its Deflectors list.

Information: This high Test Value coincides with the Keep Apart operator's Force value (even though the operator's Force value is actually set much higher). It's set this high so that any other velocity values or changes in velocity can be ignored, in essence ignoring the velocities set by the Speed and Force operators. If, however, you wish to change the scene later on and find that the particles are stopping mid-track, increase the Force value and set the Test Value higher to exclude them from being tested positive. This Collision test is introduced to prevent the traveling particles from passing below Z = 0 as mentioned before.

9 Add another Collision test to the event and add the SDeflector01 Space Warp to its Deflectors list. Drag out a Delete operator to the event display to create a new event and wire the output of the second Collision test to the input of this new event as illustrated.

Information: As mentioned earlier, this SDeflector is introduced to the system to ensure that any particles that go "out of bounds" are removed so as to save memory and calculation times. When the particles hit this deflector, then they're automatically passed to another event where they're deleted.

PART THREE: Finally we'll surface the aggregate particles and shade them accordingly before adding a background image to reflect and refract through the material.

10 At frame 0, add a Blobmesh Compound Object to the scene in the Top Viewport and set its Render and Viewport Evaluation Coarseness values to 1. Click on the Pick button and choose the PF Source Frost Wind icon in the scene. Click the Pick button again to turn it off. In its Particle Flow Parameters rollout, turn off All Particle Flow Events and click on the Add button. In the resulting dialog, choose the PF Source Frost Wind, then Seed Particles event and click OK. Add a Relax modifier to the Blobmesh01 object and set its Relax Value to 1 and Iterations to 2.

Information: The Blobmesh object is the only piece of geometry that is going to be rendered in this tutorial; if we use the actual particle shape, the result would render faster, yet look ineffective. We want only the Seed Particles (and therefore the aggregate) to be affected by the Blobmesh object; so All Particle Flow Events is disabled and the relevant event is chosen. However, this still results in quite a bulbous mesh; therefore, the Relax modifier has been added to smooth out the resulting high polygon mesh (as defined by the Relative Coarseness value). We've done all this at frame 0 to ensure the Blobmesh doesn't calculate the thousands of particles present in the system while you're further on in the timeline. If your system hangs, hit the Escape key on your keyboard to cancel the Blobmesh operation and return to frame 0. To avoid this situation, you can always turn on Off In Viewport in this object.

11 Open the Render Setup panel and change the renderer to mental ray Renderer. Open the Material Editor and add a Glass (physics_phen) material to a sample slot and label the material Ice. Set the Light Persistence color to RGB 1,1,1 (mental ray values differ from Scanline RGB values) and set the Index Of Refraction (IOR) value to 1.309. Assign this material to the Blobmesh01 object in the scene.

Information: As we're using a mental ray shader for the ice material, we need to set the renderer to mental ray to be able to access this and see its results in the Material Editor. The Light Persistence color has been set to RGB 1,1,1 (while in this dialog) so that there isn't any color cast in the resulting material. The Index Of Refraction value has been set to 1.309 – that of ice.

12 In a new sample slot, add a Bitmap map and load the *KC_outside_Xsm_blur.hdr* image included with 3ds Max (in its \maps\HDRs folder). Choose Real Pixels (32 bpp) if not already selected and click OK to accept. In the resulting Bitmap map's Coordinates rollout, choose Environ and set Mapping to Spherical Environment. Instance this map to the Environment and Effects panel's Environment Map slot.

Information: We're using this map purely for the surfaced particles to reflect and refract against, nothing more; it's suitable for this particular camera position; however, should you want to reorient the camera, I'd suggest using a different map, or its larger counterpart!

13 Finally return to the Render Setup panel and navigate to the Indirect Illumination tab. Turn off Final Gathering and render off the scene from the Camera01 Viewport.

Information: As there's no Skylight or any advanced lighting or caustics set in the scene, we've Final Gathering disabled, which will speed up render times a touch.

Taking it further

As with any scenes that handle a lot of particles and use a Blobmesh object, this scene is going to take a while to render, not due to particle interaction calculations but purely because the Blobmesh tends to struggle with small particles and low Evaluation Coarseness values; should you decide to increase the Evaluation Coarseness value, this would be at the expense of geometry accuracy and increased flickering as the geometry is updated every frame.

The end result is pretty effective; it'll take a while to kick in as the particles need to travel across the scene to reach the other particle system. It could still need some additional material work to emulate the internal IOR values of hail aggregation, mainly due to dust and debris contained within ice, and also due to the fact that by the time the ice has collated together part of it would have already melted. However, the high-altitude frost we've simulated here does work pretty well; if you think to adapt to the effect more, I'd suggest adding a few additional seed particles and also try playing with some different values within the Force Space Warp which will yield different aggregation patterns. You may also want to try throwing in some more Space Warps, such as a Vortex or Noise, to see what type of fractal effects you'll end up with.

I've added another scene with this tutorial which doesn't use any Space Warps at all, just a ton of particles with the Seed particle being emitted after the initial amount has been born so that they react to it correctly. This generates a more natural frosting effect, radiating out from the Seed particle, though obviously the resulting pattern is quite uniform with few defined branching arms.

If you really think to throw caution to the wind, try adapting this technique to generate more intricate 3D formations; keep the seed particle at the base of the scene and the emitter approximately 1000 units above it. Kill the Gravity (or reduce its Influence), then try using additional Space Warps such as Vortex to generate interesting spiral aggregation shapes. You may also want to try frosting up additional geometry; try it on the leaves with proxy leaves as deflectors, then check for particle collisions with this object.

I've added another test scene for you to play with; this scene uses this technique on a basic teapot; however, for speed I've left the particles renderable and added a rudimentary scaling there to get the frost to grow when it hits the surface and/or another particle. These particles scale out from the point where they hit the surface, thanks to the Rotation operator aligning the particles based on their motion direction, and the pivot point at the base of the particle due to

the referenced geometry. Again, this scene is pretty basic due to the size of the particles (you may want to make them smaller, but for an effective result you'll have to add additional particles into the original system's Birth operator), but the theory – wind direction and shape dictating the shape of the resulting aggregation – is for you to adapt on further.

There's another system disabled in the scene in question which scatters a few thousand particles over the teapot geometry so that the aggregation spreads out when the particle hits the surface, in essence combining the original method with the other Taken Further scene!

6 Icicles

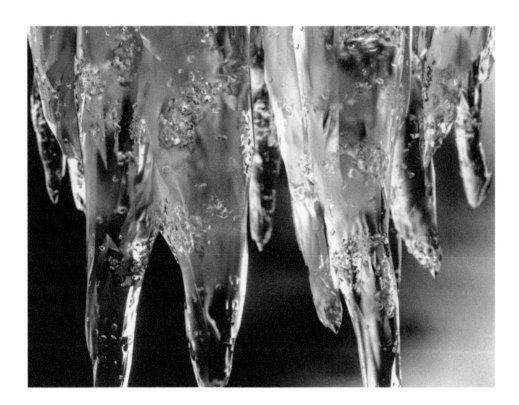

Introduction

In this tutorial we're going to simulate an icicle formation. This will take on two forms – initially the basic construction of the icicle geometry derived from a surfaced particle system, and secondly the final material using an Arch & Design material with varying refraction glossiness and density colors to remove the "CG" feel from the image. Finally we'll throw in a touch of depth of field to give the resulting render a nice macro effect.

Analysis of effect

(a) The main shape of the icicle formation is derived from the aggregation of frozen water as it flows down either an existing contour in terrain or an object collating and freezing. Additional water droplets flow down this aggregation surface and form a long, thin peak pointing towards the ground. Its general shape depends on the external forces, namely winds, which determine how the water is dragged over the surface before it freezes, resulting in a more textured surface and intricate patterns. For shielded icicle formations, these patterns aren't as strong because the water droplets aren't being affected by the winds. (b) The refraction properties of ice aren't necessarily dependent on how pure the water is, but more on how fast the water freezes; there's a discernable difference in how "cloudy" (nitrogen) the ice is due to internal bubble formation. (c) That isn't to say there can be additional dirt and debris suspended in the freezing water, causing cloudy fractal-esque patterns within the ice structure. The surface texture of the ice, again, is influenced by external forces, and can yield a diamond-esque linear shape depending on the purity of ice. Additionally, we can see smaller fine speckle detail over the structure due to the freezing water being bombarded with air particles, resulting in sporadic patterns over the icicles. (d) Importantly the ice shouldn't retain any color; the presence of color can be attributed to light scattering derived from the refracted external environment. We'll also see some additional internal hairline cracks in the structure which can be attributed again to the external forces and also a "pause" in the aggregation process. This would result in intricate white lines due to light scattering, giving the ice its distinctive internal texture (akin to cracked ice cubes).

In 3ds Max we can create icicles quite easily by using a basic particle system to "draw" out the shape of

external forces can affect the shape of the icicle formation.

the speed at which the ice freezes can dictate the amount of the "frosting" effect within the ice.

Image courtesy Laura James

pitted areas can be present due to the rate of freezing and influence from external particle matter.

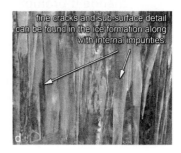

fine cracks and sub-surface detail can be found in the ice formation along with internal impurities.

Image courtesy Laura James

the icicles, then use a Blobmesh Compound Object to surface them, resulting in the icicle geometry. This geometry can then be cloned and collapsed so that the result is static, before applying a few additional modifiers to the collapsed geometry, namely an Optimize modifier, to generate some nice chips and facets akin to the reference material, plus a Smooth modifier so that these facets are sporadic through the geometry, adding to the realism in the render. However, the main crux of the system is based within the material assigned to the icicle geometry. This will be based on an Arch and Design (mi) material that is transparent but has maps applied to the Refraction Color and Glossiness, resulting in a cloud of impure ice (Color) and some speckled noisy refractions (Glossiness). These effects will be produced with a basic Cellular map for the Refraction Color and Glossiness, and to top it all off some nice nested Speckle maps masked out with Noise maps will be used to produce the sporadic surface texture. Finally the scene will be completed with a basic environment map – this map is a simple bitmap with some snow and rock blurred out to fake the depth of field and to blur out any joints (as the bitmap may not be tiled), plus finishing off with some Camera depth of field to get a nice macro shot in the final render.

Walkthrough

PART ONE: First, we'll load the start scene file before setting up the initial Space Warps and particle system to "draw" out the icicles.

1 Open the *06_Icicles_Start. max* file included with this tutorial and accept any file unit change if prompted. In the Top Viewport, create a Wind Space Warp. In its Force group, set the Strength value to 0. In the Wind group, set the Turbulence value to 1, Frequency to 5, and Scale to 3. Label this Space Warp Wind_ Small. Add another Force Space

Warp to the Top Viewport and label it Wind_Large. Again, set Strength to 0, Turbulence to 1, Frequency to 10, and Scale to 1.

Information: Make sure you accept the file unit change so that any procedural maps and settings we dial into the software will yield results as those in this tutorial. The Wind Space Warps have been introduced to add some additional random directional motion to the particles that draw out the icicles, giving the impression of some external forces affecting the shape of the icicles as can be seen in the reference material. We've used two Wind Space Warps to break up any uniformity that one single Space Warp would produce. Bear in mind that the Wind Space Warps' physical position in the scene will also dictate the shape of the icicles; so your results may differ slightly from those in this tutorial.

2 Select the PF Source 01 icon in the scene and click on its Particle View button. Add a Birth operator to the Particle View event display to create a new event and set its Emit Stop value to 0 and the Amount value to 50. Wire the input of this new event to the output of the PF Source 01 event. Label the event Icicle Draw. Add a Position Icon operator to the event.

Information: The Particle Flow system has its Viewport and Render Quantity Multiplier values and Integration Steps set identically for both Viewport and Render so that we can see the whole bunch of particles in the Viewport, even though we aren't actually going to render these particles, just using them to produce scene geometry later on. This is to avoid confusion later when you may see only 50% of the original particles you dialed into the system and wonder what had happened!

3 Add a Speed operator to the event and set its Variation to 200 mm. Add a Force Space Warp to the event and add both Wind Space Warps to its Force Space Warps list. Set the Influence value of this operator to 500. Add a Shape operator to the event and set its Shape, Sphere, and Size values to 20 mm.

Information: We're using Speed as a directional velocity instead of using something more "natural," such as a Gravity Space Warp, as it can give an immediate response; a Gravity Space Warp would gradually accelerate. Purely out of design – nothing can stop you using the Space Warp method (in fact, it would look better!). Even though the particles aren't going to be rendered, they need to have a physical shape so that the Blobmesh Compound Object can surface them correctly. The Shape operator's Type was set to Sphere purely for illustrative purposes when we're ready to test out the simulation shortly. It has no effect on the shape of the surfaced geometry.

4 Add a Scale operator and set its X, Y, and Z-axes settings in the Scale Variation group to 75. Add a Keep Apart operator to the event and set the Force value to −100 mm. Set the Accel Limit value to 500 mm. In the Range group, set Core Radius to 50 mm and Falloff Zone to 50 mm. In the Scope group, choose Current Particle System.

Information: Here we've added a touch of random scale to the particles so that the icicles aren't of a uniform size. The Keep Apart operator ensures the icicles don't interact. Now this may not be exactly accurate as collations of ice can occur in real life; it's more of an aesthetic for this scene. You may want to amend this operator and/or add another Keep Apart operator to the system so that when the particles get close they merge and stay merged together (HINT: negative Force and high Accel Limit value, plus low Core Radius and Falloff Zone). We're using the entire particle system in the Keep Apart operator so that the "drawn out" particles are also avoided.

5 Turn the particle system off by clicking on the light bulb icon in the PF Source 01 event. Add a Spawn test to the event and set it to By Travel Distance in the Spawn Rate and Amount group. Set Step Size to 50 mm. In the Speed group, set the Inherited % value to 0.

Information: TURNING OFF THE SYSTEM IS VERY IMPORTANT! Sorry about the capitals there, but should you add a Spawn test with these settings (i.e., set to By Travel Distance), then the system would crash/hang if you were scrubbing through the animation as there isn't any event (yet) for the spawned particles to go to; they'd sit in the current event and spawn themselves exponentially. We don't want the Spawned particles to move, hence set the Inherited % value to 0.

6 Drag out a Scale operator to the Particle View event display to create a new event and label the event Icicle Scale. Wire the input of this new event to the output of the Spawn test in the previous event. In the Scale operator, set Type to Relative First and set Sync By in the Animation Offset Keying group to Event Duration.

Information: This operator will be used to create the width of the icicles by animating the scale of the spawned static particles based on their duration within the event.

7 Click on the Default In/Out Tangents For New Keys flyout (next to the Set Key button in the main interface) and choose a linear key. Go to frame 100 and turn on Auto Key. Set the Scale Factor group's X, Y, and Z percentage values to 300 and the Scale Variation group's X, Y, and Z percentage values to 75.

Information: We've changed the Default In/Out Tangents For New Keys to a linear keyframe type so that there's a linear growth for the icicle from top to bottom – the older the particle, the larger it will be, coupled with a touch of variation thrown in for good measure!

8 Turn off Auto Key and return to frame 0. Set both Display operators to geometry and re-enable the particle system. Save the scene and scrub through the timeline to see the particle trails emit and grow. If the system fails due to the Keep Apart operator (i.e., if the trailing particles disappear), then return to frame 0 and set a new seed value in the Position Icon operator.

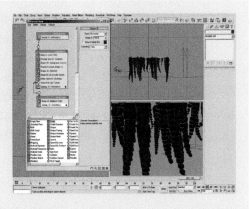

Information: We saved the scene in order to check the simulation; it's always good to test out a system that has a Keep Apart operator contained within it as it could often fail, resulting in the particles disappearing (actually they're shooting off to infinity) and causing the resulting surfaced geometry (Blobmesh) to fail. However, we shouldn't have any problems with this particular scene due to low particle count, but it's always good to test out the simulation. We've set both Display operators to Geometry so that we can see the second Scale operator in action.

PART TWO: With the icicle drawing system established, we'll now surface the particles and edit the resulting geometry.

9 Navigate to frame 100. In the Top Viewport at the origin (XYZ coordinates 0,0,0), create a Blobmesh Compound Object. Label it Blobmesh_ Icicles. Set Render and Viewport Evaluation Coarseness to 30. Click on the Pick button and choose the PF Source 01 icon in the scene. Click the Pick button again to turn it off.

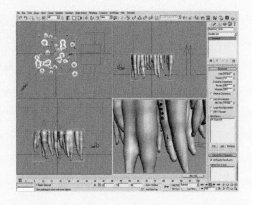

Information: We've positioned the Blobmesh at the origin so that it just keeps its Local Axis Co-ordinates central to the scene; this actually makes no difference to the end result in this instance, but it's good to keep things tidy. We've increased the Evaluation Coarseness values to reduce the polygon count of the resulting geometry due to the size of the particles. Drop this value down if you want a more blobby ice formation as can be seen in the reference material (though it will take longer to surface).

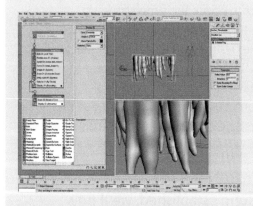

10 Ensure you're still at frame 100 and clone the Blobmesh object and choose Instance when prompted. Rename the new Blobmesh object Icicles_Renderable. Right-click the object, and in the resulting Quad Menu choose Collapse To: Editable Poly. Return to frame 0 and turn off the particle system. Add a Relax modifier to the modifier stack and set its Iterations value to 2.

Information: We're cloning this object at frame 100 so that the full extent of the icicles is available to the Blobmesh. We're instancing it so that the system updates faster – if we simply copied it, then the system would have to re-calculate the Blobmesh for both objects, which may possibly result in a scene lag. As we're simply going to collapse the geometry, we don't need the particle system (and therefore the original Blobmesh) any more; so once the collapse has been performed, we can simply turn off the system to save update times. The Relax modifier has been added simply to smooth out any kinks in the surfaced geometry.

11 Add a Noise modifier to the stack and set its Scale value to 500. Enable Fractal and set the Roughness value to 0.5 and Iterations to 5. In the Strength group, set the Z value to 300 mm. Add an Optimize modifier and set the Face Thresh value to 5. Finally add a Smooth modifier and turn on Auto Smooth. Set the Threshold value to 12.5.

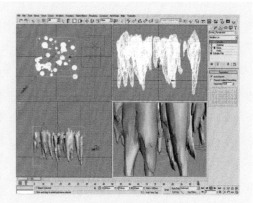

Information: The Noise modifier has been added to create some vertical deformations in the collapsed geometry so that the icicle formation looks a bit more natural. The Optimize modifier has been added not only to reduce the polygon count but also to produce faceted geometry, which the Smooth modifier will use to sporadically reveal these facets, thanks to the low Threshold value.

PART THREE: Finally we'll set up the icicle geometry before adding a background image and setting up the Depth of Field.

12 Open the Render Setup dialog, and in the Assign Renderer rollout change the Production renderer to mental ray Renderer. In the Material Editor, add a new Arch and Design (mi) material to a free sample slot and label the material Icicles.

Information: As we're using a material that is only available with the mental ray Renderer, we've to enable this renderer in the Render Setup dialog.

13 In the Reflection group, set the Reflectivity value to 1. In the Refraction group, set the Transparency value to 1 and the IOR value to 1.309 (that of Ice). Add a Cellular map to the Refraction Color map slot and label it Icicle Impurity Color. In the Division Colors group, set the first color swatch to RGB 233,233,245 and the second color swatch to RGB 207,207,230. In the Cell Characteristics group, set the Size value to 250 and Spread to 1. Enable Fractal and set Iterations to 20. In the Thresholds group, set the Low value to 0.2.

Information: Setting a high Reflectivity value makes the material perfectly shiny; however, this will be broken up by the Bump map we shall introduce later on. The IOR value has been set to 1.309 (a value derived from online sources). The Cellular map has been added to the Refraction Color to dirty up the resulting refractions in the material – the darker the color, the more "dirty" the ice appears! The settings we used will create a large dusty cloud within the icicles, clamped with the raised Low value, so that there are defined areas of pure and dirty ice.

14 Back at the top level of this material, copy the Icicle Impurity Color map to the Refraction group's Glossiness map slot. Navigate to this new map and label it Icicle Refraction Glossiness. In its Division Colors group, set the first color swatch to RGB 120,120,120 and the second to RGB 60,60,60. NOTE: After setting up this map, you'll find a drop in performance when updating the material since mental ray calculates every material change with this

new Refraction Glossiness map that produced the frosting effect based on ray scattering. If you're working on a slower system, it's advisable to disable this map in the General Maps rollout until the material is complete, before re-enabling it. This map also has a big knock-on effect with Depth of Field (DoF); so if you decide to implement DoF later on, be aware that your render will take considerably longer to render with the Refraction Glossiness map enabled.

Information: Now it has to be mentioned here that this feature will have a detrimental effect on the Depth of Field we'll add later on – it may slow down your system a lot; so you may think to disable it if you experience performance issues in the render. It's simply there to frost up the ice, creating the illusion of nitrogen bubble buildup as discussed in the "Analysis of effect" section. We're using similar settings as the previous Cellular map so that they overlap and complement each other; the impurities too cause the frosting effect, akin to the reference material.

15 Back in the top level of this material and in the BRDF rollout, choose By IOR (fresnel reflections). Expand the Advanced Rendering Options and enable Max Distance in the Reflections and Refraction groups. Set the Max Distance value to 40 mm. Enable Color at Max Distance in the Refraction group and set its color swatch to white (RGB 1,1,1).

Information: As we know the real IOR value for ice, we can let the system generate correct reflections for our material instead of inputting it ourselves! The settings we've introduced to the Advanced Rendering Options simply restrict the distance that a surface can be reflected and/or refracted. This actually will aid render times at the expense of reflection/refraction accuracy, but as we're blurring the material with our Cellular maps, any loss in quality will be negligible.

16 Expand the Special Purpose Maps rollout and set the Bump value to 1. Add a Stucco map to the Bump map slot and label the map Icicles Bump Indentations. Set Size to 20, Thickness to 0.02, and Threshold to 0.675. Set the Color #2 swatch to white (it's currently off-white).

Information: We're using a high amount of bump so that in the render we can differentiate Bump texture from frosting. This Stucco map creates small surface indentations much like air bubbles which have been frozen and then collapsed, akin to those in the reference material.

17 Add a Speckle map to the Color #1 map slot and label the new map Icicle Bump Speckle Small. Set the Size value to 200. Click on the Swap button to change the colors around (purely for illustration purpose, we'll add maps to these map slots). Add a Noise map to its Color 1 slot and label it Icicle Bump Speckle Small Mask. Set Noise Type to Turbulence and set Size to 100. Set the High value to 0.6, Low to 0.4, and Levels to 5. Set the Color #2 swatch to RGB 215,215,215 to reduce its intensity.

Information: To add the effect of ice being exposed to fine dust and debris which produces this fine pitted material as mentioned in the "Analysis of effect" section, we're going to use two main Speckle maps, which will be masked out with Noise maps. We've swapped the colors around in this map purely for illustrative purposes, so you can tell at-a-glance what the (main)

color of its sub-map will be, plus it also aids us in the next step where we'll copy the Speckle/Noise map combination into the existing Speckle map and we want these colors swapped in the copy. I really hope that makes sense to you...!!

18 Back up in the Icicle Bump Speckle Small map, and copy this map into its own Color #2 map slot. Label the new copy Icicle Bump Speckle Large as illustrated. Set its Size value to 500. Go to its Noise Map in the Color #1 map slot and rename the map Icicle Bump Speckle Large Mask. Set the Size value to 350. Assign this material to the Icicles_Renderable object in the scene.

Information: ... and here's the copy as I mentioned before; this time we're using a larger Size value for both Speckle map and its (new) Noise sub-map, resulting in larger pitted areas in the surface texture, breaking up any uniformity that would be present with just one Speckle and Noise map combination.

19 Add a Bitmap map to a free sample slot in the Material Editor and load the *icicles background.jpg* file included with this tutorial. In the Coordinates rollout, choose Environ and ensure the Mapping is set to Spherical Environment. Set the U Offset to 0.25 and Tiling to 0.5. Choose Mirror for the U-axis and set the Blur offset value to 0.01. Expand

the map's Output rollout and set the RGB Level value to 1.5. Open the Environment and Effects dialog and instance this map into the Environment Map slot.

Information: The image we're using as background is a simple photograph that isn't tiled; therefore, we've mirrored and offset the bitmap so that no seam is visible in the resulting render. It's blurred to fake a touch of Depth of Field. We've increased the RGB Level value to brighten up the image so that we don't have dull white values in the resulting reflections and refractions in the icicles.

20 Finally select the Camera01 object in the scene. In the Modifier tab in the Command bar, in the Multi-Pass Effect group, click on Enable and choose Depth of Field (mental ray) in the drop-down list. In the Depth of Field Parameters rollout, set the f-Stop value to 4.5. Reposition the scene's Camera Target to focus on an icicle and render off the scene.

Information: Here's where the entire system grinds to a halt when you render! This is due to the Refraction Glossiness map, so you may want to disable this if you're using Depth of Field and are using a slower machine. If you still want to use Depth of Field, try adjusting the f-Stop value to reduce the Depth of Field blurring, which will aid render times. As mentioned earlier, your results will differ from those in the screenshots due to the position of the Wind Space Warps; so you'll need to adjust the position of the Camera's Target to pull focus on a specific icicle.

Taking it further

Even though it had taken an age to render, thanks to the Depth of Field and pretty cool refraction glossiness (the speed culprit), we've got a really nice result, yet in places it still does look a little too clean. This can be rectified quite easily by having a closer look at the reference material. As these icicles have been derived from impure water sources (i.e., coming off grass, soil, rock, etc.), you'll find small amounts of debris contained within their structure. This can be implemented with a Scatter Compound Object or a Particle Flow system by using a copy of the collapsed Blobmesh as an emitter, then using a touch of Keep Apart to collate the particles together before collapsing them down so that they're static and render quickly.

Additionally, you'll also want to introduce additional particle effects to simulate nitrogen collation in the ice – this is the internal bubbles we see in the reference, mostly causing the frosting effect, but occasionally on purer water sources we'll see small internal bubbles running down the length of the entire icicle that has been frozen in situ. Again, these can be simulated with a simple particle system akin to the aforementioned debris system and surfaced with a Blobmesh so that you don't get any geometry intersections. Unfortunately, unless you introduce some collision detection, you'll get some leakage through the icicles; so you'll have to selectively remove the polygon elements from the collapsed bubbles, but this isn't difficult. The Taken Further scene included with this tutorial has this implemented.

To adapt the scene even further, you may want to forego the entire geometry-collapsing setup and have the ice actually growing within a sequence. This makes things more difficult as you'll have to rethink the icicle construction process; the particle count and sizes we've at the moment will cause the resulting Blobmesh to "pop" every time a particle is spawned. Also bear in mind how icicles are actually formed, by a process called aggregation – one particle on top of another; so try designing a system that simulates this type of effect with smaller particles and higher particle counts; have a look at the Ice Aggregation tutorial (the clue's in the title!) for more information on how to achieve this type of collation effect and try applying it to this scene to get the icicles grow out naturally.

Due to the way the original scene is constructed, you can pretty much attach icicles to any piece of geometry by simply replacing the Position Icon operator with a Position Object operator and assigning an emitter object to its list. Icy teapot anyone?! Bear in mind that even though the icicles look pretty

convincing as-is, if we tilted the camera further up then we'd see the icicles don't collate together enough.

This can be rectified by increasing the particle count to create the initial ice buildup, sending a percentage of these particles to another event which will draw out the icicles with the Spawn test (so that only a few particles are spawned to create the icicles) and finally adjusting the Keep Apart operator depending on the size of your scene.

Finally finish off the scene with some nice water droplets running down the icicle geometry and gathering at the end, some freezing and other dripping off the end of the icicle. You may even want to change the entire structure of the material; the scene could be amended quite easily to change the icicles to stalactites (or stalagmites "that's how I remember 'em," to quote a comedian; to those who know who I'm on about, don't worry – I won't do hand gestures…).

7 Condensation

*Now with added condensation!

Pete Draper & Elsevier do not proposition the consumption of alcohol
... just so you know...!

Introduction

In this tutorial we're going to create a kind of product shot for a beer commercial. Here we're going to concentrate not only on shading the bottle and internal liquid correctly with the right assignment of IOR values but also on setting up the condensation by using varying Refraction Glossiness values in an Arch and Design (mi) material and assigning snapshotted particles over the surface of the bottle and shading them correctly to give the impression of the collation of condensation (try saying that three times as fast!).

Analysis of effect

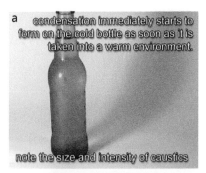

a condensation immediately starts to form on the cold bottle as soon as it is taken into a warm environment.

note the size and intensity of caustics

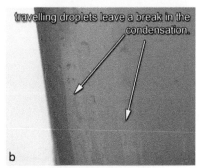

travelling droplets leave a break in the condensation.

b

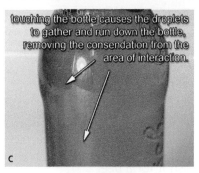

touching the bottle causes the droplets to gather and run down the bottle, removing the consendation from the area of interaction.

c

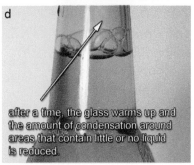

d

after a time, the glass warms up and the amount of condensation around areas that contain little or no liquid is reduced.

(a) Even though we tend to see this type of effect daily, it's quite a complex procedure to simulate mainly due to the type of stippled surface the condensation produces. (b) This scattering of light through refraction would result in a noisy surface; however, depending on the amount of water vapor present, the droplets can reach a saturation point where the friction holding them onto the surface is less than the gravitational force being exerted on them, thus dragging them downwards, leaving a (virtually) clean trail in the droplet's wake. (c) This may also be attributed to any form of external interaction, such as holding the bottle, as this would cause the small droplets to collate, therefore there will be more vertical "wake" trails around these areas than others. (d) Due to the temperature of the liquid present in the bottle, after a while, there will be a greater collation of condensation around the area where the liquid is contained; for example, there will be less condensation around the top of the bottle. The duration of the exposure to air can be determined by the size of water droplets – initially, the cold surface will simply cloud up before the collation of defined water droplets starts to occur. In addition to the reference images of beer in the bottle, I've also included the images of an open bottle, beer in a glass, and foam (should you need it) for color reference purposes.

For this particular effect, we're going to rely on mental ray's Arch and Design (mi) material as it contains a nice feature for blurring refractions to yield a pretty decent condensation effect. However, we don't want the full bottle to be covered by this effect due to collation and drips running down the side of the bottle; so using procedural maps

we'll mask off the top of the bottle (as someone has gripped the bottle), and, additionally, have elongated procedural maps run vertically down the side of the bottle to mask out the desired areas. The bottle and beer materials will be designed within two main objects: firstly, the bottle itself and the internal beer interface; secondly, the surface of the beer. The materials have to be assigned this way to derive the correct IOR values. Typically, IOR values are based on the fact that we're viewing the object in air (IOR value of 1.0003); however, those values get thrown out of the window as soon as we start seeing interface transitions (the passing of light from one medium to the next – e.g., glass to water). Therefore, the outer surfaces of the bottle will have its "native" IOR value of 1.55, while the glass/beer interface will have an IOR value of 0.886 [1.33 (water)/1.55 (glass)], and the beer surface geometry will have a "native" IOR value of 1.33 (glass). The external water droplets (condensation) will have an IOR of 1.55 for their outer surfaces, and the interface between water and glass will be 1.165 [1.55 (glass)/1.33 (water)]. For more information on this, search for IOR Interface in the 3ds Max Help file. The water droplets themselves will be distributed using a particle system, emitted from a derivation of the original bottle model, with their distribution confined to areas that contain condensation. These particles will be surfaced with a Blobmesh Compound Object; however, they may intersect with the bottle model, which is undesirable. Therefore, using another version of the bottle model, we'll perform a Boolean operation to remove these intersections, which will leave a sub-object polygon selection for us to assign the correct material to the water/glass interface! However, we don't simply want round droplets; by studying the reference material, you'll understand that droplets have a distinct shape as they're affected by gravity, so they've a larger mass at the top than at the bottom. This can be achieved by using an XForm modifier with a touch of soft selection, using the existing soft selection derived from the Boolean operation so that we don't need to go in and manually select the faces/vertices, and by offsetting the XForm modifier's Gizmo downwards a touch, we can deform the geometry to the shape we want. Finally we'll enable caustic emission from specific objects in the scene, disable the particle system (after collapsing the Boolean result), and render off the scene.

Walkthrough

PART ONE: First we'll load the start 3ds Max scene and set up the materials to be assigned to the scene's geometry.

1 Open the *07_Condensation_Start. max* file included with this tutorial and accept any file unit change that pops up. This scene has several properties already established, namely the renderer is set to mental ray; the main scene light is in situ and set to a desired strength; plus we've the exposure present as well as the required bottle, beer surface geometry, and background provided with some materials assigned. The bottle objects in the scene already have the required mapping assigned, which is consistent across all versions of the model; so all we really need to do is set up the materials and particles.

Information: The base scene assets have been provided by the "modeler"; so all we've to do is a bit of effects design and assign it to the scene. Lighting and exposure have also been established with a single photometric light and corresponding exposure. So, further to setting up the elements mentioned above, simply render off the scene.

2 Open the Material Editor. Create a Multi/Sub-Object material in the first available sample slot and label it Bottle and Beer. Assign this material to the Bottle object in the scene. Click on the Set Number button and set Number of Materials to 2. Click OK to confirm and close this dialog. Add a Blend material to the Material 1 slot and label it Glass Condensation Blend.

Information: The Bottle object in the scene already has its Sub-Object ID's assigned to the relevant faces; so it's a simple case of designing the material and assigning it to the object as a whole; 3ds Max will then associate the Material ID with the corresponding ID in the Bottle object's Edit Poly modifier. As mentioned in the "Analysis of effect" section, we need these two materials assigned with the correct IOR values in order to design the right interfaces between mediums.

3 Add an Arch and Design (mi) material to the Material 1 slot of the Blend material and label it Green Glass. In the material's Diffuse group, set Color to black. In the Reflection group, set the Reflectivity value to 1. In the material's Refraction group, set the Transparency value to 1 and set IOR to 1.55 (that of glass). Set the Transparency Color to RGB 0.208,0.741,0.208. Expand the BRDF rollout and choose By IOR (fresnel reflections).

Information: Here we've designed a basic glass material that simulates a "perfect" surface. Obviously in real life there's some additional detail like small pitted areas of glass and seams generated in the production process, but this is slightly out of the realm of this tutorial. Feel free to add these as bump mapping later if you think it'll fit. We don't need to manually produce falloff settings for our reflections as the material can handle all that automatically by setting the material to design the falloff using the IOR values. The refraction color of the material was derived from the reference material, and the Diffuse color has been set to black so as to prevent any additional matte or glossy effects showing through the material.

4 In the Glass Condensation Blend material, copy the Green Glass bottle into its Material 2 slot and label the new material Green Glass Condensation. Add a Noise map to the Glossiness map slot in the Reflection group and label it Bottle Condensation Mask. Set its Y Tiling value to 0.02. In the Noise Parameters rollout, set Noise Type to Fractal, Size to 7, High to 0.475, and Low to 0.474. Click on the Swap button to change the colors around, and set the Color #2 swatch to RGB 50,50,50.

Information: This is where the main part of the condensation material is designed. We're simply blurring the original glass material with some nested sub-maps so that in areas of these maps that are white there's no blurring, and where there are shades of gray there's blurring. The 0–255 grayscale values correspond to the 0–1 Glossiness value; so the low RGB value we've input will blur the refractions (and reflections later on) by a fair amount. We've set the Y Tiling value so that the map can be vertically stretched, giving the illusion that the droplet trails run down the side of the bottle.

5 Add a Splat map to the Bottle Condensation Mask map's Color #1 slot and label it Bottle Condensation. Set its Size to 10 and # Iterations to 5. Set the Color #1 swatch to white and the Color #2 swatch to RGB 50,50,50. In the Green Glass Condensation material, instance the map in the Reflection Glossiness map slot we've just set up into the Refraction Glossiness map slot.

Information: This map produces finer detail in refractions (and now reflections due to the instance), creating a nice pitted texture; otherwise the result would have been a little too smooth and lacking in detail.

6 Navigate back to the Glass Condensation Blend material and add a Gradient Ramp map to the Mask map slot. Label the map Condensation Blend Control and set the V Tiling to −0.2 and enable Mirror in V checkbox. Set the W Angle value to 90. In the gradient, add a flag at position 10 and set its color to black. Reposition the flag at position 50 to position 30 and set it to white. In the Noise group, set Amount to 0.05, Size to 2, and choose Fractal.

Information: This Gradient Ramp map masks off the top of the bottle, simulating either interaction with the bottle or warming of the glass (as mentioned in the "Analysis of effect" section) around the neck so that it blends between the original glass material and its blurred copy.

7 Create a new Arch and Design (mi) material in a free sample slot in the Material Editor and label it Beer Surface. In the Diffuse group, set Color to Black. In the Reflection group set Reflectivity to 1, and in the Refraction group set Transparency to 1 and IOR to 1.33. Set Color (in the Refraction group) to RGB 0.878,0.504,0.102. In the BRDF rollout, choose By IOR (fresnel reflections). Assign this material to the Beer_Surface object in the scene.

Information: Here we've simply set up a water-esque material and shaded the refractions accordingly so that it resembles the beer. The color was derived from point sampling the reference material (additional images are included with this tutorial) and tweaking a touch to saturate the colors slightly. As the Beer_Surface only interfaces with the air, the resulting IOR value is set to the standard value for water (1.33).

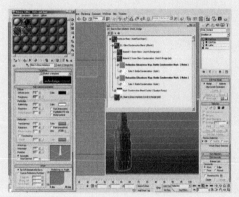

8 Copy the Beer Surface material, paste (copy) it into the second Sub-Material in the Bottle and Beer material, and label the new copy Beer to Glass Interface. In its Refraction group, set IOR to 0.888.

Information: Here's where things start getting a little complex. As mentioned in the "Analysis of effect" section, we need to set a different IOR value for the interface between liquid and glass. This value is 0.888 [IOR of liquid (1.33)/IOR of glass (1.55)]. We don't need to do anything else as all the properties have already been set up in the original version of this material.

9 Create a new Multi/Sub-Object material in a free sample slot in the Material Editor and label it Droplets. Click on the Set Number button, set Number of Materials to 2, and click OK to confirm and close the dialog. Copy and paste (copy) the Beer Surface material to the Material 1 slot of this new material and label it Droplet Water. In the Refraction group, set Color to white (RGB 1,1,1).

Information: As before, the Multi/Sub-Object materials will be assigned to the relevant object in the scene; however, this object hasn't yet been created (the droplets), so we'll assign it later on. Again, we're using this type of material so that we can selectively assign the correct interfaces.

10 Back in the Droplets Multi/Sub-Object material, copy the Green Glass material to its Material 2 slot and rename the copy Droplet to Glass Interface. In the Refraction group, set the IOR value to 1.165.

Information: As mentioned in the "Analysis of effect" section, we need to set a different IOR value for the interface between glass and liquid. This value is 1.165 [IOR of glass (1.55)/IOR of liquid (1.33)]. We don't need to do anything else as all the properties have already been set up in the original version of this material. Even though we're dealing with the same type of interface (liquid to glass), the calculation this time is the other way around due to the light passing through the mediums in a different order.

11 Create a new Standard material in a free sample slot in the Material Editor and label it Droplet Emitter. Set the Diffuse color to black and add a Mask map to its Diffuse map slot. Label the map Droplet Emitter Mask. Instance the Condensation Blend Control Gradient Ramp Map into the Mask map's Map slot. Copy the Bottle Condensation Mask map

to the Mask slot of the Droplet Emitter Mask map and label it Droplet Emitter Placement. Set Color #1 to black, remove the Splat map from the Color #1 map slot, set Color #2 to white, and assign this material to the Bottle_Droplet_Emitter object in the scene.

Information: As we need the particle droplets to be emitted only on the existing areas of condensation, and not in the warmed areas or droplet trails, we'll use the existing Gradient Ramp map and (a derivation of the) Noise map to mask out these areas, preventing the particle system (emitted from the Bottle_Droplet_Emitter object in the scene) from generating particles in these areas. We've set the Diffuse color to black as the Mask map will be overlaid on top of this color, while, on the other hand, the original grey color would result in particles being emitted on the masked areas, which is undesirable.

PART TWO: With the materials designed, we'll set up the condensation droplets by designing a particle system, and then exert "forces" on them to sculpt them in the desired fashion.

12 Navigate to the Graph Editors menu and choose Particle View (or press 6 to open Particle View). Drag out a Standard Flow operator to the Particle View canvas to create a new particle system. Select the PF Source 01 event, and in its resulting Parameters bar, set the Viewport % value to 100 in the Quantity Multiplier group.

Information: We've increased the Viewport % value to its full amount so that we can exactly see how many we're going to get at render time.

13 Set the Birth operator's Emit Stop value to 0 and its Amount to 500. Replace the Position Icon operator with a Position Object operator and add the Bottle_Droplet_ Emitter object to its Emitter Objects list. Enable Density By Material in the Location group, and in the If Location If Invalid group, enable Delete Particles. In the Shape operator, set Shape to Sphere and Size to 1.5 mm.

Information: We want the particles to be born at once and at desired areas in the bottle, hence we enabled the Density By Material option. The Delete Particles option was enabled to ensure any wayward particles are removed as the system can't decide where to place them, else these may even appear on top of the bottle! The Shape operator has its type set to Sphere purely for Viewport display purposes; this has no effect on the end surface size or shape when surfaced with a Blobmesh Compound Object.

14 Remove the Rotation and Speed operators and add a Scale operator to the event. In the Scale Variation group, set the X, Y, and Z percentage values to 50. Finally set the Type in the Display operator to Geometry.

Information: We don't assign Speed or Rotation to the particles as we don't want them to move, and as they're going to be surfaced anyway, rotation isn't necessary. We do, however, need a touch of scale variation, else the resulting droplets may all be of the same size! The Display operator has been amended so that the particles' shapes and sizes can be displayed in the Viewport to give us a rough idea where they may be positioned and how the end result would appear.

15 In the Top Viewport, create a Blobmesh object and label it Blobmesh_Droplets. Set its Viewport Evaluation Coarseness value to 3 and click on the Pick button in its Blob Objects group. Choose the PF Source 01 icon in the scene, wait for the scene to update, and click on the Pick button again to avoid choosing any other objects in the scene.

Information: We've reduced the Evaluation Coarseness value so that the resulting geometry would be more refined, and therefore more accurate, when surfacing the particles. Ensure you turned off the Pick button after choosing the PF Source 01 icon (or by hitting the Select By Name button in the interface to choose the icon), else you may accidentally add additional objects to the Blobmesh!

16 Add a Relax modifier to the Blobmesh_Droplets object. Instance this object and collapse it down to an Editable Poly by right-clicking the object and choosing Convert To: Convert to Editable Poly in the resulting Quad menu. Rename the object Blobmesh_Droplets_Collapsed. In the Particle View, turn off the particle system by clicking on the light bulb icon in the root PF Source 01 event.

Information: Here we've smoothed out any small kinks in the geometry, thanks to the Relax modifier, and created an instance of the object. This is done so that the Blobmesh doesn't have to recalculate the surfacing (it would

if we simply copied it). We've collapsed the geometry down and turned off the system (preventing the uncollapsed Blobmesh object from recalculating) as we just need the resulting snapshotted droplet geometry but don't expect it to recalculate. We've performed this operation on a clone of the original Blobmesh just for safety, so that we can go back to the system and add more (or lesser) droplets later on.

17 Save the scene. Select the Blobmesh_Droplets_Collapsed object, and in the Create tab in the Command bar, navigate to the Compound Objects and choose ProBoolean. In its Parameters rollout, select Subtraction (if not already chosen) and click on the Start Picking button in the Pick Boolean rollout. Choose the Bottle_Boolean_ Subtraction object in the scene and (once the scene has been updated – it may take a little while due to the geometry count of the collapsed geometry) click on the Start Picking button again to turn it off. NOTE: If you've stability issues with the Boolean operation, add a MultiRes modifier to the collapsed geometry and reduce the polygon count a touch. Collapse again and retry the Boolean. Alternatively, go back to the Particle Flow system and set a new Seed value in the Position Object operator to recalculate the positioning of the particles; collapse again and reperform the Boolean operation.

Information: Here we're simply preventing the intersection of the collapsed droplet geometry with the bottle by subtracting a derivation of the original bottle model from the collapsed geometry. If we didn't perform this operation, the resulting render would look incorrect due to incorrect IOR values within the glass bottle.

18 Add a Material modifier to the resulting Booleaned geometry. Add a Poly Select modifier and click on the Polygon Sub-Object button in the Parameters rollout. Add another Material modifier and set Material ID to 2.

Information: The first Material modifier sets the entire object to a Material ID of 1 for safety. The Poly Select modifier simply exposes the existing sub-object selection derived from the Boolean operation so that it can be passed up the modifier stack and used within the second Material modifier. This will, therefore, correspond to the material we've set up in the Material Editor (that we'll assign shortly).

19 Add another Poly Select modifier to the object to clear the Sub-Object selection. Next, add a Vol. Select modifier, and in its Stack Selection Level group, choose Vertex. In the Selection Method group, enable Invert. In the Select By group, enable Mesh Object and click on the None button and choose the Bottle_Selection object in the scene. In the Soft Selection rollout, enable Use Soft Selection and set the Falloff value to 4.

Information: By using the additional derivation of the bottle (which has been Pushed out a touch to intersect the coplanar polygons that interact with the bottle), we've used Vol. Select to invert the resulting selection and feathered out the resulting vertex selection so that the selection strength is high on the outermost part of the droplet.

20 Add an XForm modifier to the object, enter its Gizmo Sub-Object level, and drag the Gizmo vertically down in the Front Viewport to shear the shape of the geometry very slightly (only by a millimeter or so). Add an Edit Poly modifier and remove the Elements on the underside of the bottle. Add a Turbosmooth modifier, and in its Surface Parameters group, enable Smoothing Groups. Assign the Droplets Multi/Sub-Object material to the object.

Information: … this is then deformed slightly (I mean very slightly) with an XForm modifier to result in the desired shape as seen in the screenshot. The Turbosmooth modifier is simply added to refine the geometry, but is set to Smoothing Groups so that the underside of the droplets doesn't smooth out with the surface, else the result would look like spherical glass beads. Once we've assigned the material, the corresponding Material ID assignment will automatically be implemented, thanks to the modifiers we've set up.

PART THREE: Finally we'll set up the render parameters, such as enabling caustics and transparent shadows, before final rendering.

21 Select the Bottle, Beer_Surface, and Blobmesh_Droplets_ Collapsed objects in the scene; right-click and choose Object Properties in the resulting Quad menu. In the resulting Object Properties dialog, navigate to the mental ray tab, and in its Caustics and Global Illumination group, enable Generate Caustics. Click on OK to confirm and close the panel.

Information: We need only a select few objects to cast caustics, namely the objects that are transparent. Now that these objects' materials have a "perfect" transparency assigned, caustic reception won't be apparent; so if you want to tweak the scene further, try adjusting the material to add some impurities to the glass and fluid to make the caustics more apparent on the bottle surface adjacent to the droplets.

22 Open the Render Setup panel and navigate to the Indirect Illumination tab. In the Caustics and Global Illumination (GI) rollout, enable Caustics and turn off Opaque Shadows. Finally hide any non-relevant objects for safety (e.g., the emitter and selection objects) and render off the scene from the pre-set Camera01 Viewport.

Information: If Opaque Shadows was enabled, then it'd have caused the caustic effect to dull down, making it appear inconsistent with the reference material, hence we turned it off.

Taking it further

The end result works pretty well mainly due to the type of materials used in the scene and the inclusion of caustics and transparent shadows; however, we can extend this exercise by a fair amount to improve on the image. Firstly, the label doesn't have any form of condensation applied to it whatsoever, apart from the occasional particle droplet sitting over it. Obviously we need to have the same condensation map applied to this material too; so to get it look right, I'd advise to blend the current material with a condensation version and use the same mapping as the bottle so that the drips run smoothly down the bottle without any breaks.

Technically the droplet interface assignment is wrong; there should be a cookie-cutout merge of the intersecting droplet geometry within the outer bottle's geometry so that these faces can have the correct IOR values assigned as we now have coplanar faces where the droplets and bottle meet. This can be fixed with additional droplets and Boolean operations so that the original droplet geometry has only the outer surface and no surface that touches the bottle, and the bottle has additional geometry incorporated in it to selectively assign the correct interface value. A bit of a pain I know, but worth it if you want the scene to be physically accurate.

Obviously we've based the drips on a procedural map. Okay, it works well in this instance, but if you were to use this model in production, I'd seriously suggest hand-painting some maps to get a more natural distribution. The same applies to the particles. Additionally, you may want to turn this static image into an animation sequence; however, you'll encounter more difficulties as the droplets run down the surface of the bottle as they need to "wipe" through the condensation map. The trick here is to render out a map that contains the paths of the particles; Render To Texture, along with a combination of particles spawning to produce the paths, will generate the desired result with a little playing around the system. Then it's simply a case of mapping on the resulting (black and white) sequence into the Refraction Glossiness map, which will correspond to the baked texture map. Easy!

Also, bear in mind that the bottle itself isn't perfect like the one we've in this scene; upon closer inspection there's very slight deformation in the glass texture throughout the entire surface of the glass, producing a deformation akin to a Cellular map set to Chips. This could be introduced to the material as a Bump map, however it needs to be exceptionally subtle; we can only see it when viewing a patterned surface through the bottle and rotating the bottle slowly so that these patterns become discernable from the rest of the colors. This, along with the bottle's seam, can be attributed to mass production.

If you seriously want to go to town on the sequence, try modeling a cap out for the bottle, animate it popping off, and then incorporate the bubbles from the Lemonade tutorial included in the supplementary book, while keeping this tutorial timed to emit once the cap is removed. Okay, you'll want to massage the settings a little for the merged assets from the Lemonade scene and create new deflector geometry, but you'll be able to create something pretty convincing by the end of it without too much trouble.

This system could easily be transposed onto other scenes requiring condensation, such as steamy windows (there's a song in there somewhere . . . !) or a pan or kettle boiling. Think about how condensation is formed – from water particles collating, and design a system accordingly so that when they reach a certain size they run down the surface collecting additional water particles as they fall, akin to the raindrops on windows (but not whiskers on kittens).

No, these aren't a few of my favorite things . . . !

8 Soap bubbles

Introduction

In this tutorial we're going to simulate a scattered light diffusion over the surface of the soap bubble, plus its shape, motion, and finally how to "pop" them! Unfortunately, it's not as simple as assigning a quick material onto a spherical particle as we see in the reference material, but through analysis we'll be able to produce a nice convincing effect. You may think this tutorial deserves to be within the "Air" section of the book; however, as we're dealing with water-based bubbles as a medium, it deserves to be placed in this section.

Analysis of effect

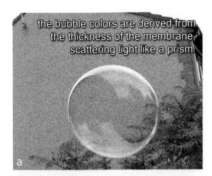

the bubble colors are derived from the thickness of the membrane, scattering light like a prism.

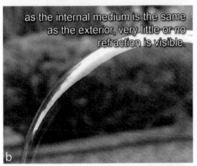

as the internal medium is the same as the exterior, very little or no refraction is visible.

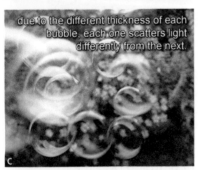

due to the different thickness of each bubble, each one scatters light differently from the next.

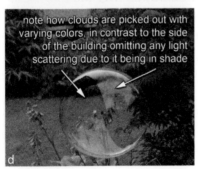

note how clouds are picked out with varying colors, in contrast to the side of the building omitting any light scattering due to it being in shade

(a) Without getting too much in-depth into its science, in a nutshell, the main compounding factor that gives a soap bubble its effect is the distribution of colors over its surface. This can be attributed to the thickness of the bubble which, even at a microscopic level, acts as a lens splitting the light into its core components to result in the breakup and refraction of the incident light. (b) As this thickness changes constantly over the lifespan of the bubble due to evaporation (the bubble gradually thins out), the color will change from one hue to the next before it pops (the final color change can normally be determined as a precursor to the final collapse of the bubble). This results in a swimming color change over the surface of the bubble as its shape is distorted due to wind speed and turbulence and at the rate in which the bubbles are emitted. Bubbles themselves don't necessarily interact, but often do converge with a split membrane or complete absorption; however, there's often a form of interaction as bubbles bounce off each other as well as the environment surfaces. (c) The physical size of the bubble tends to dictate the structural stability of the membrane, with larger bubbles popping sooner than smaller ones. This collapse in structure can sometimes yield additional smaller bubbles. (d) Smaller bubbles, however, don't deform as much as larger ones, with the larger ones performing a rippling effect as the structure attempts to keep its shape while influenced by external forces. Due to internal reflection, the scattering is reflected from one side of the bubble to the other; so the colors at the top will be the same as those at the bottom, albeit slightly diminished.

In 3ds Max we can simulate the motion of the bubbles quite easily with a few Space Warps – a

couple of Winds to break up the motion so that it doesn't look too uniform; a Gravity to add a touch of mass to them; and a Drag to simulate interaction with the air. Easy! However, the main crux of the simulation comes when the bubbles start popping. Not as easy as you may think. The reason behind this is that you hardly see a bubble in a bubble (yes, I know you can perform this in real life, but not by simply blowing air through a soap-eyelet!). This, therefore, prevents us from using standard particles as renderable geometry; so we'll have to surface them using a Blobmesh Compound Object. This actually helps us, believe it or not, as we can now have particles interact with each other resulting in a deforming mesh which works. However, when a particle dies (based on an Age Test or Delete operator), we need all the adjacent particles to be deleted too, else the resulting surfaced geometry (Blobmesh) would simply shrink in size! This can be achieved by sending the popping particles to another event for a short amount of time (before they're deleted) and using an additional Keep Apart operator to accelerate the remaining particles (within a distance threshold) faster than they're being influenced by the Space Warps, and then testing for speed. The particles after being influenced by this speed increase are then passed to this holding event before they're deleted. This, therefore, results in the entire "bubble" collapsing as the Blobmesh will only act on certain events, with possibly one or two tiny bubbles remaining, as in the reference material. The light scattering effect will be controlled by an animated Gradient Ramp map with a gradient derived from point sampling the colors from the reference material (and exaggerating them a touch). Set to Mapped with a Raytrace map dropped in its Source Map slot, the resulting reflections will be shaded with the animated gradient, thus creating the swirling color effect.

Walkthrough

PART ONE: First we'll load the base scene and set up the initial Space Warps used to drive the bubble motion.

1 Open the *08_Soap_Bubbles_Start. max* file included with this tutorial and accept any unit change if prompted. In the Top Viewport, create a Wind Space Warp. Label it Wind_Dir_Small_Turb (Wind Direction, Small Turbulence) and, using the Select and Rotate tool, rotate the Space Warp in the Front Viewport so that it's −45 degrees in the Y-axis as illustrated (type in this value or use the Angle Snap tool). Set the Space Warp's Strength value to 0.4.

Information: A basic step to start with, but important. As we're going to deal with procedural maps and particles, we need to ensure we're all working with the same unit scale setup. If this isn't applied, the settings you'll use later on in this tutorial may yield different results from mine. We'll use two Wind Space Warps to break up the uniformity of a single one – one with a larger waveform (the one with a low Scale value) and another with a smaller waveform (the one with a high Scale value – yes you read that right!). We're also using a small amount of directional force to blow the particles (bubbles) away from the camera, hence the angle.

2 In its Wind group, set the Turbulence value to 1, Frequency to 5, and Scale to 0.1. Reposition this Space Warp to the origin of the scene (XYZ coordinates 0,0,0) by selecting the Select and Move tool and right-clicking all the three spinners in the Transform Type-In fields at the bottom of the interface (if this isn't present, right-click the Select and Move tool to bring up the Transform Type-In dialog and perform the action there).

Information: Again, we're using a high Scale value for this Space Warp in order to generate a finer waveform which can be broken up with another one next. We've set the exact angles and are relocating the Space Warp to the origin so that we've the same bubble distribution pattern at render time. More on the reasons behind this, we see it later. Occasionally the transformation type in the feature at the bottom of the interface disappears, though you may use a floating tool of the same by right-clicking the relevant tool.

3 Back in the Top Viewport, create another Wind Space Warp and label it Wind_Large_Turb. Set its Strength value to 0, Turbulence to 1, Frequency to 5, and Scale to 0.01. Reposition this Space Warp to the origin as before.

Information: Same deal as before: we're relocating the Space Warp to the origin of the scene so that we all have the same distribution pattern. The reason behind this is that we're using multiple Keep Apart operators in this system whose high attraction value can cause the system to fail. The settings I've derived, including the positions of the Space Warps, will work though I'd advise testing the system once it's built. Again, more on that later.

4 Create a Gravity Space Warp in the Top Viewport. Create a Drag Space Warp in the Top Viewport also and set its Time Off value to 1000. Ensure all X, Y, and Z-axes settings in the Damping Characteristics group are set to 5 (this varies between different versions of 3ds Max).

Information: To simulate air/bubble interaction, we'll add a Drag Space Warp to the scene to dampen down the particle motion over time. If you're following this tutorial in a version of 3ds Max prior to 2009, you may notice that the X, Y, and Z-axes values in this Space Warp aren't the same by default, hence the statement. The Time Off value has been set to 1000 to extend the duration of the Space Warp's influence beyond the end of the scene's duration in case you decide to add more frames to the end of the sequence!

PART TWO: With the Space Warps set up, we'll now design the particle system that defines the shape of the bubbles and how they interact with each other.

5 Go to the Graph Editors menu and choose Particle View. In Particle View, and with the Top Viewport or any Perspective/Camera Viewport currently highlighted, drag out a Standard Flow event to the event display. Select the PF Source 01 root event. In the resulting Emission rollout in its Parameters panel, set Icon Type to Circle and Diameter to 150.

In the Quantity Multiplier group, set the Viewport % value to 100. In the Integration Step group, set Render to Frame. Select the Render operator and set its Type to Phantom.

Information: By creating a Standard Flow in Particle View, and with the Top or any Perspective Viewport highlighted, the system automatically positions the icon at the root of the scene and orients the scene icon in the correct direction, which is where we want it to be. We've set the Viewport % value to 100 and set the Render Integration Step to Frame to ensure the simulation we see in the Viewport is exactly the same as what we'd get at render time. We don't need to see the particles in the resulting render, but their position and scale information need to be passed to the renderer so that the Blobmesh object we'll introduce later on can utilize these properties to determine its geometry structure.

6 Rename the Event01 event Small Bubbles. Remove the Rotation and Speed events from the event. In the Birth operator, set the Emit Stop value to 250 and choose Rate. Set the Rate value to 400. With the Default In/Out Tangents for New Keys set to Bezier (next to the Key Filters button as illustrated), turn on Auto Key. Animate the Rate value so that at frame 40 the Rate is 0 (you'll have to enter this value twice due to a bug in the system – it may revert to the original value of 400 but would suggest that it's animated; if so, re-enter the value 0 to be sure!).

Information: We simply want the positional and scale information in the system, so no need for the Rotation operator. The Speed operator has been removed as any directional force will be handled by the Wind Space Warps. We're using Rate so that we can animate the birth amounts in the system which we've implemented in this step, resulting in a nice initial amount of bubbles which tail off before the next "breath" emits the next batch.

7 Next, at frame 60 set the Rate to 600; at frame 120 the Rate to 0; at frame 160 the Rate to 600; and at frame 250 the Rate to 0. Go back and add additional keyframes to frames 58 and 158 with the Rates set to 0 for both as illustrated (NOTE: The screenshot illustrates the Rate curve in Track View to confirm the settings – this isn't necessary but useful to check the values and resulting animation curve). Turn off Auto Key.

Information: Here we're continuing with the Rate animation; we've also added zero-value keyframes at the noted frames to ensure the Rate only builds up to its full value a couple of frames beforehand, else as soon as the previous Rate had dropped to 0, it'd immediately build up again! NOTE: Ensure you turn off Auto Key afterwards as we'll be entering more values next, which don't need animating. After setting the keyframes, the keys may not immediately appear in the Timebar at the bottom of the interface if you've the PF Source 01 icon selected in the Viewport like what I've in the screenshot, however they'll be there. To force a redraw, deselect the icon and then reselect it. Et voila!

8 Back at frame 0, in the Shape operator, set the Shape to Sphere and set the Size value to 35. Add a Scale operator to the event and set its Scale Variation to 75 for all the three axes. In the Display operator, set Type to Geometry.

Information: This step gives the particles shape and scale; however, the

Shape operator's type is only for Viewport reference (along with the Display operator Type change); it'll make no effect to the end result in the Blobmesh object. The Scale operator has introduced a high amount of scale variation, which we'll utilize shortly.

9 Add a Keep Apart operator and rename it KA_Bubble_Bounce. Set Accel Limit to 2000. In the Range group, choose Relative to Particle Size and set Core % to 100 and Falloff % to 200. In the Scope event, choose Current Particle System. Add a Force operator to the event and add the Drag01 Space Warp to its Force Space Warps list. Set the Influence value to 500.

Information: This initial Keep Apart operator deals with repulsive collisions between particles so that they brush off each other as they're passing through the air. We're using Relative to Particle Size so that the scale of the particle is taken into consideration instead of one pre-set size value. The Drag Space Warp has been introduced to simulate air resistance to any harsh erratic motion derived from the Keep Apart operators.

10 Add another Keep Apart operator to the event and label it KA_Bubble_Attraction. Set Force to −100 and Accel Limit to 10 000. In the Range group, choose Relative to Particle Size and set the Core % value to 100 and Falloff % to 0. In the Scope group, choose Current Particle System.

Information: This Keep Apart operator attracts particles that intersect each other (i.e., at birth), or if the previous Keep Apart operator fails to deflect the particles away, then they're sucked into the "bubble" and orbit each other, resulting in a nice deforming surface in the Blobmesh.

11 Add a Force operator to the event and add both Wind Space Warps to its Force Space Warps list. Next, add another Force operator to the event and add the Gravity Space Warp to its Force Space Warps list. Set its Influence % value to 100.

Information: Here we've simply added the remaining Space Warps into the scene; I've purposely split these into two operators so that they can be controlled independently. NOTE: These Force Space Warps can be scripted so that the heavier particles aren't affected as much by the wind and are affected more by gravity, and vice versa for the smaller particles! See the Bubble Stream tutorial for more information!

12 Add a Scale Test to the event. Add a Speed Test to the event and set its Test Value to 5000. Add an Age Test to the event and set its Test Value to 200 with a Variation of 100.

Information: We've added the Scale Test so that we can set a lower lifespan for particles over a certain size (as they pop much easier!). The Speed Test has been introduced to check high velocities generated by the Keep Apart operator we'll introduce shortly. The Age Test is there to take the particles out of the event, after a certain amount of time, towards the same event the Speed Test will send them to.

13 Drag out a Speed operator to the event display to create a new event and label the event Bubble Pop Influence. In the Speed operator, set the Speed value to 0. Select all Keep Apart and Force operators in the Small Bubbles event and instance them to this new event as illustrated. Add an Age Test to this event and set it to Event Age with a Test Value of 2 and Variation of 0. Wire the input of this event to the output of both Speed and Age tests in the Small Bubbles event.

Information: ... which is this event here! Here the particle's speed is killed, thanks to the zero-value Speed operator (else, thanks to the Keep Apart operator we'll introduce next; they will speed off to the extents of the scene); however, we still need the particles to move slightly, following their initial trajectories, so that the direction-orientated operators are instanced across for safety. We need these particles in the event only for a short time, enough for any other adjacent particles in the other event(s) to react against them.

14 Back in the Small Bubbles event, add a Keep Apart operator to the event above the Force operator that contains the Wind Space Warps and label it KA_Pop_Influence. Set its Force value to 100 000 and turn off Accel Limit. In the Range group, choose Relative to Particle Size and set the Core % to 100 and Falloff % to 0. In the Scope event, choose Selected Events and choose the Bubble Pop Influence event in the resulting list.

Information: And here comes the aforementioned Keep Apart operator. Here we're using a very high Force value so that the velocity we're testing in the Speed Test is above that value existing in the scene, i.e., that of the Force operators and the existing Keep Apart operators. This operator forces the particles to check for interaction with those particles that either reached the particle age value set in the event's Age Test and caused them to accelerate with no limitation; this is then checked in the Speed Test, and any particles with this high acceleration are sent through to the Bubble Pop Influence event.

15 Next, select and instance all the Keep Apart operators (including the new one), the Force operators, and the Speed and Age tests to the event display to create a new event. Label the new event Large Bubbles and wire its input to the output of the Scale Test in the Small Bubbles event. Make the Age Test in the Large Bubbles event unique and set its Test Value to 150. Ensure they're in the same order as those in the other event as illustrated.

Information: We still need the large bubbles to have exactly the same motion properties as the smaller ones (although we could make these operators unique and tweak their settings to make them more susceptible to Gravity) so that these operators and tests are instanced across; however, we need these larger bubbles to pop earlier on in their lifespan so that this event's Age Test is made unique and its values reduced. We're ensuring that the operators are in the same order so that the motion is the same as in the Large Bubbles event; if not, the results would possibly be slightly different.

16 Wire the output of the Speed and Age tests of the Large Bubbles event to the input of the Bubble Pop Influence event. Next, drag out a Delete operator to the event display to create a new event and wire its input to the output of the Age Test in the Bubble Pop Influence event. Right-click the Play Animation icon in the 3ds Max interface to bring up the Time Configuration dialog. Turn off Real-Time and click OK to close the dialog. Save the scene and click on the Play icon to test the simulation.

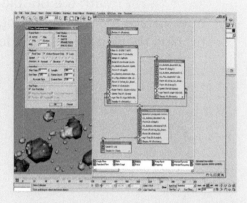

Information: After a couple of frames, we don't need the particles in the "holding event" any more, so they're deleted. Okay, now here comes the painful bit. We need to save the scene at this point in case the simulation fails due to the large amount of Keep Apart operators in the scene. If it does for some reason, amend the Seed value in the Position Icon operator and recheck the simulation (turning off Real-Time ensures every frame is displayed one after the other). You may end up with slightly different results than that in this tutorial, but this would be negligible in the long run! NOTE: In this screenshot, I've also set the Display operators in the other events to Geometry to see the particle sizes in the Large Bubbles event and in the Bubble Pop Influence event, though this will have no effect on the final simulation.

PART THREE: With the bubble simulation set up and stable, we'll now surface the particles using a Blobmesh Compound Object before refining the geometry and adding some additional deformations.

17 Add a Blobmesh Compound Object to the scene and reposition it to the origin. Set its Evaluation Coarseness to 10 for its Render and Viewport settings. Turn on Off In Viewport. In its Blob Objects group, click on the Pick button and choose the PF Source 01 icon in the scene. Click the Pick button again to turn it off. In the Particle View Parameters rollout of this object, turn off All Particle Flow Events. Click on the Add button and select the PF Source 01 -> Small Bubbles and PF Source 01 -> Large Bubbles in the resulting dialog panel. Click OK to confirm.

Information: The Blobmesh is relocated to the origin purely because that's where the particle system is located. We've increased the Evaluation Coarseness to 10 as we don't need much geometry detail, plus it'll speed up surfacing calculations. Off In Viewport has been enabled purely for Viewport interaction speeds; if you want to see the surfaced particles in the Viewport, turn this feature back on. Entirely up to you! We've loaded the PF Source 01 system into the Blobmesh, but we only need the Small Bubbles and Large Bubbles events to be surfaced, not the "holding event."

18 Save the scene. Via the pull-down Modifiers drop-down list at the top of the interface, add a UVW Map modifier and choose Shrink Wrap. Add a Push modifier and set its Push value to 5. Add a Relax modifier and set the Iterations value to 3. Finally add a Noise modifier and set its Scale value to 500. Enable Fractal and set the X, Y, and Z values in the Strength group to 50. NOTE: In the screenshot, I've turned off Off in Viewport so as to see the result of the Noise modifier – note that the geometry is displaced, so the smaller particles don't exactly align. This is normal.

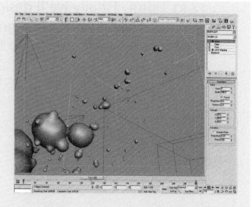

Information: We're using the pull-down menus to add multiple modifiers on top of the Blobmesh object. Unfortunately, at the current time (3ds Max 2009 at the time of this writing), adding modifiers the "traditional" way of using the Modifier List above the Modifier Stack can result in 3ds Max hanging (or crashing with an out-of-memory report) when using the Modifier List to add a modifier above a Relax modifier. Therefore, using the pull-down menu is safe. Anyway ... back to the tutorial! The UVW Map modifier has been added so that animated Noise can be applied to its assigned texture (which we'll create shortly) as the Blobmesh by default doesn't come with any mapping coordinates assigned. The Push modifier is used to create a more bulbous mesh, while the Relax modifier smoothes out any kinks in the geometry. The trick here is the Noise modifier; the Blobmesh object itself doesn't move, but its sub-object polygons are generated and deformed by the Noise modifier, which also remains static. This results in the mesh having a subtle wave noise deformation applied to the surface, which will look like bubble rippling while attempting to hold its form due to external winds!

PART FOUR: Finally we'll design the light scattering material in the Material Editor and assign it to the Blobmesh geometry before assigning a background map to the scene from the 3ds Max stock library.

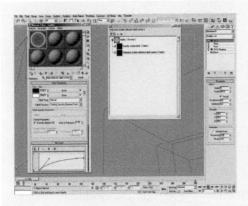

19 In the Material Editor, label a Standard Material Bubble. Set the material to 2-Sided and expand the Extended Parameters rollout. Set the Index of Refraction to 1. In the Maps rollout, add a Falloff map to the Opacity slot and label it Bubble Falloff. Set the Side color to RGB 130,130,130 and set the Falloff Type to Fresnel. In the Model Specific Parameters group, set the Index of Refraction to 1.33.

At the top level of the material, add a Falloff map to the Reflection slot. Label it Bubble Reflection Falloff Control and set its Falloff Type to Fresnel. In the Model Specific Parameters group, set the Index of Refraction to 1.33. Design the Mix Curve as illustrated.

Information: The material itself is set as transparent and uses an IOR value akin to that of air; however, the opacity falloff (as we aren't dealing with refractions in this scene) has its correct IOR set, that of water in the Bubble Falloff map. We don't want the reflection to be as strong face-on to camera, so a Falloff map is introduced initially to the Reflection slot to mask off the reflection. The Mix Curve has been amended so that the reflections are stronger on the perpendicular, but with a steeper attack than in the Opacity map.

20 Add a Gradient Ramp map to the Side slot of the Falloff map and label it Light Scattering Colors. Set Mapping to Texture in the Coordinates rollout. Remove the flag at position 50. Add flags to positions 20 (RGB 60,150,0), 37 (RGB 255,185,5), 55 (RGB 255,0,255), 70 (RGB 47,0,195), 82 (RGB 80,195,40), and 90 (RGB 127,212,183). Set Gradient Type to Mapped. In the Noise group, set Amount to 0.5, Size to 20, and choose Fractal. Back in the top level of the material, set the Reflection value to 50.

Information: This is where the beauty of the light scattering effect lies. Here we'll use a map to drive the distribution of the gradient's colors (derived from the reference material) so that any object or environment that is reflected will have the reflected image re-colored. This re-coloring will be broken up by the animated Noise which we'll set up next, simulating the varying thickness of the bubble as mentioned in the "Analysis of effect" section. Note that we're still using black and white at the ends of the gradient so that dark reflections (no light) aren't reflected and very bright reflections have no light color scattering.

21 Open Particle View and turn off the particle system. Next, change the Default In/Out Tangents for New Keys to a linear curve. Turn on Auto Key and go to frame 300. Set the Phase value in the Gradient Ramp map to 2. Turn off Auto Key and go back to frame 0. Turn the particle system back on.

Information: We've turned off the particle system so that we can easily animate the Phase value, else if we jumped straight to frame 300, we'd have to wait for the system to catch up before animating the value!

22 Add a Raytrace map to the Source Map slot of the Gradient Ramp map. In this map expand the Attenuation rollout and set Falloff Type to Inverse Square. Assign the material to the Blobmesh01 primitive in the scene.

Information: This Raytrace map will drive the reflections in the scene and, therefore, the color distribution in the Gradient Ramp map. We're using attenuation so that distant surfaces aren't calculated by the raytrace engine, hence speeding up the render. The Falloff Type is set to Inverse Square which gives a more realistic effect as light dissipates (scatters), akin to an inverse square curve.

23 Add a Bitmap map to a free sample slot. Load the KC_outside_hi.hdr map included with 3ds Max (in the Maps\HDRs folder) and ensure you choose Real Pixels (32 bit) in the resulting dialog panel. Click OK to confirm and return to the Material Editor. In the resulting Bitmap map, choose Environ and set Mapping to Spherical. Set the Blur offset value

to 0.01, and in the Filtering group in the Bitmap Parameters rollout, choose Summed Area. Expand the Output rollout and set the RGB Level to 0.75. Instance this map across to the Background Map slot in the Environment and Effects panel, change the production renderer to mental ray Renderer, and render off the scene.

Information: Here we've introduced a background map to the scene for our bubbles to reflect; the stock map that we're using works pretty well for this camera angle as it gives a nice variation in the terrain to be reflected in the bubbles. We've blurred the background a touch to throw in some fake Depth of Field; however, to improve the blurring, we've changed the filtering to Summed Area which adds little to the render time, but the result is worth it. The RGB Level has been dropped to 0.75 to decrease the "exposure" of the .hdr image as it's too bright. We're using the mental ray Renderer instead of the standard Scanline renderer so that the scene renders quicker; Scanline has a bit of an issue with two-sided reflective surfaces, with the render grinding down to a halt, while mental ray doesn't seem to have much of a problem with it.

Taking it further

The end result does produce a pretty convincing simulation; however, there are a few things we could do to improve on it. The main issue is the uniformity of the animated texture; obviously each bubble has a different thickness than others, resulting in different light scattering; so we should have a number of different animated textures to assign to our Blobmesh object; this could be achieved by selective elements.

Additionally, be aware that the particle counts are animated to simulate the breath so that the bubbles are emitted more realistically. This also has a compounding effect on the stability of the bubble simulation itself; as we've built a system that causes adjacent particles to be deleted depending on the particle's proximity, it can result in the bubble popping immediately after it's been born! If you decide to amend the scene (e.g., increasing the amount of particles in the scene) and find that this is occurring, try amending the size of the Particle Flow icon in the scene, which should fix the problem.

Try adding some more smaller bubbles; to do this you'll either need an additional system to feed into this main one (and therefore reference it and its relevant events in the Blobmesh object) or increase the amount of particles in the main system and split off a large amount to an additional event that will drive their scale.

The material itself isn't too bad though you could improve on it by using the Arch and Design material, specifically working with a transparent object that is set to Thin-Walled in its Advanced Transparency Options group; this reduces any refraction right down.

One additional thing to note with respect to the colors of the bubble – not every single bubble is the same due to each bubble being of a different thickness (thus the light scatters differently within each one); therefore, you might want to set up a Multi/Sub-Object material with different color distributions and assign the material(s) to the bubble elements so that the distribution looks more realistic.

Finally you may want to add some additional interaction with scene geometry. Obviously this is going to be a bit trickier than it sounds as we need the deforming Blobmesh surface to interact with the scene geometry. As the resulting bubble geometry is of varying sizes, determining any type of surface interaction is going to be difficult, though you could fake it with multiple UDeflectors so that the larger particles collide with pushed (non-renderable) geometry with the push being approximately the radius of the particle, and as a result the particle centers interact with this collision geometry, resulting in the appearance that the scene geometry is displacing the bubble and/or causing it to pop depending on your setup.

Earth

In this section we'll cover effects ranging from a new mountainous terrain weathering system to snow drifts over the Arctic tundra. By using base procedural modeling techniques, we'll deform surfaces before blending the materials together to yield the correct result. In addition to procedural modeling, we'll also design and execute a terrain weathering system within the core 3ds Max software and apply it to a new mountain terrain. Finally we'll illuminate the environment and add additional effects such as fogging where applicable.

9 Mountain weathering

Introduction

This tutorial isn't necessarily about creating a general mountain shape, even though this is what we may end up with, but instead producing a generic terrain weathering system that can be used for any type of terrain surface that you may decide to throw at it. Due to the way it's constructed, this will take a substantial amount of time to simulate (a matter of hours or all night) depending on the speed of your machine and the sheer amount of particles you use. Based on a feedback loop effect, the particles will deform the surface, creating chasms for additional particles to travel down, just like how water weathers the rock.

Analysis of effect

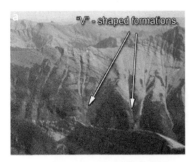

"V" - shaped formations.

Image courtesy USGS

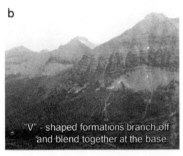

"V" - shaped formations branch off and blend together at the base.

Image courtesy USGS

snow forms not only on the peaks but also between the weathered channels.

Image courtesy NOAA

Image courtesy USGS

(a) Mountain weathering obviously takes over millions of years and mostly takes on a common V shape formation where rain has created channels down the side of the rock. As the water flows down the rock, debris, sediment, and winds get into these channels and weather them out even further, creating a wedge-shaped indentation into the surface. (b) Towards the base of the mountain, depending on the original surface topology, these V shape formations tend to branch off into further channels before flowing into the rivers at the base of the mountain(s) or creating flood plains. The strength of weathering depends on how long the rock has been there, how much rain the area has had, and also what type of material the structure is made up of; sandstone, for example, erodes more quickly than granite as it's a much denser material. Additionally, winds erode less dense materials more easily than harder materials, thus resulting in a smoother round texture than the rain channels mentioned above. Again, check your reference material to see this in action. In this instance, we're going to simulate an erosion of denser material. (c) The surface material also depends on the altitude; towards the top we'll likely see a larger snow covering than towards the base. This will break up considerably before plant life begins to gather further down the mountain we progress; however it isn't defined but a more gradual effect. (d) We'll also see considerable rock fall debris around these points, which is something we could add to enhance this scene later on.

As there's no native way to produce these types of weathering effects directly within 3ds Max, i.e., a bespoke weathering engine (akin to the plugin Dreamscape), and no procedural map structure can produce these intricate branching structures as the rain carving out of the rock, we'll have to build one of

our own. We're going to exactly do what nature does, but instead of rain we'll use particles. The trick is to get these particles to deform the surface geometry of the terrain. This isn't necessarily a difficult process, but it's a bit fiddly. Firstly, we'll create a generic mountain terrain using basic deformations. Next, with the existing Particle Flow icon situated directly above the terrain, we'll make the particles renderable once they hit the terrain surface and, using a UDeflector, ensure these particles travel down the surface of the terrain before they're deleted at the bottom, to save memory. To get them to deform the surface, we'll make the terrain geometry non-renderable and save the resulting image to a file that will be called back into 3ds Max via an .ifl sequence which is time-offset, therefore leaving a "trail" and put to the background of the rendered Viewport so that the particles will additively render over themselves using Additive Transparency. This map will also be applied to an additional Displace modifier to deform the surface, creating the initial chasm(s). Because of these deformations in the geometry, more particles will flow into these "streams," generating a stronger displacement and thus deforming the geometry more, to create the weathering pattern we require. Unfortunately, we're going to render off the entire 300-frame sequence to ensure the maps are generated properly; if we just render off frame 300, the particles will be calculated and rendered, but only in their positions at frame 300; in other words, there will be no feedback which has to be build up.

Walkthrough

PART ONE: Loading the start scene file and setting up the Space Warps.

1 Open the *09_Mountain_Weathering_Start.max* file and accept any unit change when prompted. In this scene we've a couple of objects already in situ for us, namely a Plane primitive which we'll refine and displace later on, plus the main particle system icon which we'll use to emit our "rain." Select the Plane01 object in the scene and rename it Terrain. Go to the

Modifier tab in the Command panel and set the Length and Width Segs values to 150.

Information: In this base scene the basic objects have already been created for you and are available in the same location as the assets used for designing this tutorial so that we'll all get the same results! The scene unit change is used so that any procedural values you enter will have the same effect as the one used in this tutorial. As we need some detail for the particles to displace, the Plane geometry has been refined, else we won't see much change in topology; the more the polygons you add, the more the detail you'll achieve, however the longer it takes to simulate.

2 In the Top Viewport, create a Gravity Space Warp. Still in the Top Viewport, create a Deflector Space Warp so that it encompasses the size of the Terrain object as illustrated. In the Front Viewport, relocate the Space Warp vertically down by about 20 units so that it's underneath the Terrain object.

Information: The Gravity Space Warp is used to gradually pull the particle "rain" virtually downwards not only from the "sky" but also after they come in contact with the terrain, else they may get stuck in a pool, continuously displacing until their death. Gravity affects water this way in real life, so we implemented the same properties in our own simulation. Once the particles have passed the boundaries of the terrain geometry, they're no longer needed; the Deflector01 object in the scene can be used to test this (catching all particles underneath the Terrain geometry), after which they can be deleted. It was relocated further down in the scene to ensure it's under the geometry and not intersecting it once we've added our displacements.

3 In the Top Viewport, create a UDeflector Space Warp. In this Space Warp's Basic Parameters rollout, click on the Pick Object button and choose the Terrain geometry in the scene. Set the Space Warp's Bounce value to 0.

Information: This object is used to check collisions with the Terrain geometry in the scene to be utilized in our Particle Flow system we'll design later on. The Bounce value was set to 0 so that the particles simply hit the surface and travel along it, dragged down by the Gravity Space Warp; we don't want them to bounce around like ping pong balls!

PART TWO: Setting up the weathering feedback effect.

4 Hide the Terrain object and open the Render Setup panel. Enable Active Time Segment and set the Width and Height values in the Output Size group in this panel to 800. In the Render Output group, click on the Files … button and create a new folder on your hard drive and name it Weathering Sequence. In this folder save the File name as *weathering.bmp* – accept the RGB 24-bit option in the resulting BMP Configuration panel. Render out the entire sequence.

Information: A basic step, yet very very important. We need to establish an image file sequence that the feedback loop can write out to and call

on later. Because of the way 3ds Max loads image sequences (via a .ifl sequence, in essence a text file which points 3ds Max to the relevant image file for that frame), it doesn't matter what these images contain as long as they exist. In this step, we're simply generating the initial sequence that the .ifl file will be generated from when we bring the sequence into the software later on.

5 Next, open the Material Editor. In the first available Sample Slot, create a new Mask map and label it Terrain Displacement Mask. In this map's Map slot, add a Gradient Ramp map and label it Terrain Basic Displacement. Ensure Use Real-World Scale is turned off. Set the flag at position 100 to black and the one at position 50 to white. Set the Interpolation to Ease In Out. In the Noise group, set Amount to 0.3 and Size to 8. Set Noise Type to Fractal.

Information: Here we're setting up the basic terrain displacement – the unweathered terrain that our weathering system will be applied to. A Gradient Ramp map is an ideal starting point for this as we can design our topography easily using the flag colors to displace the terrain and add a bit of noise there to break up the shape; however note that the Amount value isn't that high. This is because we don't want too much of a "rate of change" in the gradient (terrain displacement), else the particles may get stuck there and pool, though in some terrain structures this is exactly what we'd need (just not in this one!). This particular gradient is left as a Linear type, forming a ridge effect. We'll control the sides of the mountain next. The Interpolation is changed to remove any harsh linear edging to the displacement so that the levels blend together more realistically. Use Real-World Scale is turned off in this map (and other subsequent Gradient Ramp maps we'll create) so that we're dealing with generic UV units for safety.

6 Back up in the Terrain Displacement Mask map, add a Gradient Ramp map to this map's Mask slot, and label it Terrain Basic Displacement Mask Control. Ensure Use Real-World Scale is turned off. Set the flag at positions 0 and 50 to white and the one at position 100 to black. Relocate the flag at position 50 to position 30. Set Gradient Type to Box and Interpolation to Ease In Out. In the Noise group, set Amount to 0.4 with a Size of 8 and set Noise Type to Fractal.

Information: As mentioned in the last step's "Information" panel, this map controls the opacity of the ridge effect gradient. Again, the Noise Amount value is set relatively low so as not to produce excessive pooling of the particles when we run our simulation.

7 Unhide the Terrain object and add a Displace modifier to it. Label this modifier Displace-Basic Terrain and instance the Terrain Displacement Mask map to the Map slot in the modifier's Image group. Set the Strength value of the new modifier to 250.

Information: This modifier is used to simply displace the original base geometry which the nested Gradient Ramp maps have produced. Note that the top of the Terrain geometry doesn't intersect the top of the PF Source 01 object in the scene; if you're using your own terrain structure, ensure this doesn't occur, else the particles won't collide with these intersecting areas and, therefore, fails weathering.

8 Back in the Material Editor and in a new Sample Slot, create a new Bitmap map. In the resulting dialog that pops up, choose the first frame of the *weathering.bmp* sequence and enable the Sequence check box. Click Open to accept this file and OK the Image File List Control panel that pops up (creating the .ifl sequence file). Label the Bitmap map Weathering Feedback Displacement. Expand the Time rollout in this map and set the Start Frame to 1.

Information: Coupled with step 4, this step is the main displacement/ weathering procedure. By enabling the Sequence check box, an .ifl file is automatically generated which calls on the external .bmp files we produced earlier (and will subsequently overwrite them when it comes to performing the simulation). The Start Frame value has been offset to a value of 4 for the particles that are traveling down the terrain to pass over the specific area/ immediate surrounding group of polygons that they're displacing (it takes about 4 frames to pass from one polygon group to another) so that they don't get stuck in their own little pools caused by their own displacement! If you're performing this with your own terrain geometry, you need an offset of 1 frame to produce the feedback loop properly.

9 Add another Displace modifier to the Terrain object in the scene and label the new modifier Displace-Weathering. Set the Strength value to −75 and instance the Weathering Feedback Displacement map to the Map slot in this modifier's Image group. In the same group, set the Blur value to 0.2, and in its Map group, enable Apply mapping.

Information: This is our main weathering displacement system. The negative Strength value determines how soft the rock is; the resulting displacement map will be white on black; therefore, we need a negative displacement value so that the white values cut into the terrain instead of displacing them upwards! The Blur value has been applied here to feather out the displacement a touch. Again, for softer rock types, try reducing this value. Apply Mapping is enabled, else the original mapping (from the base Plane level) may give a distorted result.

10 Copy the Weathering Feedback Displacement map to a new Sample Slot in the Material Editor and label the new map Weathering Feedback Background. In this map's Coordinates rollout, enable Environ (the screen should now be automatically selected). Open the Environment and Effects panel and instance the Weathering Feedback Background map to the Environment Map slot in the Environment and Effects panel.

Information: This step puts the time-offset displacement sequence to the background so that it can be overlaid with the current frame's particle positions. We're doing it this way instead of applying it to and rendering the Terrain geometry as the displacements may shield and warp the texture, even when viewed and rendered from the Top Viewport.

PART THREE: Constructing the particle system that produces the weathering effect.

11 Select the PF Source 01 icon in the scene, and in the Modifier panel, click on the Particle View button. Drag out a Birth operator to the Particle View event display to create a new event and label the new event Rain Birth. Set the Birth operator's Emit Stop value to 300 and Amount to 100 000. Wire the output of the PF Source 01 event to the input of this new event.

Information: Here we're simply setting up the basis for the rain system, utilizing the existing PF Source 01 icon in the scene. If you view this object's properties, you'll notice that the Viewport % value in the Quantity Multiplier group is quite low due to the sheer amount of the particles that are used. The more the particles used, the sooner the desired effect to be produced, but this will obviously have a knock-on effect with regard to rendering times due to particle position and collision calculations.

12 Add a Position Icon operator to this new event. Add a Speed operator and set the Speed value to 50. Set the Speed operator's Direction to Icon Arrow Out. Add a Force operator to the event and add the Gravity01 Space Warp to its Force Space Warps list. Set the Influence value of this operator to 150. Add a Collision test to the event and add the UDeflector01 object in the scene to its Deflectors list.

Information: The Speed operator's Direction is simply introduced to gently push the particles away from the middle of the particle system, and therefore from the top-most point of the Terrain geometry, preventing them from collating at the top of the mountain to avoid accidental pooling, and therefore a crater, at the top! The Gravity01 Space Warp has been added to force the particles downwards as they travel down to meet the Terrain geometry. Its Influence value has been reduced so that they don't rush downwards too quickly! The Collision test checks for particle interaction (with the UDeflector01 Space Warp); if detected, they're passed to the next event.

13 Drag out a Shape operator to the Particle View event display to create a new event and label the new event Rain Renderable. Wire the output of the Collision test to the input of this new event. Set the Shape operator's Shape to Sphere and Size value to 2. Add a Material Dynamic operator to the event, and in its Animated Texture group, enable Reset Particle Age. Instance the Force

operator from the previous event to this new event. Add a Delete operator to the new event and set it to By Particle Age, and set the Life Span value to 200 and Variation to 0.

Information: As the Shape operator has only been introduced in this event, the particles that are falling to meet the surface from the previous event aren't renderable as they don't have any shape properties. The Material Dynamic operator is added to change the particle's opacity over its lifespan which is derived from the Delete operator. Reset Particle Age is enabled, else the particle age may be taken from when the particle was born, which would result in an incorrect color (opacity) distribution. As we still need the particles to travel downwards as they flow over the terrain, the Force operator containing the Gravity01 Space Warp is instanced from the previous event so that the gravity value is constant.

14 Instance the Collision test from the previous event to the Rain Renderable event and add a new Collision test. Add the Deflector01 Space Warp to its Deflectors list. Drag out a Delete operator to the Particle View event display to create a new event and label this new event Delete All. Wire the output of the second Collision test (the one that contains the Deflector01 Space Warp) to the input of this new event. Select the root event of the particle system, right-click and select Properties. Enable Image in the Motion Blur group and click OK.

Information: As before, we need particle interaction over the surface, else the particles would just pass right through the geometry after interacting with it initially. The new Collision test with the Deflector01 Space Warp checks for particle collisions underneath the Terrain geometry in the scene; as the particles, by this point, may no longer interact with the terrain, they can now be deleted to save memory. Motion Blur has been enabled to help blend together the particle streams.

15 Back in the Material Editor, label the new material Rain. Set the Diffuse color to white and set the Self-Illumination value to 100. Expand the Extended Parameters rollout, and in the Advanced Transparency group, set Type to Additive. Add a Gradient Ramp map to the Opacity slot and label it Rain Opacity. Remove the flag at position 50 and set the flag

at position 100 to black. Add flags to the gradient at positions 5 and 80 and set them to white. Set Gradient Type to Mapped. Expand the Output rollout and set Output Amount to 0.01.

Information: This is the material to be applied to the particles. As we'll have thousands of particles in the scene with the feedback effect, they overlap themselves and with each other. With Additive Transparency enabled, even low opacity values would result in the displacement image sequence quickly becoming very bright, forcing the particles to pool; hence the Output Amount (and therefore the opacity) has been set to a very low value. Because we want to give the particles a chance to get into the grooves and crevices of the geometry, the particle's opacity is animated on and fades out before its death so that we don't get abrupt trails which start and stop, thus affecting the displacement; we want them to establish their trajectory before displacing the geometry.

16 In the resulting Source Map slot in the Gradient Ramp map, add a Particle Age map and label this new map Rain Particle Opacity Age. Instance this entire material to the material slot in the Material Dynamic operator in the Particle Flow system.

Information: As the Gradient Ramp map is set to Mapped, any underlying map in its Source Map slot will drive the distribution of colors in the gradient. Therefore, the Particle Age map will dynamically change the resulting opacity of the material; we could simply use a Particle Age map as the material's opacity, though utilizing it this way gives us more control over the color distribution instead of the basic three-color swatches.

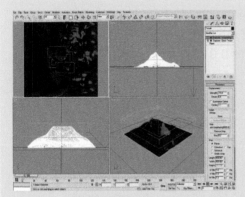

17 Next, maximize the Top Viewport as illustrated. Right-click the viewport label and enable Show Safe Frame. Select the Terrain object, and by using the Viewport's Pan and Zoom tools, center the object in the Viewport so that it's perfectly edge-to-edge as illustrated, with no overlaps or gaps at the edge of the frame.

Information: Again, a very simple, yet very important step. Because we want the particles to feedback in and overlap themselves, we need to ensure the particles are in the right position and the mapped displacement matches the background exactly. Unfortunately, this must be done by the eye. The Safe Frame aids with this as it shows the exact edges of the rendered frame.

18 Right-click the object and select Object Properties. Turn off Renderable. Click OK to accept this and close the Properties dialog. Save the scene as *09_Mountain_Weathering_ Weather-o-Matic.max*. Render off the scene in the Top Viewport; 3ds Max will ask if you want to overwrite the existing images. Accept this by clicking on Yes.

Information: If the Terrain geometry was renderable, then it'd occlude the background image, rendering the effect useless. You could instead hide the geometry, but it's good to have it for reference in the Viewport in case you accidentally nudge the Viewport resulting in a wayward effect. Okay, the main thing to note here is that it may take ages to render out due to the sheer amount of particle calculations. Be on standby to check it sporadically, but you won't see anything for

the first 50–60 frames or so quite simply because the particles need to become established (due to the animated opacity map and overlapping and brightening the images, thanks to Additive Transparency). In all honesty, I'd suggest going out, having a walk or a kip, making some food, taking the bins out and generally chilling for a few hours, depending on the speed of your machine (just as a benchmark, a dual 2.2 system took 8 hours to generate it)! If, for some reason, the effect doesn't work as planned and you decided to re-render, you'll need to re-output the entire black sequence again, else you'll have the previous sequence being fed back into the new setup! To do this, save the scene and create a new blank scene to produce these frames before loading the scene we're working on and make changes as necessary. Additionally, if this is taking too long, you could reduce the geometry in the Terrain object, render out the weathering system, then re-input the original Length and Width Segs values before you carry on with this tutorial. Don't forget, however, that this may result in a less-refined weathering or yield different results from the screenshots shown in this tutorial.

PART FOUR: Loading the weathered result and setting up the final materials and lighting before rendering.

19 Once rendering is completed, re-save the scene as *09_Mountain_Weathering_Finished.max*. Right-click the Terrain object and select Object Properties. Turn Renderable back on. Click OK to accept this and close the Properties dialog. Select the PF Source 01 root node and turn off the particle system to prevent accidental particle emissions. Open the Environment and Effects panel and remove the map from the Map slot in this panel. In the Material Editor, remove the Weathering Feedback Background map by copying

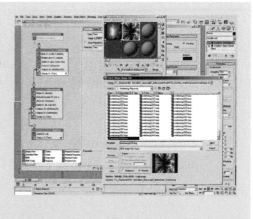

a material over it so that it isn't loaded when rendering. Open the Weathering Feedback Displacement map and load the 300th frame in the *weathering.bmp* sequence. Ensure Sequence is turned off and click Open to accept this file.

Information: Quite a big step, but self-explanatory. Saving the scene will prevent accidental overwriting of the weathering system scene, just in case you'd decide to go back and tweak the settings and/or use a different terrain setup in your own scenes as you're going to edit it heavily. As we're now going to make the scene renderable, and then complete with mountain materials and lighting, we don't want the particle system to be active anymore, nor do we need the background map; however we need the result of the weathering system. The 300th file is the last frame in the weathering sequence, so therefore the strongest. Sequence was turned off when loading back this map, else you'd load the sequence back in (or a derivation thereof).

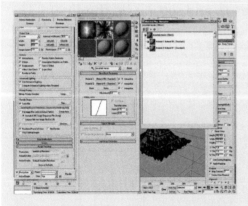

20 Open the Render Setup panel. Expand the Assign Renderer rollout and set Production (and therefore by default the Material Editor) to mental ray Renderer. Back in the Material Editor, create a Blend material in a new Sample Slot and label it Mountain Terrain.

Information: The renderer is changed to mental ray as we're going to use the mental ray Daylight lighting setup and also the Landscape (lume) terrain shading system that is designed to scatter colors realistically across the terrain. Because the Scanline renderer can't utilize these features, changing to mental ray is a necessity. We'll use a Landscape (lume) map to drive the blending of two materials with the Blend material.

21 Navigate to the material in the Material 1 slot and label it Base Terrain. Add a Cellular map to the material's Diffuse slot and label it Base Terrain Diffuse. In the Coordinates group, set the Source to Explicit Map Channel. Set the Cell Color to RGB 40,30,20. Set the first Division Color to RGB 45,40,35 and the second Division Color to RGB 45,40,33. In the Cell Characteristics group, set Type to Chips. Set Size to 0.05, enable Fractal, set Iterations to 4, and set Roughness to 0.4.

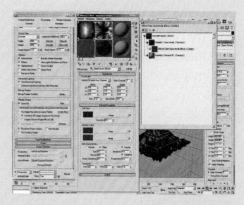

Information: We're using Explicit Map Channel (i.e., Planar mapping applied by the top Displace modifier of the Terrain object in the scene) so that some texture detail could be stretched down the sides of the geometry. The RGB settings were derived by point sampling the colors in the reference material. These RGB values are quite dark and similar in appearance, but do yield a more natural result than using one single uniform color. The Chips type is used to give the illusion of chipped and fragmented rock. Fractal and Roughness are used to give the surface some extra detail.

22 Back up in the Base Terrain material, add a Mix map to the material's Bump map slot and label it Base Terrain Bump Mix. Instance the Base Terrain Diffuse map to the Color #2 slot of this new map and set the Mix Amount value to 50. Add a Mask map to the Color #1 slot of the Base Terrain Bump Mix and label it Base Terrain Bump Weathering Detail.

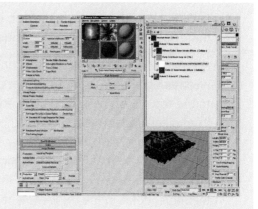

Information: In this Bump map we're blending the detail generated with the Diffuse map to get some finer detail there, and have dropped the Mask map into the Color #1 slot to blend the detail from the weathering system's map used to displace the terrain.

23 Instance the Weathering Feedback Displacement map into the new Mask map's Map slot. Add a Gradient Ramp map to the Mask slot and label it Weathering Edge Mask. Set the colors of the flags at positions 0 and 50 to white and the one at position 100 to RGB 140,140,140. Set Gradient Type to Radial. Instance the Base Terrain Bump Weathering Detail (Mask) map into the Map slot of the second Displace modifier of the Terrain object, replacing the existing Bitmap map. Set the modifier's Blur value to 0.05. In the Plane base level of the Modifier Stack, set the Density value to 5. Back in the Material Editor, go up to the top of the Base Terrain material and set the Bump amount to −50.

Information: The Weathering Edge Mask map is used to ensure the weathering effect's strength, like in the reference material, is mainly confined to the top 4/5 of the Terrain geometry, so that it smoothes out and uses its original displacement towards the outside edges of the geometry. By instancing this Mask map to the second Displace modifier, we also restrict displacement so that Bump mapping and displacement match. We've increased the Density multiplier to increase the amount of polygons and, therefore, detail in the displacement at render time. The Blur value has been reduced to 0.05 so that the displacement is more refined and less smooth, complementing the increase in polygon count.

24 Back up in the Blend material, navigate to the second material slot and label this material Snow. Set the shader to Oren-Nayar-Blinn and set the Diffuse color to white. Add a Bump (3ds Max) map to the Bump map slot. Set the Multiplier value to 0.4. Add a Landscape (lume) map to the Bump map's Map slot in the Bump Parameters rollout and label it Snow Mixer. Set Base Color to black and Overlay Color to white. Set Blur to 0.1.

Information: We're using an Oren-Nayar-Blinn shader to yield a nice scattering falloff of shade as well as a nice and cheap representation of snow. The Landscape (lume) map will be used not only to drive the Bump map in this Snow material but also to drive the mixing of materials. We need the Blur value to be relatively low so that we get a nice definition between rock and snow, but not too low to cause aliasing and not too high to cause much blurring or grey areas over the rock areas.

25 In the Height rollout, set the Height value to 180 and Spread to 40. In the Slope rollout, set Influence to 6 and Angle to 60. In the Positional Noise rollout, set Influence to 2, Scale to 4, Roughness to 0.75, and Coverage to 0.1. In the Shape Based Noise rollout, turn on the Active checkbox. Set Influence to 5, Scale to 4, Roughness to 0.9, Coverage to 0.1, and Vertical Scale to 0.5. Go to the top of the Snow

material and set the Bump amount to −100. Instance the Snow Mixer map to the Mask map slot in the Mountain Terrain (Blend) material. Assign the Mountain Terrain material to the Terrain object in the scene.

Information: Quite a big step of number crunching. Here we're mixing Influence values between parameters in the Landscape (lume) map; the higher the influence, the greater the effect that particular section has on the map's end result. We've increased Scale values to get a decent size of noise so that its shape is visible but still gives a sense of scale in the scene. Vertical Scale has been amended in the Shape Based feature (which has also been enabled to take the shape of the geometry into consideration when designing the noise pattern) to stretch the noise vertically, giving the illusion that the snow has fallen down smaller detailed crevices in the terrain.

26 In the Top Viewport, create a new Daylight system – accept the exposure control change when prompted so that the compass is at the origin, and drag out the resulting Daylight Sun/Sky group so that it's quite a distance from the origin. Click on the Get Location button and change the location to Godthab Greenland (you'll need to set the Map to World to choose this). Set the Time in the Control Parameters rollout to 15 hours, Month to 5, Day to 15, and Year to 2008.

Information: As we're dealing with a snow mountain, we'll choose our location that is somewhat colder! The time parameters have been amended purely to angle the light and, therefore, to set the environment and sky colors.

27 Select the Daylight lights in the scene and go to the Modifier panel. Change the Sunlight to mr Sun and the Skylight to mr Sky. Accept any environment dialog panel that may pop up. In the mr Sun Basic Parameters rollout, set the Multiplier value to 1.5. In the mr Sky Parameters rollout, set Ground Color to white. In the mr Sky Advanced Parameters rollout, set Blur to 7.5.

Information: By changing the lighting types, we'll automatically start dealing with the mr Sky environment setup which is assigned by 3ds Max. The same deal applies with camera exposure too. Ground Color was amended to white so that any distance fogging (haze) will blend with the right color, and that the environment background horizon will be the same. The horizon has been blurred a touch so as not to see the edges of the terrain.

28 Open the Environment and Effects panel and instance the mr Physical Sky map in the Environment slot across to a free slot in the Material Editor to edit its properties and set Visibility Distance (10% Haze) to 200. In the Exposure Control rollout in the Environment and Effects panel, enable Process Background and Environment Maps. Instance the mr Physical Sky map into

the Volume slot in the Camera Effects rollout of the Render Setup panel (you'll possibly want to name it). Reposition the Perspective Viewport so as you're looking up the surface of the Terrain geometry and click on Render Preview in the Environment and Effects panel.

Information: As we want to gain access to the properties of the automatically added mr Physical Sky map, accessing it via the Material Editor is the only way, hence instancing the map into it. The Visibility Distance (10% Haze) option enables us to blend the haze/ground color depending on the scene scale and distance to the camera. Smaller values yield smaller viewing distances before the haze omits the geometry. As we want the environment to match the foreground with regard to exposure, enabling the Process Background and Environment Maps allows us to do just that. The mr Physical Sky map is instanced into the Camera Effects rollout so that the mental ray engine can call on it as a Volume shader to add the haze we've designed in the Material Editor. We've had a quick preview of the render using the Render Preview button for visible changes we'll want to make to the exposure next.

29 In the mr Photographic Exposure Control rollout, change to Photographic Exposure if not already assigned. Set Shutter Speed to 1/1000 (simply enter 1000 as the "1/" is already there), Aperture to 4, and leave the ISO at 100. Set Highlights (Burn) to 0.75, Midtones to 0.5, and Shadows to 0.1. Set Color Saturation to 0.75 and Whitepoint to 6300 Kelvin.

Information: Here, besides checking the preview we made in the last step, we've set a balance between Shutter Speed, Aperture, and ISO to yield a good result, though we've also amended the Highlights, Midtones, and Shadows to achieve a nicer contrast without burning out the detail.

30 Open the Render Setup panel and set a new output file by clicking on the Files button in the Render Output group and specifying a new file and location so as not to accidentally overwrite our weathering sequence! Finally render off the scene.

Information: Obviously we don't want our weathering files accidentally overwritten, so choosing a new filename and location is a necessity! If you're producing an animation, it'd be worthwhile to bake out the Final Gather map to prevent any unnecessary flickering. The final Finished scene has this included.

Taking it further

The end result does yield a convincing weathered effect, thanks mainly to the feedback loop system, but saying that the mountain texture itself could do with being expanded upon. Even though it's using a map originally designed to create a decent terrain texture distribution, it could do with some additional maps to drive additional detail, such as tree placement, foliage, and heavier snow-capped peaks. See the original Mountain tutorial in the supplementary book for another approach to creating the terrain texture, then try elaborating on it by adding geometry such as fallen rocks, landslides, and additional detail.

The weathering system itself, as mentioned in the "Analysis of effect" section, can be used for any type of terrain geometry. Try tweaking the system to produce a Badlands sandstone weathering system; you'll obviously need to start out with the desired initial geometry deformation beforehand; a stepped Gradient Ramp deformation should suffice, before piping it into our weathering system for it to work! Try out craters, hills, and full mountain ranges; however, bear in mind that the more the geometry the base terrain has, the more the weathering detail you'll get, though obviously it may take longer to generate the displacement maps.

Try adding additional Forces such as Wind to direct the rain; this will obviously yield different results from the original central Icon Arrow Out speed direction, utilized to throw the particles from the peak outwards. These forces would be more suited for "larger" terrain surfaces, such as mountain ranges, where there aren't specific peaks which the particles need distributing outwards from to be sure of no excessive weathering in this area (else you'll get pools of displacement as mentioned earlier in the tutorial).

Finally finish off the scene with some clouds at the top of the terrain geometry (again, see the original Mountain tutorial for more information) and/or some snow-blowing off the peak. Try using the weathered displacement map we've generated to drive a vertex selection within a Vol. Select modifier, and then use a combination of Wind Space Warps to create a gentle yet turbulent effect as the snow particles get blown off the terrain.

10 Atoll

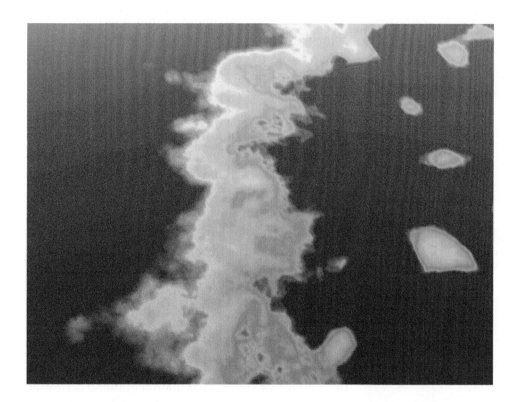

Introduction

In this tutorial we're going to create a procedural Atoll (or Barrier Reef) formation as viewed from lower earth orbit. To remove any type of uniformity to the structure and to break up the effect, we'll use nested Gradient Ramp maps to drive the distribution and shape of the islands, coupled with an additional Gradient Ramp map to control its color, which will be sampled from the source material so that we get the colors just right. We'll finish off with a touch of shading to the overall scene and a little Bump mapping to add a bit of texture.

Analysis of effect

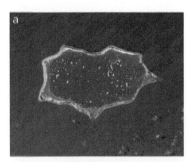

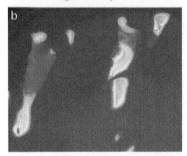

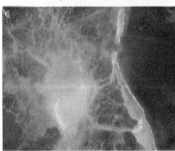

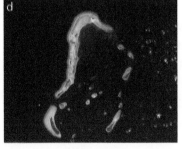

(a) An Atoll normally, judging by reference photos, takes the shape of a (distorted) circular formation, containing lighter coral sub-surface tinted water surrounded by terrain that may or may not contain some plant life. However, this isn't always the case, again judging from the reference material. (b) Some formations appear broken and all this depends on how they're formed (most favor the Darwinian explanation of coral formations around eroding volcanic terrain, creating the more shallow and thus lighter interior waters). However, as they're formed, the color scheme does seem to travel across the board, mainly due to the fact that the majority of these formations are found in similar waters, mainly in the Pacific Ocean. (c) The colors themselves tend to differentiate depending on which side of the Atoll the erosion has taken place. Large surface coral and/or terrain deposits travel to light sub-surface coral formations which contain substantial darker surface detail. This abruptly tails off to the typical ocean color, with occasional singular smaller Atoll or islands surrounding the main formation. (d) As each piece of reference material is slightly different from the next, we'll base the main formation of the structure on *Atoll_04.jpg* image included in the reference material. This gives us a broken effect with a few sporadic-placed islands to the right of the main structure.

The main challenge with creating this type of effect is how to create a natural broken-up effect using procedurals without it looking rubbish and uniform. At close ranges, there seems no much uniformity in a structure; however, when we pull back, even with large noise sizes, you can see patterns emerge in procedural maps. The standard process of mixing maps isn't going to work for this method as we need more control over distribution and shape. Enter the Gradient Ramp map

and its infamous Mapped type! This method, coupled with procedural noise values for each nested Gradient – we're going to use a fair few to control the distribution of the shape and how wide the falloff should be – plus some additional Noise maps to mix colored flags together in a different fashion than the others, will break up the overall uniformity of the shape and result in a more natural distribution. Finally we'll add some additional islands using the gradients to distribute their colors too, a touch of self-illumination to the resulting material, and assign the final material to a deformed Plane primitive that is already established in the scene.

Walkthrough

PART ONE: Loading the start scene and amending the scene's base geometry.

1 Open the *10_atoll_start.max* file and accept any unit change when prompted. Select the Plane01 primitive in the scene and rename it Atoll_Sea. In the Modify panel, set the Density Multiplier value to 10.

Information: As there's no need to deal with that much geometry in the Viewport, we can simply up the Density multiplier value in the Plane primitive to increase the amount of polygons at render time.
The scene also uses a single Omni light to illuminate the Plane primitive and is positioned to cast favorable illumination so that the material we'll set up later on can have some contrast.

2 Add a Bend modifier to the stack and set its Angle value to 30. Set Bend Axis to X. Add another Bend modifier to the stack and set its Angle value to 30. Set Bend Axis to X. Go to its Gizmo sub-object level and rotate the Gizmo 90 degrees on the Z-axis as illustrated.

Information: This process creates a slight curve in the X and Y directions over the geometry. Unfortunately, no single modifier allows you to do this, but using a combination of Bend modifiers provides a quick and simple solution. The geometry is curved slightly to simulate a subtle curvature of the earth and also gives something for the light to play over, increasing the amount of contrast in illumination and, therefore, in the material assigned.

PART TWO: Designing the base Gradient Ramp maps that will drive the main shape of the Atoll.

3 Open the Material Editor. In the first available sample slot, create a new Gradient Ramp map and label it Atoll Shape. Ensure Use Real-World Scale is turned off. Insert flags at positions 68 and 88 on the gradient. Set the flag at position 50 to black, the flag at position 68 to RGB 128,128,128, and the one at position 88 to white. Set the Noise Amount value to 1 and Size to 20. Set Noise type to Turbulence and increase the Levels value to 10. Finally set the Phase value to 0.61.

Information: This map is going to drive the entire shape of our Atoll (see the "Taking it further" section for more information on how to tweak this to other shapes) as it'll control the distribution of colors across additional Mapped gradient types nested within. The shape itself isn't within the white or black areas but within the noisy grayscale area as the gradients that this map nests within were designed around offsetting grayscale information (akin to a Gradient map within Photoshop). The Phase value was simply the author's choice and amended to produce a nicer result of noise pattern than the default value of 0, nothing more! Use Real-World Scale is turned off in this map (and other maps we'll create later on) so as to deal with generic UV units safely.

4 In a new Material Editor sample slot, create a new Gradient Ramp map and label it Atoll Detail. Ensure Use Real-World Scale is turned off. Set Gradient Type to Mapped and instance the Atoll Shape Gradient Ramp map into the (now) available Source Map slot of this new map. Set Noise Amount to 0.5 with a Size of 3. Set Noise type to Turbulence and set Levels to 1.5.

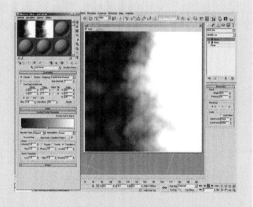

Information: Here we see the direct results of nesting another map within a Gradient Ramp map. It may not look much at the moment, but the combination of Noise patterns will make a large difference to the overall shape of the Atoll later on. Here we used a considerably smaller Noise value which is blended and controlled by the underlying Atoll Shape Gradient Ramp map.

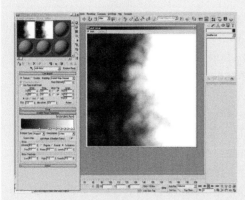

5 Remove the flag at position 50 in this new map's gradient. Add flags and set colors to positions 35 (RGB 70,70,70), 52 (RGB 128,128,128), 56 (RGB 156,156,156), 67 (RGB 184,184,184), 76 (RGB 207,207,207), 83 (RGB 225,225,225), 88 (RGB 230,230,230), and 96 (white). Whew!

Information: Okay, we've done a fair amount of number crunching here, and in all fairness, I could have simply provided the gradient as a file to be loaded; however, by manually inputting these values, you can immediately see how the new gradient starts to take shape; it's now offsetting the colors in this new gradient as determined by the one in the Source Map slot. This map is exceptionally important as it's the one that blends the colors of the Atoll once applied to another Gradient Ramp map later on. Should you wish to tweak the position of color blending, this is the map you choose to do it as it's less flags to amend than the one with the actual color we'll design later on.

PART THREE: Next we'll design and add additional detail to create islands driven by Stucco maps before setting up the rest of the material's appearance.

6 In a new Material Editor sample slot, create a new Mix Map and label it Atoll Island Mix. Instance the Atoll Detail map into the second slot of the new Mix map. Add a Stucco map to its Color #1 slot and label it Atoll Island Height. Set Source mapping to Explicit Map Channel. Set Size to 0.075 and Threshold value to 0.15. Set Color #1 to white and Color #2 to RGB 133,133,133.

Information: This Mix map allows us to add additional detail to the Atoll formation instead of being restricted to the gradient setup. By using small imprint detail produced by the Stucco map (with its parameters designed to be quite small and sporadic and not very heavy), you can see instant result.

7 In the Atoll Island Mix map, copy (not instance) the Stucco map into the Mix map's Mix Amount slot and label the copy Atoll Island Mix Control. In this new map, set Thickness to 0.2, Threshold to 0.57, and Color #2 to RGB 45,45,45.

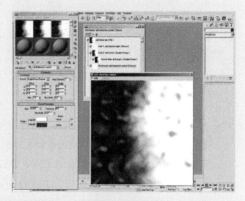

Information: … however, we don't want the Stucco effect to be as strong as total white, else we'll have no color distribution around them (when applied to the Gradient Ramp map we're about to create). The reduction in harshness of colors of this map will produce grayscale information within the white area of the Gradient Ramp map located in the Mix map's Color #2 slot, therefore producing detail to the colors for use in the map we'll design shortly.

8 In a new Material Editor sample slot, label the new material Atoll. Set the shader to Oren-Nayar-Blinn and enable Self-Illumination by enabling the check box next to its numerical entry field.

Information: The Oren-Nayar-Blinn shader gives the nicest falloff for this type of effect as it yields an even distribution of shade without any harsh luminance lines. Self-Illumination has been enabled so that we can use a color instead of a numerical value (or a map driving this numerical value) to illuminate the material.

9 Add a Falloff map to its Self-Illumination slot and label it Atmosphere Falloff. Set Falloff Type to Shadow/Light. Add a Falloff map to its Lit (the second) map slot and label this new map Atmosphere Color. Set the Side Color swatch to RGB 40,190,255. In this Falloff map's Mix Curve, set the point at position (0,0) to Bezier-Corner and design the curve as illustrated.

Information: The initial Falloff map is, in essence, being used as a mask for the Perpendicular/Parallel sub-map. That is to say, due to the change in Falloff type, the areas of self-illumination in the shade will be dark and the areas of luminance will be shown in blue, but only on the perpendicular, giving an indication of atmospheric falloff! The Mix curve has been amended to reduce the intensity on the Parallel (to camera) view as it was too harsh and needed to be constrained.

PART FOUR: Finally we'll design and distribute colors across a new gradient that will have its color distribution based on the maps we've just created.

10 Back up at the top of the material, add a Gradient Ramp map to the Diffuse slot, and label the new map Atoll Color. Ensure Use Real-World Scale is turned off. Set Gradient Type to Mapped and set Interpolation to Ease In. Instance the Atoll Island Mix map to the Source Map slot of this new Gradient Ramp map. Set Noise Amount of this new map to 0.2

and Size to 0.75. Set Noise type to Turbulence and Levels to 3. Turn off the Show End Result icon in the Material Editor to see this map built more clearly.

Information: This new Gradient Ramp map will distribute colors over the Atoll shape(s) driven by the nested sub-maps in its Source Map slot. Noise Amount is amended to create further variation to the color distribution; note that its Size value is considerably smaller than that for the sub-maps in its Source Map slot. Ease In is used as the Interpolation type to create a ramping effect when colors change from one flag to the next, akin to the reference material. Noise Levels have been reduced as we don't need too much of fine detail, else the colors break up and appear much like one big fractal!

11 Remove the flag at position 50 from the gradient and set the flags at positions 0 and 100 to RGB 25,25,45. Again, we need to add more flags to generate the desired color distribution – see below to determine how they were derived.

Information: Here we're simply clearing out of the gradient to add a new color. The flags at positions 0 and 100 are amended to simulate the color of the sea. Unfortunately, again, it's time for a lot of crunching with numbers and adding flags. This is apparent due to the sheer amount of color detail present in the reference material. The numerical RGB values have been derived from point sampling the reference material image and then designing the gradient to mimic these positions and values, in essence redrawing the Atoll color distribution across a part of the gradient. But not all of the gradient … this will become apparent momentarily. Take a deep breath, and here we go ….

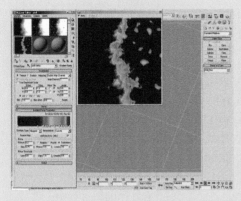

12 Add a flag to the gradient at position 38. Add additional flags to positions 48 (RGB 50,67,73), 50 (RGB 120,100,90), 54 (RGB 105,95,85), 57 (RGB 123,115,105), 62 (RGB 180,180,165), 71 (RGB 60,150,140), 80 (RGB 50,135,133), 85 (RGB 20,107,110), 88 (RGB 25,112,115), 92 (RGB 82,163,165), and finally add one at position 95 and set it to RGB 12,70,98. Whew! (again!)

Information: By now the working of this system is apparent. If you imagine the original gradient color distribution depending on its Source Map from black (0) to white (100), then any color added at point 50 on the gradient will be distributed by the RGB value 128,128,128, wherever this color may be in the underlying Source Map. The same thing applies with all other colors applied here; the reason we see so much detail is that these colored flags are added within this grayscale area, which are then distributed over the Noise grayscale values.

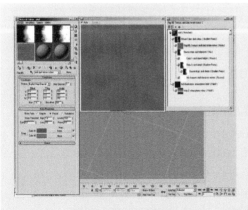

13 Right-click the flag at position 50 and select Edit Properties. In the resulting Flag Properties panel, add a Noise map to the Texture map slot and label it Atoll Dark Terrain Color. Set Source mapping to Explicit Map Channel, and Noise Type to Fractal. Set Size to 0.2 with 10 levels and set Color #1 swatch to RGB 88,72,67 and Color #2 to RGB 120,100,90 (the same value as the original flag color).

Information: Here we're simply adding some additional color variation to the "raised" sand/coral terrain which looked a little too uniform earlier.

Looking at the reference material, there's a large amount of color variations, more so than simply adding a Noise map. You may want to use additional sub-maps or bespoke texture maps for this purpose in future.

14 Back up in the Atoll Color map, right-click the flag at position 62 and select Edit Properties. In the resulting Flag Properties panel, add a Noise map to the Texture map slot and label it Atoll Light Terrain Color. Set Source mapping to Explicit Map Channel and set Noise Type to Fractal. Set Size to 0.2 with 10 levels and set Color #1 swatch to RGB 180,180,165 (the same value as the original flag color) and Color #2 to RGB 136,158,145.

Information: Again, we're simply adding some additional color detail to the gradient, creating some extra definition in the coral shape and how it weathers. Consult the reference material for a real-world example of this in action.

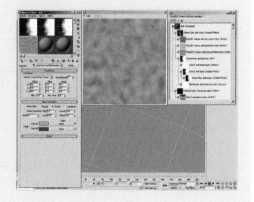

15 Back up at the Gradient Ramp map, right-click the flag at position 92 and select Edit Properties. In the resulting Flag Properties panel, add a Noise map to the Texture map slot and label it Atoll End Coral Blend Color. Set Source mapping to Explicit Map Channel and set Noise Type to Fractal. Set Size to 0.1 and Low value to 0.25 with 10 levels. Set Color #1 swatch to RGB 82,163,165 (the original

flag color) and Color #2 to RGB 12,70,98 (the color of the next flag along the gradient).

Information: Again, we're adding some additional color variation to the gradient; however, this time we're changing the way the colors are blended between flags by using the original color value of the flag which bleeds through into its adjacent flag color.

16 Back up at the top of this material, copy (not instance) the Gradient Ramp map in the Diffuse slot to the Bump Map slot. Navigate back to the Diffuse slot's Gradient Ramp map, right-click the Atoll Island Mix map in the Gradient Ramp map's Source slot, and select copy in the resulting menu. Go to the Gradient Ramp map in the Bump map slot and label this copy Atoll Terrain Bump.

Right-click the Source map slot in this Gradient Ramp and select Paste (Instance) to instance the Mix map into the Source map slot of the Atoll Terrain Bump map.

Information: To add a slight amount of Bump to the scene, we're going to use the original gradient to drive the bump map; however, as the majority of it is submerged, we don't need the entire gradient to drive the bump map, else it'd appear as if the entire Atoll detail is deforming the surface waters! Hence copy the gradient and paste it into the Bump map. However, by copying the gradient means that any of its sub-maps are also copied. To make life easier later on, should you wish to tweak its shape, we've established an instance of a sub-map tree so that as you amend one gradient ramp map (which defines the shape of the Atoll) it automatically amends that in the Diffuse and Bump map slots!

17 Remove all flags from this gradient, apart from those at positions 48, 50, 54, and 62. Set the colors of flags at positions 0, 48, 62, and 100 to black. Expand this map's Output rollout and set the Bump Amount value to 0.001. Finally assign this material to the Atoll_Sea object in the scene and render off the scene.

Information: Again, we don't need the full amount of detail in the Bump map but only that which is protruding through the sea surface; therefore, the rest of the flags are deleted and flags on either side have had their colors amended to keep the Bump within the correct areas. Note that one of the flags with the Noise map assigned is still present; this is totally fine as it adds additional surface terrain detail. Finally the Bump Amount value has been reduced in the map, and not in the Bump value at the top of the material tree, as this gives us more control and ability to dial in values less than 1, as well as this effect needs to be very subtle due to the "altitude" at which it's being viewed!

Taking it further

Even though the result isn't too bad, we can expand on it by adding additional maps into the colored Gradient Ramp map so that each flag mixes more realistically. Naturally this adds a great deal of complexity to the setup; so take care to name your maps and keep a close eye on your material tree structure so as not to get too lost!

Additionally, it might be worthwhile baking out this entire map tree to a single large bitmap, taking it into Photoshop (or equivalent) and manually painting strokes to simulate coral formations and sand texture.

It's also worth mentioning that the Island tutorial in this book uses a similar method to construct the terrain displacement map; however, it uses a totally different approach to create sub-surface detail, specifically that of using Mental Ray shaders specially designed for that approach. It, therefore, might be worthwhile

combining the two techniques – using the map generated from this tutorial with the Mental Ray setup in the other for some closer-proximity shots.

Try adding some additional detail, like a odd tree or animated waves traveling (slowly) towards the beach. However, as we're viewing this scene from a long way up, the wave detail isn't going to be that prominent, so keep it very very (very!) subtle and concentrate on surface texture in the blue sea areas – a simple uniform Noise map will suffice with an exceptionally low Bump value so as not to overly exaggerate it; don't forget that we're using very low Bump values already for the height of the raised sand/coral, so a fraction of this value would do any decent realistic effect.

To give the impression of height, you may also want to add the odd cloud over the seas and around the Atoll, akin to the reference material. Try mixing Noise maps with Splat and/or Cellular maps as masks to create such an effect.

You may also want to try different Atoll shapes; as the entire system is gradient-driven, try changing the shape of the base gradient to Radial and see what happens! You'll obviously need to play with the settings a bit, but you'll undoubtedly be able to create formations akin to those in the reference material! I've included this in the Taken Further scene for your perusal.

Finally try expanding on the tutorial by making key parts of the setup larger; reference images 10, 11, and 12 are actually of the Farasan Islands in the Red Sea and are considerably larger than your average Atoll; note their structure and shape, plus the distribution of the surrounding coral. Don't forget – texture detail dictates size.

11 Snow drifts

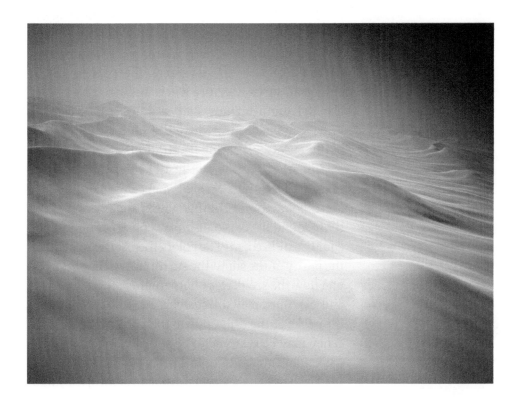

Introduction

In this tutorial we're going to re-create another Arctic scene. "Not another one," I hear you cry! However, these types of scenes are entirely different in structure and, therefore, need a different technique to create such an effect. We'll first set up the initial displacement before relaxing and deforming the geometry to suit the correct shape, finishing off the sculpting with additional Noise modifiers controlled by selections. Next we'll design and apply the relevant materials, and finally light the scene with Mental Ray's Daylight system and set up relevant exposure values before final rendering.

Analysis of effect

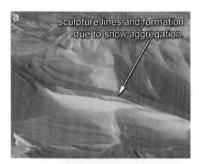

sculpture lines and formation due to snow aggregation.

Image courtesy NOAA

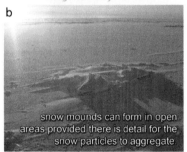

snow mounds can form in open areas provided there is detail for the snow particles to aggregate.

Image courtesy NOAA

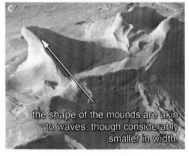

the shape of the mounds are akin to waves, though considerably smaller in width.

Image courtesy NOAA

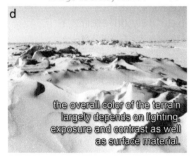

the overall color of the terrain largely depends on lighting, exposure and contrast as well as surface material.

Image courtesy NOAA

(a) This effect is, overall, produced by the winds which sculpt and shape snow aggregation into these unique-shaped mounds. This type of effect can also be seen in the dunes of desert imagery/footage. (b) Snow aggregation itself doesn't appear to be uniform throughout, in fact there are large open spaces where aggregation doesn't take place; in these areas, there's a noticeable change in surface texture where snow is more "sand-like," giving a texture akin to a dry salt-bed in the USA. So it may be worthwhile to source a few images of this effect for scrutiny. (c) The drifts are sculpted not dissimilarly to waves, but just at the point of crashing; however, these "wave" shapes are considerably more pointed and thinner along their length than those found at sea, so a similar construction method could be utilized. (d) The colors themselves depend on the purity of the snow, the surrounding environment, and how the scene was photographed; therefore, light and exposure play a large part here. Additionally, at the peaks of the drifts, due to their size, some translucency may be required to be added in our final scene (depending on scene scale and snow "density").

We'll utilize a lesser used map to control the initial deformation design in 3ds Max – that being of a Planet map. The reason behind this is that, even though it doesn't allow us to use sub-maps in its color palette, it still gives us enough to work with regard to the control of the resulting shape by gradually increasing luminance colors in creating the desired sculpting effect. However, some additional control is required for blending; so this map itself will be integrated within an Output map for this purpose. Dropped into a Displace modifier with an angled displacement, we'll see that the result is far from desirable, though the basic shape is preserved; therefore, the surface can

be distorted further by adding combinations of Relax, Push, and further Relax modifiers to smooth out the geometry, create more refined pointed peaks, and tweak these peaks to ensure no geometry overlaps itself. Once this is established, we can selectively add additional Noise modifiers using a Volume Select modifier to drive the selection method to add deformation to the base of the terrain so as to create dragged snow effects akin to the reference material, before adding a final global deformation to break up the uniform height of the overall terrain shape and a final Relax modifier to remove any harsh detail (this can be tweaked to taste!). The overall lighting scenario will be handled by Mental Ray's Daylight and environment systems, coupled with a touch of haze and exposure utilizing Gamma for added contrast. Finally the surface material will be pretty much uniform using a Standard material with an Oren-Nayar-Blinn shader and nested procedural maps in the Bump slot, Noise for the dragged snow over the drifts, and a Cellular map for the salt bed-esque base terrain. These two maps will be mixed using a Mental Ray Landscape (lume) shader tweaked for desired blending.

Walkthrough

PART ONE: First we'll load the base scene and set up the initial procedural maps and modifiers to drive the main surface displacement.

1 Open the *11_snowdrift_start.max* file included with this tutorial and accept any unit change if prompted. Select the Plane01 object in the scene and rename it Snowdrift_Terrain. In the Modifier stack, set this object's Length and Width to 5000 and the Length and Width Segs to 500.

Information: A basic step to start with, but necessary. As we're dealing with

procedural maps, it must be ensured that we're all working with the same unit scale setup, hence accept the unit change while loading the scene. If this isn't taken care of, the settings used later in this tutorial may yield different results from mine; additionally, this tutorial is dealing with generic units and you may be dealing with real-world values (cm, in, etc.), which will simply compound the problem. As the initial object in the scene is there with basic settings, we've simply increased its size detail, so we can exactly see what we're going to get at render time once we apply the modifiers. You can add additional detail by tweaking the render multiplier – see the "Taking it further" section for more information.

2 Add a Displace modifier to this object and set its Strength value to 600. Enable Luminance Center. Go to the Front Viewport, enter the modifier's Gizmo sub-object level, and with Angle Snap enabled rotate the Gizmo 55 degrees clockwise as illustrated. Come out of the Gizmo sub-object mode so as not to accidentally change the angle again.

Information: The Displace modifier is the main tool that drives the shape of the terrain. We've set the initial displacement Strength value to give enough deformation to the geometry once we've designed and added the map that drives it shortly. The Angle Snap value was simply enabled so that the Gizmo could be rotated precisely (alternatively, dial the values in the fields at the bottom of the interface). The Gizmo was rotated to give the shearing displacement effect, in essence, to drag the geometry at an angle instead of being directly vertical, creating the drift effect.

3 Open the Material Editor and create a new Output map in the first available sample slot. Label this map Displacement Refinement. Add a Planet map to the Map slot of the Output map and label it Snowdrift Displacement. Amend the Y Tiling to 0.5. Set the Water Colors to RGB 20,20,20 for Color #1 and RGB 40,40,40 for Colors #2 and 3. In the Land Colors section, set Color #4 to RGB 80,80,80,

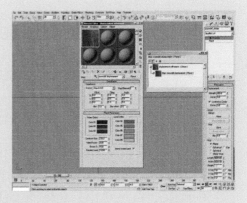

Color #5 to RGB 100,100,100, Color #6 to RGB 120,120,120, Color #7 to RGB 140,140,140, and Color #8 to RGB 170,170,170. Set the Continent Size to 130, the Island Factor to 20, and Ocean % to 75.

Information: This is where the main crux of displacement lies. The Output map is used to tweak the blending of colors in the Planet sub-map, which will be amended next. These specific colors are used to generate a large open area of non-displaced geometry (the Water Colors section) and larger defined peaks (the Land Colors section). Other values such as Continent Size and Island Factor are used to define how wide these drifts are in respect to the overall scene size and how much detail they have, while the Ocean % value determines how much of the flat area is present in respect to the rest of the scene.

4 Navigate back one level to the Displacement Refinement map, expand the Output rollout, and turn on Enable Color Map. Add extra points into the curve at (0.35,0.2), and (0.623,0.3), and relocate the point at (1.0,1.0) to (1.0,1.8). Amend each point to Bezier-Smooth by right-clicking the points and choosing this option (the corner points change the

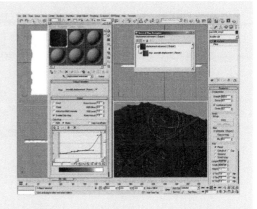

Bezier-Corner), and adjust the curve handles to produce a curve akin to that in the screenshot. Finally instance this Output map into the Map slot of the Displace modifier.

Information: The Output curve simply gives us more control over blending and distribution, plus the ability to increase values higher than RGB 255,255,255, if necessary, by increasing the value beyond 1.0 in the curve's Y direction. Here we've added some smoothing by amending harsh linear points on the curve to Bezier handles, which blends and smoothes the distribution. By instancing the map tree into the Displace modifier, you can see the final displacement result; it's currently quite jagged, which we'll sort out next.

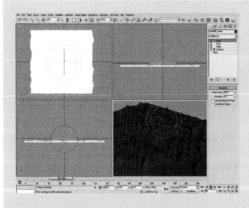

5 Add a Relax modifier to the Snowdrift_Terrain's modifier stack and set its Relax value to 0.1 and Iterations to 50. Turn off Keep Boundary Pts Fixed. Add a Push modifier to the stack and set the Push value to −50. Add another Relax modifier to the stack, set its Relax value to 0.75, Iterations to 70, and turn off Keep Boundary Pts Fixed again.

Information: The initial Relax modifier is available to smooth out jagged edges of the previous displacement. We need to have a high Iterations value to achieve this; Boundary Points is disabled to ensure the entire geometry is smoothed out. The negative valued Push modifier is available to inset the geometry a bit by its own polygon Normal direction, resulting in a more pointed effect. This isn't without problems, as some geometry around the "crest" of the drifts may overlap, hence adding the second Relax modifier to fix these issues.

6 Add a Volume Select modifier, set its Stack Selection Level to Vertex, and in the Soft Selection rollout enable Use Soft Selection. Set the Falloff to 200 and Pinch to 0.8. In the Front Viewport, relocate the Volume Select modifier's Gizmo vertically downwards as illustrated so that it's just beneath the base of the terrain; so no vertices are selected red but the gradient passes vertically up the geometry.

Information: As we desire the snow detail to be confined to the flatter areas of the terrain (again, see the reference material for examples of this), the Volume Select modifier restricts the effect of Noise modifiers added afterwards. This is derived from the relocation of Gizmo and the amendment of the Pinch value, so that any subsequent modifiers will affect the geometry at the base of the terrain with the effect tailing off in a non-linear fashion towards the top of displaced geometry.

7 Add a Noise modifier to the stack and rename it Noise-Small. Set Scale to 200, enable Fractal, set Roughness to 0.1, and set Iterations to 10. Set X Strength to 60, Y Strength to 100, and Z Strength to 30. Go to this modifier's Gizmo sub-object, and in the Top Viewport, Scale up Gizmo in the X-axis by 400%. Add another Noise modifier and label it Noise-Large. Set Scale to 500 and enable Fractal. Set Roughness to 0.1, Iterations to 10, and X Strength to 50. Go to this

modifier's Gizmo sub-object, and in the Top Viewport, scale up Gizmo in the X-axis to 400% and that in the Y-axis up to 120%.

Information: We're using two modifiers so that the horizontal deformation effect they produce can be broken up, else it'll look too uniform and repetitive. The Gizmos were scaled up to exaggerate deformation further, to stretch out the geometry more along one axis.

8 Add a Mesh Select modifier to the stack. Add a Noise modifier and rename it Noise-Global. Set Scale to 1000, enable Fractal, and set Z Strength value to 25. Finally add a Relax modifier to the stack, turn off Keep Boundary Pts Fixed, and set its Iterations value to 3.

Information: The Mesh Select modifier clears the Sub-Object selection, else any additional modifiers we may add further down the stack will only be affected by Volume Select's selection. This final Noise modifier simply adds an overall vertical displacement to the entire terrain, breaking up any final uniform linear shape as it stretches out to the "horizon." The Relax modifier is introduced to smooth out any harsh shearing from the two Noise modifiers driven by the Volume Select modifier; its values are quite low so that the majority of details will still be there.

PART TWO: Next we'll create and assign a snow terrain material to our displaced geometry using nested maps.

9 Open the Render Setup panel and change the Production and Material Editor renderers to mental ray. Open the Material Editor and, in a new sample slot, rename the material Snowdrift Terrain. Set Shader to Oren-Nayar-Blinn and enable Self-Illumination. Set Diffuse color to white. In the Self-Illumination slot, add a Falloff map, label it Snowdrift SI Control, and set it to Shadow/Light.

Information: We're using an Oren-Nayar-Blinn shader type to give a nice dusty shade effect. We could go into further detail using a combination of Mental Ray shaders and materials to give a more desirable result, but this will suffice for our example. Feel free to adapt on it later on though! Self-Illumination is enabled so that the Falloff map we introduced affects self-illumination by color instead of just value. The Falloff map itself is set to Shadow/Light so that any sub-map we may introduce momentarily is masked off by illumination.

10 Add another Falloff map to the Lit (the second) slot of this map and label this new map Rim Light Effect. Set Falloff Type to Fresnel. Back up at the top of the material, add a Mix map to the Bump slot, and label it Snowdrift Bump Mixer. At the top of the material, set the Bump amount to 20. Back in the Mix map, add a Noise map to the Color #1 slot and

label it Drift Streak Large. Set X Tiling to 0.1. Enable Fractal Noise Type and set Size to 40. Set High to 0.7 and Low to 0.2.

Information: The new Falloff map produces a subtle rim-lighting effect (now) based on illumination. Basically, in areas where the geometry receives light, you'll get a lighting effect applied to the material, while in shadow you won't. The Mix map is added to the Bump map slot and its Bump amount reduced so that it isn't as strong as usual (default value is 30). This map was introduced to blend map detail depending on geometry shape with noisy streaks at the top and a dusty cellular shape at the bottom. The Noise map added is stretched by reducing the Tiling value, with other parameters designed for the geometry's size; the High and Low values are introduced to clamp off the colors so that they're defined a bit more.

11 Add a Noise map to this map's Color #2 slot and label this new map Drift Streak Small. Set X Tiling to 0.02, Size to 10, enable Fractal Noise Type, and set the Low value to 0.2. Set the Color #1 value to RGB 80,80,80. Back up in the Snowdrift Bump Mixer map, add a Cellular map to its Color #2 slot, and label it Dust Terrain. Set the first Division Color to RGB 200,200,200 and the second Division Color to RGB 128,128,128. Set Size to 2 with a Spread of 1. Enable Fractal and set Iterations to 2.

Information: As with Noise modifiers, we've also introduced a large and small Noise map setup quite simply to break up the overall detail effect, else it'll look too uniform overall. The Cellular map is introduced to create a "dry desert" effect over the base of the terrain. For extra detail, you could couple additional maps with it to create some nice twinkling specular highlights!

12 Back up in the Bump Mixer map, add a Landscape (lume) map to the Mix map's Mix Amount slot, and label it Terrain Mix Control. Set Base Color to white and Overlay Color to black. Set Blur to 1 and enable Relative to Object, turning off Relative to World. De-activate Height and Positional Noise, so only Slope is set to Active. Set Influence to 1 and Angle to 2. Finally assign this material to the Snowdrift_Terrain geometry in the scene.

Information: The Landscape (lume) map is akin to the Blend material but with more control over detail and distribution. The colors of the two maps in the Mix map are changed so that they mix correctly as the Mix map deals with luminance, not color. Relative to Object has been used so that if the object's translation were to be amended its distribution shouldn't change. The only option available is Slope with a low angle threshold. This is because the geometry's detail isn't that harsh, so any large values will clip off the distribution. We also don't need additional detail at the top or base of the geometry, except the rate of change of angle, hence turning off everything else.

PART THREE: Finally we'll set up the lighting of the environment and some subtle fogging before final exposure and rendering.

13 In the Top Viewport, create a new Daylight system – accept the exposure control change when prompted so that the compass is at the origin, and drag out the resulting Daylight Sun/Sky group so that it's quite a distance from the origin (I've set the Orbital Scale at about 8500 units, located on the Control Parameters rollout of the Motion

Panel). Click on the Get Location button and change the location to Godthab Greenland (you'll need to set the Map to World to choose this). Change Time in the Control Parameters rollout to 8 hours, Month to 6, Day to 21, and Year to 2008.

Information: As we're dealing with an Arctic scene, we'll set our location as somewhere that's a bit on the chilly side (no offense to people in Greenland!). The time parameters have been amended purely to angle the light and, therefore, set the environment and sky colors.

14 Select the Daylight lights in the scene and go to the Modifier panel. Change the Sunlight to mr Sun and the Skylight to mr Sky. Accept any environment dialog panel that may pop up. In the mr Sky Parameters rollout, set Ground Color to white. In the mr Sky Advanced Parameters rollout, set Horizon's Height to −1 and Blur to 0.25. The background of the Perspective Viewport will change automatically as it has already been set up in the scene to use the environment background, which has now been automatically added.

Information: By changing the lighting types, we automatically start to use mr Sky environment setup which is assigned by 3ds Max. The same deal applies with camera exposure. Ground Color was amended to white so that any distance fogging (haze) will be blended with the right color, and that the environment background horizon will be the same. The horizon height has been dropped down and blurred a touch so that the edges of the terrain aren't seen, plus the horizon being a touch too high by default due to terrain displacement and position.

15 Open the Environment and Effects panel and instance mr Physical Sky map in the Environment slot across to a free slot in the Material Editor to edit its properties, and set Visibility Distance (10% Haze) to 150. In the Exposure Control rollout, enable Process Background and Environment Maps. Instance mr Physical Sky map into the Volume slot in the Camera Effects rollout of the Render Setup

panel. Re-position the Perspective Viewport so that you're looking along the surface of the terrain, and click on Render Preview in the Environment and Effects panel.

Information: As we aim to gain access to the properties of the automatically added mr Physical Sky map, the only way to do this is by accessing it via the Material Editor, hence instancing the map into it. The Visibility Distance (10% Haze) option enables blending the haze/ground color depending on scene scale and distance to camera. Smaller values yield smaller viewing distances before the haze omits the geometry. As we expect the environment to match the foreground with regard to exposure, enabling the Process Background and Environment Maps allows us to do just that. The mr Physical Sky map is instanced into the Camera Effects rollout so that the Mental Ray engine can call on it as a Volume shader to add the haze we've designed in the Material Editor. We've had a quick preview of the renderer using the Render Preview button for visible changes we'll make to the exposure next.

16 In the mr Photographic Exposure Control rollout, change to Photographic Exposure and set Shutter Speed to 1/250 (simply enter 250 as "1/" is already there), Aperture to 8, and leave ISO at 100. Set Highlights (Burn) to 0.22, Midtones to 0.55, and Shadows to 1. Set Color Saturation to 1.5, Whitepoint to 5300 Kelvin, and Vignetting to 5. Finally render off the scene.

Information: Here, as you check the preview we made in the last step, setting a balance between Shutter Speed, Aperture, and ISO gives a nice result, though we've also amended Highlights, Midtones, and Shadows to achieve a nicer contrast akin to some of the reference material images. Whitepoint is amended to yield a bluer hue, and a touch of Vignetting will add a bit of aging and draw focus on the middle of the scene before rendering (though Vignetting isn't visible in the render preview).

Taking it further

With the final setup in this tutorial established, the end result looks pretty convincing, yet there are a few elements (pardon the pun) missing from the overall aesthetics of the scene. Initially the scene could do with some motion; okay there's some camera motion added to the Taken Further 3ds Max scene I've included; this was set up by assigning nested Noise controllers within the Camera's Rotation controller to give it occasional judder and roll to simulate a Helicopter mount. I've also enabled Motion Blur to give it a nicer feel.

When it comes to rendering, as we're using Final Gathering (enabled by default as soon as we switch over to Mental Ray), we may notice occasional flicker in the resulting sequence. This is because Final Gathering is being sampled at every frame, and obviously as scene cameras change, the calculation is slightly different. Therefore, it's worthwhile baking out a single frame of Final

Gathering and locking the Read Only (FG Freeze) option in the Final Gather Map section of the Indirect Illumination render tab. This will then force the system to only call on the one Final Gather frame, resulting in no flickers. Again, the Taken Further 3ds Max scene has this included and its corresponding Final Gather Map is also included.

You can add considerably more detail to the terrain by utilizing the maps that are used to displace the terrain within the Bump map of the assigned material. Additionally, you can add further detail by upping the Density multiplier value in the base of the Plane primitive, but bear in mind that this will have a knock-on effect of the Relax values – you'll have to increase these to get a similar relaxed result. To put this new detail to good effect, try adding additional displacements controlled by mixed maps or selections to add finer detail into the terrain.

If you're going to do this, it might be worthwhile cranking up the quality a bit as all the Final Gather calculations will already have been done; so after one single frame of calculation (prior to rendering), you'll have a nice and clean rendering at the end.

However, you could adapt on the scene further by adding additional cloud and snow dust scattered across the terrain, specifically turbulent particles flowing across the geometry and being displaced by the peaks of the mesh.

This can be applied by a basic particle system using the geometry itself as an emitter; use selected vertices or faces at the peaks of the (low polygon version) terrain, and use Wind Space Warps to push these particles off the surface, akin to sea spray.

Coupling this with an additional system tied into this can create swirling particles over the base of the terrain, and you'll end up with quite a nice result.

You may also want to tweak the materials somewhat; even though we're dealing with a two-step material depending on topography, check the reference material and you'll see that the surface textures are more complex than what we've assigned. Try sculpting pieces of the geometry to create finer detail such as icicles on the drifts and more flatter terrain in the areas between drifts.

Finally add a cloud or two in the sky – consult the Cloud video tutorial in the online book's assets to see how to create one using procedural materials and try this with the Mental Ray sky system we've set up here. It's not a difficult procedure, so you shouldn't have much trouble with it!

12 Mars

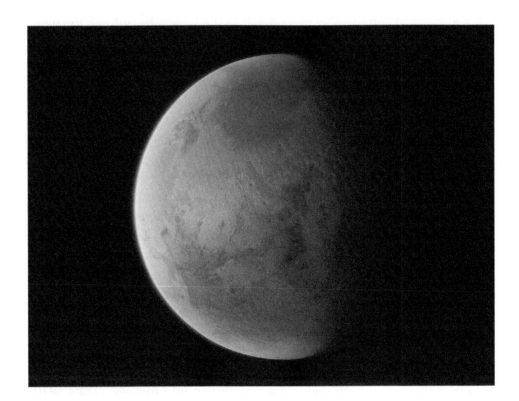

Introduction

In this tutorial we'll attempt to create a planetary surface. Normally with planets, the general tendency is to simply source a diffuse map, wrap it around a sphere, add a bit of falloff, and finally render. Unfortunately, the results aren't brill. Firstly the falloff; a fair number of people just apply it to the entire model, so even the dark side of the planet is mistakenly illuminated! Secondly the atmosphere; getting a decent density, size, and color is a difficult task, which is something we'll tackle in this tutorial. There's also the case of air desaturation. And last but no means least, NO BUMP MAPS!! Or stars . . .

Analysis of effect

(a) The first thing we see in any reference photos of planets taken by the Hubble Space Telescope or any probes visiting these planets is that there are no stars. This is due to the exposure of the camera, which is one thing that makes a photorealistic image different from something that appears fake. Okay, obviously you could see stars with the naked eye due to that your eyes dynamically adjust for light levels, but in photos you can't see anything. You don't need to worry about creating them (if you really want some in your scene, see the "Taking it further" section). (b) The next thing to note is the size of the atmosphere – it's exceptionally thin and, depending on what reference you obtain, is colored either orange or blue akin to the Earth, but not as dense. I'd the fortune a few years ago to have a conversation about Mars' atmosphere coloration and density with Sir Patrick Moore (a famous astronomer and presenter in the UK), who mentioned that the color should aesthetically be the same as images taken from the surface and is almost an orange hue. (c) There's also a slight desaturation of color on the perpendicular due to air density; take a look outside and into the distance. Notice how the colors become desaturated. Same deal here, but on a planetary scale. The planet surface material itself is quite uniform in shade as we don't have to negotiate varying specularities from oceans, only landmasses. There's a very slight subtle hint of specularity from the rocks, but this is more aesthetic than anything else and could be reduced or removed if desired. (d) The main crux lies in the surface texture detail of craters, volcanoes, etc. Even though these are considerably higher than those on the Earth, any discernable height is virtually negligible from a distance, particularly from Hubble images which have been shot with a very (VERY!) long lens that flattens out the image and removes any sense of perspective.

Image courtesy NASA/
Space Science Institute

Image courtesy NASA/
ESA/Hubble Heritage Team

Image courtesy NASA/
ESA/Hubble Heritage Team

Image courtesy NASA/
Space Science Institute

Within 3ds Max the main object will be a basic Geosphere primitive; however, we'll convert this to a NURBS surface primarily due to surface adaptation depending on distance to camera (so if you render off a close view you won't be able to see any linear edges). The main surface material will be designed with mental ray's Arch and Design material simply because it gives the best result for this type of surface; you can easily produce the same kind of effect with a Standard material (in fact, I'd advise using one for any other planets, particularly the Earth); however, this material works nicely for the type of surface we need and gives us enough parameters to play with to achieve good result. The maps themselves have been sourced already from NASA; however, we need to produce a Normal map from the height/displacement/bump map derived from laser scanning information taken from NASA probes. This is a simple procedure in Photoshop, but requires the installation of a Photoshop plugin from NVIDIA. However, you can always produce your own Normal maps with Render To Texture in 3ds Max, though this may not yield as good a result as the NVIDIA plugin. Once the Normal map has been derived, it'll be used in our material as a Bump map to produce a nicer surface texture than a standard grayscale Bump map. The atmosphere effect will be produced with a couple of attenuated Omni lights with volumetrics applied and offset slightly from the center of the planet model so that they point towards the Sun – a Direct light with a Gradient Ramp map can be applied as a Projector map to create a nice reddening around the areas of sunrise and sunset. The Diffuse map from NASA will be blended with a desaturated version of itself (courtesy of a Color Correction map) within a Falloff map to simulate color desaturation due to air density.

NOTE: Please read the copyright information included in the text file within the Source folder regarding the use of texture maps.

Walkthrough

PART ONE: Loading the start scene file and setting up the lighting.

1 Open the *12_Mars_Start.max* file included with this tutorial and accept any unit change if prompted. Select the Geosphere01 primitive in the scene and rename it Mars. Right-click the object, and choose Convert To: Convert to NURBS. In the Modifier tab and in its Surface Approximation rollout, choose Renderer and click on the High button in the Tessellation Presets group. Enable View-Dependent in the Tessellation Method group and click on the Advanced Parameters button. In the resulting dialog, set the Maximum Subdivisions Levels to 5. Click OK to confirm and close the dialog.

Information: We're using a base start scene, and accepting any file unit change ensures that we're all dealing with the same unit values later on. Here we've a simple Geosphere primitive of radius 100 units in the scene positioned at the origin. We're converting the object to NURBS to enable surface approximation at render time so that we don't see any linear geometry edges even if we get very close to the surface! We've increased the amount of Maximum Subdivision Levels to refine the geometry further at render time (you could forego this and amend the Edge, Distance, and Angle settings in the Tessellation Method group instead).

2 In the Top Viewport, create a Dummy object and label it Dummy_ Sun_Rotation_Pivot. Relocate this object to the origin (XYZ coordinates 0, 0, 0) as illustrated. In the Left Viewport, create a Free Direct light and relocate it to XYZ −2000,0,0 (i.e., minus 2000) so that it's positioned 2000 units to the left of the Dummy object in the scene as illustrated.

Information: This Dummy object will be used to orient the Sunlight (the Direct light) around the planet, should you decide to animate a sunrise or sunset. The reason behind this is the way the atmosphere volumetrics are set up later on. More on this later!

3 Label the light FDirect_Sun. Expand the Directional Parameters rollout and set the Hotspot/Beam value to 100, which will automatically set the Falloff/Field value to 102 (unless you've different values set up in your software configuration; if so, enter this value manually). Expand the Advanced Effects rollout and set the Contrast value to 50.

Information: The Direct light only encompasses the planet; so if you decide to add other objects such as satellites/ probes/little green men, etc., then you'll need to exclude all other geometry from this light and set up an additional light to illuminate other objects. The reason for this is that we can add a projector map in the Direct light to simulate reddening in the sunrise/sunset areas of the planet's illumination. We've added a touch more Contrast to increase definition around the area where light and shade meet.

4 Go to the Material Editor and add a Gradient Ramp map to a free sample slot. Label the map Sun Color and set the flags at positions 0 and 50 to white. Relocate the flag at position 50 to position 90 and set the flag at position 100 to RGB 170,107,73. Set the Gradient Type to Radial and instance this map into the Projector map slot in the Direct_Sun light's Advanced Effects rollout. Link the light to the Dummy object in the scene.

Information: Here we're creating the reddening effect around the sunrise/ sunset (falloff) areas of the planet as the Falloff value is constrained to that of the radius of the planet geometry; therefore, there will be little spillover and the resulting Gradient Ramp map will be fully used. By linking the light to the Dummy, as mentioned earlier, we can orient the light around the planet while still maintaining the reddening effect.

PART TWO: With the lighting set up, we'll now generate the Normal map in Photoshop. If you don't wish to install or use the Photoshop plugin, please skip over to Part Three with the Normal Map provided with this tutorial.

5 Open your favorite web browser and navigate to http://developer. nvidia.com/object/photoshop_dds_ plugins.html. Download the software and install it*. Open Photoshop and load *mars_height.jpg* included with this tutorial. Navigate to the Filter

*Pete Draper and Taylor & Francis can't be held responsible for any disruption to your machine or work that may arise from installing any third-party software.

menu and select NVIDIA Tools: Normal Map Filter. In the resulting panel, use the default settings and simply click OK to confirm and close the panel. The Normal map will be produced in a moment. Save the resulting image as *mars_normal.jpg*.

Information: Sorry for the disclaimer! Just have to play safe with these third-party applications you know! This specific tool simply takes the grayscale information of the bitmap and derives a Normal map from its luminance (grayscale) values. This map will then be used back in 3ds Max to drive the Bump map, which will yield a nicer result than the original height map itself. You can produce your own Normal maps with Render To Texture, should you wish so by using the height map in a material assigned to a Plane primitive, and then baking it out!

PART THREE: Loading the texture maps and setting up the material.

6 Back in 3ds Max, open the Render Setup dialog and change the renderer to mental ray Renderer. In the Material Editor, create a new Arch and Design (mi) material and label it Mars. In the Main material parameters rollout, add a Falloff map to its Color map slot in the Diffuse group. Label this map Atmosphere Desat Falloff and design the Mix Curve as illustrated.

Information: We're using the mental ray Renderer whose Arch and Design (mi) material gives us access to advanced shader design and is handy for the subtle falloff shading we need for this type of material. The Falloff map has been introduced to blend between the standard Diffuse Bitmap map we'll load next and its (partially) desaturated derivative on the perpendicular. We've tweaked the Mix curve so that the blending between these two maps is stronger at the perpendicular and then face-on to camera.

7 Add a Bitmap map to the Front slot, load the *mars_diffuse.jpg* map, and label the map Mars Diffuse. Set the Blur value to 0.1 in its Coordinates rollout. In the Atmosphere Desat Falloff map, add a Color Correction map to its Side slot and label it Atmosphere Desat. Instance the Mars Diffuse map to the Map slot in the Color Correction map and set the Saturation value to −50 in the Color rollout.

Information: The aforementioned Bitmap map was sourced from NASA and color corrected to match the shading in the reference material included with this tutorial (a simple case of increasing saturation, adding a touch more blue and green to the shadows, and upping the reds in the midtones). We've dropped the Blur value to 0.1 so that the resulting texture once rendered is sharper than normal. The Color Correction map simply desaturates the instanced Bitmap map (instanced to save memory) by 50%; the two are then blended together in the Falloff map.

8 Back at the top level of the material and in the Reflection group, set the Reflectivity value to 0.5 and Glossiness to 0.25. Enable Highlights+FG only. Expand the BRDF rollout and set the 0 deg. refl to 0.225, 90 deg. refl to 0.7, and Curve shape to 3.75.

Information: Although we've some Reflectivity values, we've restricted it so that these "reflections" are only applied to the material's highlight and final gather controls. Even if this is going to be applied to the one piece of

geometry in the scene, the material still reflects the volumetric light we'll be adding shortly, so enabling this feature is necessary. The BRDF (bidirectional reflectance distribution function) settings are designed to tweak the design of the resulting reflection (and therefore specular highlight), creating a nicer falloff (curve) and restricting the 90 deg and 0 deg values (perpendicular/parallel strength).

9 In the Special Purpose Maps rollout, set the Bump value to 0.2 and add a Normal Bump map to its Bump map slot. Label this map Mars Bump and add a Bitmap map to its Normal map slot. Load the *mars_normal.jpg* we've created (or the one included with the tutorial) and label the map Mars Normal. Set the Blur value to 0.1.

Information: Here we're loading the custom Normal map we just created; however, it needs to be contained within an additional map which tells 3ds Max that the map we're using is designed as such and isn't just a standard texture map. We've dropped the Blur value to 0.1 (as before) so that the resulting texture once rendered is sharper than normal.

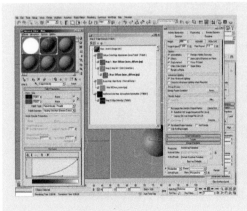

10 Back in the top level of the material, add a Falloff map to the Additional Color map slot in the Special Purpose Maps rollout and label the map Atmosphere Illumination. Set the Falloff Type to Shadow/Light. Add another Falloff map to the Lit map slot and label it Edge Intensity. Set the Side color to RGB 100,65,37

and design the Mix Curve as illustrated. Assign this material to the Mars object in the scene.

Information: This particular map is similar to Self-Illumination in a Standard material, although it breaks the physically correct aspects of the material's design. This doesn't matter to us in this particular scene as all we need to use it for is a subtle falloff around the lit area of the planet to enhance the illuminated side. This (the nested Falloff map) is masked off by another Falloff map (shadow/light) so that the edge effect is only visible in the illuminated side.

PART FOUR: Setting up the final atmospheric effects.

11 In the Top Viewport, create an Omni light and label it Omni_Atmos_Inner. Relocate the light to XYZ coordinates −4,0,0 so that it's 4 units to the left of the origin of the scene. Link this light to the Dummy object in the scene. Turn off the light's Shadows (if not off already) and set the Multiplier value to 5 with an RGB value of 222,157,110. In the Decay group, set the Type to Inverse Square and the Start value to 96. In the Far Attenuation group, enable Use and Show and set the Start value to 96 and the End value to 98.

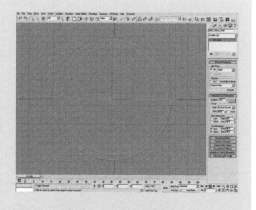

Information: Here we've created and positioned light with very tight attenuation and decay so that it just peeks over the side of the planet. This light is offset from the center of the planet so that at render time its (visible) strength grows the further it gets to the horizontal plane directly aligned with the Direct light in the scene (currently Z = 0). If it wasn't offset, then the volumetric effect would be visible all around the planet in the resulting render, even on the night side. The color was derived from point sampling the sky in the reference material images.

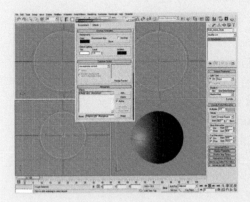

12 Copy this light (don't instance) and label the copy Omni_ Atmos_Outer. Set its Multiplier value to 2 and Start value in the Decay group to 94. In the Far Attenuation group, set the Start value to 94 and the End value to 102. Open the Environment and Effects panel and add a Volume Light Atmospheric Effect. Rename the effect to Volume Light-Atmosphere.

Information: Here we've copied the light and tweaked its settings to produce a slightly larger (yet of reduced intensity) light that dithers the volumetric effect out into space.

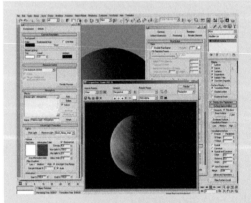

13 In the Volume Light Parameters rollout, click on the Pick Light button and add both Omni_Atmos lights to the effect (click on the Select By Name tool if you've a problem accurately selecting these lights in the Viewport). Enable Exponential and set the Max Light value to 100. Finally open the Render Setup panel, navigate to the indirect Illumination tab, and turn off Final Gather. Render off the scene.

Information: The final step sees the inclusion of two Omni lights within the Volume Light. We're using Exponential so that the light fades away correctly due to distance and interaction with the Mars geometry in the scene. We've increased the Max Light value to 100 to ensure there isn't any clipping of light at the (default) value of 90. We've turned off Final Gather to prevent Volumetric lights from being reflected in the assigned material; the Highlights & FG option in the material restricts reflections in the material, but as we only need the highlights we've to disable Final Gather.

Taking it further

There are a couple of things that make the end result look pretty convincing – firstly the surface material, thanks to the Arch and Design material we've designed, and secondly the atmosphere design. However, depending on what reference material you're looking at, Mars occasionally appears to have a bit of blue hue to its atmosphere akin to Earth images (though not as dense or as large). Therefore, you can tweak the color of atmosphere volumetrics to give it this shade. As mentioned before, I've also included the original Bump map obtained from NASA data from which we derived the Normal map. Try doing a low orbit shot and use this map to generate terrain displacement within the mental ray material instead of using the Normal map. Again, keep it subtle so as not to give an impression that the mountains/volcanoes, etc., are thousands of miles high! If you really want to break from the photoreal and into a bit more artistic licensing territory, try adding some stars, but again keep it subtle. A far while ago, I wrote a tutorial and hosted on my website to produce just that, plus some nice little dust clouds to break up the effect. Again, keep things simple and at low intensity; bear in mind that if you tried taking a picture of the sky, you won't see any stars in the resulting image unless you do a long exposure (in which case your planet would be over-exposed).

Oh yeah, and don't blow the planet up … I think the Internet is full of it already (though you can always smash the Asteroid from the original book into it if you feel like it …)!

Finally try applying the same techniques on your own planet designs or other reference material out there. NASA has a huge repository of texture maps and altitude laser scan data that can produce really nice and clean Displacement/Normal/Bump (eugh) maps for you to use, but make sure the maps line up exactly; the 4K maps I've provided had to be offset. If you don't want to do any further work on producing maps, there's a fair amount of it at http://planetpixelemporium.com/planets.html which includes numerous high-resolution maps and a good Mars map source with retouched crater illumination. Worth a visit.

Air

In this section we'll cover a wide range of effects, from different sized bubbles rising through a liquid to a full Galaxy system! Even though some of the tutorials in this section aren't necessarily 100% air-related, they do possess some similar characteristics and/or air effects in their physical appearance or motion, so therefore are entirely relevant.

13 Bubble stream

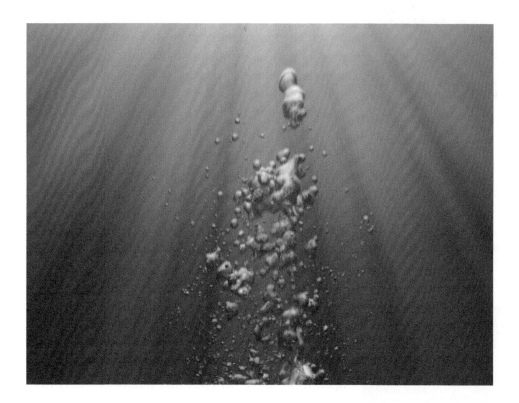

Introduction

In this tutorial we're going to create a stream of rising bubbles from beneath the camera. Not overly complex, you may initially think; however, to get the effect right, we're going to use material-based emissions and a bit of scripting to ensure that the velocities and forces exerted on the particles behave correctly based on their size. Coupled with this, we need to surface the bubble particles and finally shade them correctly, which involves a bit of mathematics to determine the correct Index of Refraction for the assigned material.

Analysis of effect

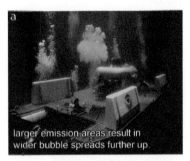

larger emission areas result in
wider bubble spreads further up.

Image courtesy NOAA

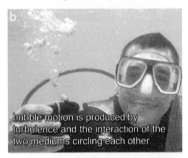

bubble motion is produced by
turbulence and the interaction of the
two mediums circling each other.

Image courtesy Ash Hall.
Mugshot also courtesy Ash Hall

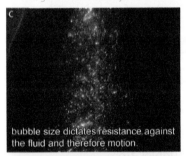

bubble size dictates resistance against
the fluid and therefore motion.

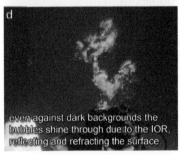

even against dark backgrounds the
bubbles shine through due to the IOR,
reflecting and refracting the surface.

Image courtesy NOAA

(a) Just by a quick glance at the bubble, you can guess the environment the footage was shot in. This isn't due to the fact that you see fishes or divers in it, but the way the bubbles move and interact with each other; even if the footage were to be shot against white, you would still be able to guess. (b) Things we really need to concentrate here are the size of the emission point, the motion of the bubbles in relation to each other, and the way air refracts the surrounding material (water). Air tends to fight against water, which not only deforms its surface as it travels (see the "Taking it further" section for more information on this) but also causes internal turbulence making the bubbles attract each other. This in turn causes the unique "dancing" motion as bubbles circle each other and collide to form larger bubbles. The size of the bubble has a direct effect on its speed. (c) Smaller bubbles don't tend to travel as fast as larger ones due to resistance; however, there's a bit of cut-off threshold: extremely larger bubbles find a large amount of resistance, so the medium-sized ones often overtake the smaller and larger ones. This isn't necessarily covered in this tutorial, but will be touched upon in the next. (d) The other unique property here is the way the bubbles are shaded which, again, is one among the factors that needs to be emulated exactly, else the end result won't look convincing. The surface of the bubble material acts akin to that of the sea surface when viewed from underwater – the depth is reflected on the underside, yet the surface is visible through the material and distorted by the medium.

The main trick here is to get the material look right; once this is established, the rest of the system is simply a matter of motion simulation. To achieve the correct appearance of bubbles, we're going to resolve to a bit of mathematics; however, it's quite simple

and doesn't require excessive material setup like the Underwater tutorial in the supplementary book. The way a transparent object is made to appear is largely dependent on two things: the material it's made up of, and the material in which we're viewing the object; as the 3ds Max manual states: "In the physical world, the IOR results from the relative speeds of light through the transparent material and the medium the eye or the camera is in. Typically this is related to the object's density; the higher the IOR, the denser the object." In this case, we're viewing air from within a water environment. Typically, IOR (Index of Refraction) values are based on the fact that we're viewing the object in air (IOR value of 1.0003). Obviously, in this circumstance, it's the other way around. Therefore, we need to work out the resulting IOR value of the bubble, and it isn't 1.0003. Typically, the correct way to work this out is to divide the medium we're viewing by the medium we're in; so therefore the correct value should be: 1.0003 (air)/1.33 (water) = 0.7521, which is the value we should dial into our IOR setting. For more information on this, search for IOR Interface in the 3ds Max Help file. The motion of the bubbles can be easily simulated with Particle Flow, though the way to getting the simulation look right is to design the system in a way that emission isn't uniform. This is achieved by using a material to emit the particles, and a Noise controller to generate the Birth Rate. This emitter material also derives particle scale by using the same emitter object to set particle speed, which is then used within a Script operator to convert this speed value to a scale value, resulting in the emitter material's white areas having larger particles than in grey/black areas! Because of the assigned transparent material, we don't want these bubbles to intersect. This also helps us with their motion, spinning around each other, and congregating with some distance tolerance. To achieve this, we can use Keep Apart operators within Particle Flow, and run a test check to see if the particles are beneath a certain size; if so, then they'll be simple particle shapes, otherwise they're surfaced geometry with Blobmesh. The particles themselves, as seen in the reference material, are influenced by their own sizes; smaller bubbles take longer to rise than bigger ones (to an extent), so this needs to be simulated by another simple script which calls on the particle's scale value to determine Force operator strength. To top off the scene, we'll add in the "God Rays" driven by an animated Noise map which is piped into an existing light in the scene before setting up the background and final rendering. Okay, enough of rambling, let's get on with it ...!

Walkthrough

Loading the start scene and setting up the Force Space Warps to be exerted on the bubble particles.

1 Open up the *13_Bubbles_Stream_Start.max* file that accompanies this tutorial and accept any unit change that may pop up. In the Top Viewport, create a Gravity Space Warp and rotate it 180 degrees so that it's pointing upwards instead of downwards. Create a Wind Space Warp in the Top Viewport and set the Strength value to 0.1. In its Wind group, set the Turbulence value to 1 with a Frequency of 5 and Scale of 0.03. Add a Drag Space Warp to the Top Viewport as well. Set its Time Off to 1000.

Information: Make sure you accept the unit change dialog panel that pops up to ensure that we're all working with the same unit values. We're going to deal with procedural maps; so if you're using a different unit setup, then your results may differ from those in the tutorial and cause problems further down the line. The Gravity Space Warp is introduced to pull the particles upwards to the "surface"; this will be controlled by a Script Operator later on; so to add some additional velocity and overall turbulence, the Wind Space Warp is introduced to the scene. However, to control all these Space Warps, an additional Drag is included to dampen their effect. We've set the Drag Space Warp's Time Off value to a high number, just in case you should decide to extend the duration of the sequence!

2 Still in the Top Viewport, create a Sphere primitive and label it Small_Bubble_Reference. Set the Radius to 1.0 cm and the Segments to 16. Add an XForm modifier to this object. Navigate to its Gizmo sub-object level and turn on the Percent Snap Toggle on the main toolbar. In the Front Viewport, vertically scale down the Gizmo along the Y-axis in this Viewport to 60%.

Information: This object is going to be used in the particle system instead of just a standard Shape operator as it yields more detail should you render the scene off with a large canvas; you can simply increase the amount of Segments in the Sphere, and the particle system will update dynamically. The XForm modifier has been added so that it only deforms the geometry, not the actual transformation of the object itself, and therefore it doesn't affect the overall scale value of the object (and therefore the particle) which may have adverse effects later on as the motion of the particles is derived from scale.

PART TWO: With the Space Warps set up, we'll construct the method for setting the particle scale values and their emission points in the Material Editor before setting up the main Bubble material.

3 Open the Material Editor and label a new material Bubble Stream Emitter. Add a Gradient Ramp map to the Diffuse slot of this material and label it Bubble Emitter Map. Turn off Use Real-World Scale in the map's Coordinates rollout if not already turned off. Set the Gradient Type to Radial. Remove the flag at

position 50 and set the flag at position 0 to white and the one at position 100 to black.

Information: We're using a Gradient Ramp map to emit the particles, simulating a large open emitter shape (e.g., sea bed surface, gas jet, broken pipe, etc.). This map will in turn drive the distribution and scale of the particles and therefore their motion later on.

Add flags to positions 23 (RGB 140,140,140), 42 (RGB 77,77,77), and 75 (black). In the map's Noise group, set the Noise Amount to 1 with a Size of 6. Set the Noise Type to Fractal with 3 Levels. Assign this material to the Plane01 object in the scene. Select the Plane01 object and rename it Bubble_Stream_Emitter.

Information: Here we're simply adding additional noise detail to the radial gradient to break up its uniformity, and therefore break up the particle distribution, scale, and motion.

Open up the Render Setup panel and expand the Assign Renderer rollout in the Common tab. Change the renderer for both Production and Material Editor to mental ray Renderer. Close the panel and navigate back to the Material Editor. In a new sample slot, create a new Glass (physics_phen) material and label it Bubble.

Information: By default, the scene's renderer is set to Scanline; so to use advanced mental ray materials, we've to change the renderer over to mental ray to gain access to them. The Glass (physics_phen) material does exactly what we expected, yet we need to change a few properties first.

6 Set the Light Persistence value to white by setting its RGB values to 1,1,1 (mental ray settings, not standard 0–255 values). Set the IOR value to 0.752 (we lose the last 0.0001 value due to the text entry box clipping that value).

Information: By default, the Light Persistence value has a slightly-off white color which can get quite intense depending on the thickness of the object. Setting the color to white ensures air in our bubbles is clear! The IOR value is the result of the calculation we made in the "Analysis" section earlier – IOR of air/IOR of water.

7 Create a new Noise map in a free sample slot and label it God Rays. In the Coordinates rollout, set the Source to Explicit Map Channel. Set the Noise Type to Turbulence. Set the Size to 0.1, High value to 0.75, and Low to 0.1. Set the Default Tangent For In/Out Keys to Linear (located next to the Key Filters button at the bottom of the 3ds Max interface), go to frame

200, turn on Auto Key, and set the Phase value to 2. Turn off Auto Key and go back to frame 0. Instance this map into the Projector map slot in the Fspot01 light's Advanced Effects group.

Information: This may drive the color, appearance, and motion of the light rays (often called God Rays) emanating from the water surface. They have been included simply for the bubbles to reflect and refract, adding realism to the scene. If they weren't present, then the overall resulting scene should look a little dull. NOTE: It's extremely important to make sure you return to frame 0 after setting the keyframes. This is because you aren't designing the particle system mid-sequence, which will take a while to update and/or may cause 3ds Max to hang. We're using a linear keyframe type so that the motion of the rays starts and stops linearly, else we may have a ramp-up or ramp-down in the motion, which would be unrealistic!

PART THREE: We'll next set up the main particle system that drives the bubble motion.

8 Select the PF Source 01 icon in the scene, and in the Modifier tab in the Command bar, click on Particle View. In Particle View, add a Material Static operator to the PF Source 01 root event and instance the Bubble material to its material slot in Particle View. Drag out a Birth operator to the Particle View event display to create a new event, wire the output of the PF Source 01 event to the input of this new event, and label the event Bubble Birth. Set the Emit Stop value to 200 and enable Rate. Ensure you've got the PF Source 01 icon selected in the scene, right-click the Rate's field value in the Birth operator, and select Show In Track View.

Information: Applying the material at this stage ensures application to the entire particle system. We're using Rate as the birth amount method so that we can vary particle amounts per frame. To do this, we're going to use a procedural controller that we'll set up next. Selecting the object in the scene followed by navigating to Track View ensures we've a focus on the object we want to amend; so Track View should jump right to the relevant controller. If not, you'll have to navigate through Track View itself and expand the PF Source 01 icon and navigate through to the correct controller; you should have no problem finding it as it's laid out intuitively.

9 In the resulting "Selected" Track View, select the Rate controller, right-click and choose Assign Controller. In the dialog panel that pops up, choose Float List. In this new List controller, add a Bezier Float controller to the new Available controller as illustrated. This will result in a new Available controller being generated underneath the Bezier Float controller.

Information: Often you'd normally add the Noise controller directly within the main controller; however, I'd advise against this as it limits your overall control. That is to say that, if you tried to add any value offset to the Noise you've had a bit of trouble. Therefore, adding a Bezier Float in the List controller allows you to set a default value by adding a keyframe into the Bezier Float controller, and then tweaking the Noise controller to suit. It's simply a case of "future proofing" the scene should you want to amend things later on. This type of procedure is handy in all circumstances, from particles through to noise from handheld camera as you can animate the mixing of the controllers independently! Okay, I'll get off my soapbox now ... on with the tutorial ...!

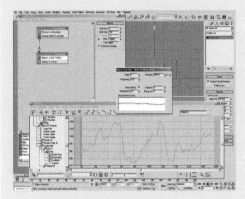

10 Add a Noise Float to the new Available controller. The Noise controller will immediately pop up. Set its Frequency value to 0.02 and Strength value to 2000. Enable the check box next to the Strength field to force the noise wave to be greater than 0.

Information: The Noise controller drives the particle emission value. The check box next to the Strength text field has been enabled, else the resulting waveform will dip below zero, resulting in no particles being born over this period.

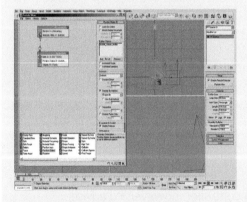

11 Back in Particle View, add a Position Object operator to the event and add the Bubble_Stream_Emitter from the scene to its Emitter Objects List. Enable Density By Material, and in the If Location Is Invalid group, enable Delete Particles.

Information: The Position Object operator scatters particles across the Bubble_Stream_Emitter object based on its assigned material, thanks to the enabled Density By Material option. If the system has issues determining the positions, it normally drops the particles at a random position on the emitter geometry. We don't want this, so enable the Delete Particles option.

12 Add a Shape operator to the event and set its Shape setting to Sphere. Add a Speed By Surface operator and set the Speed value to 10 cm. Add the Bubble_Stream_ Emitter object from the scene to its Surface Geometry list. Enable Speed By Material.

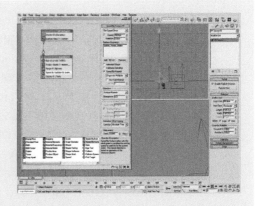

Information: The Shape operator is required to set the particle size that the rest of the system can derive the motion from, though it'll never be seen in the final render. The Size value isn't changed as it's already the same size as the Sphere in the scene. This is because it'll be replaced later on in the Small Bubbles event while the Large Bubbles event having Renderable turned off as this event will be handled by a Blobmesh Compound Object. The Speed By Surface operator is used simply to (momentarily) drive particle motion based on the material assigned to the Bubble_Stream_Emitter object.

13 Add a Script operator to the event and click on its Edit Script button. In the resulting Script Operator panel, select all the text and delete it. NOTE: Ensure you remove all text first as loading the new script simply merges it with the existing one. Click on the File menu and select Open. Load the *13_Bubble_Stream_Scale.ms* script into this operator. Add a Send Out test

to the event and change the Display operator's Type to Geometry to see the Script operator in action.

Information: We've removed the existing default script from the Script operator as loading a new script merges it with the existing one. The script we're loading is quite basic, yet it's little too long to type in, in the confines of this book anyway. However, all what the script does is perform a loop through the particles in the system (count) and run the equation that the scale of the particle is equal to the speed of the particle, multiplied by 200 – a derived value to get particles to a decent size. This value could be reduced (or increased) by amending the Speed value in the Speed By Surface operator. And that's it. Very simple, but very effective. The Send Out test is added to output the newly scaled particles to the next event.

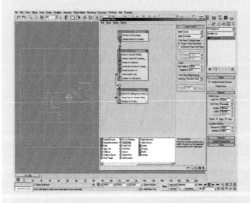

14 Add a Speed operator to the Particle View event display to create a new event and label this event Large Bubbles. Wire the input of this new event to the output of the Bubble Birth event. Set the Speed operator's Speed value to 0 cm. Add a Scale test to the event and enable Is Less Than Test Value in its Test True If Particle Value group.

Information: We killed the motion of the particles using the Speed operator as we wanted the Space Warps in the scene to handle this. The Scale test is added to check for particle scale values derived from the Script operator in the last event; those below the 100% scale threshold will be passed to the next event, which we'll introduce later on.

15 Add a Keep Apart operator to the event. Set its Force value to −10 cm and Accel Limit to 200 cm. Enable Relative to Particle Size and set the Core % to 100 and Falloff % to 150. Set the Scope to Current Particle System.

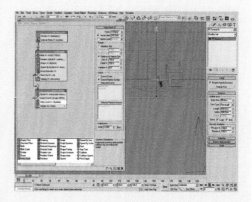

Information: A basic step, this helps drive the main turbulent motion of the particles. The Force value has a negative value, which does exactly the opposite of what the operator was originally designed for; instead of forcing the particles apart, it makes them attract each other. Because of their low Falloff % value and high Accel Limit, they circle each other, often interacting with groups and forming clusters.

16 Add a Script operator to the event and click on its Edit Script button. In the resulting Script Operator panel, select all the text and delete it. Click on the File menu and select Open. Load the *13_Bubble_Stream_Force.ms* script into this operator.

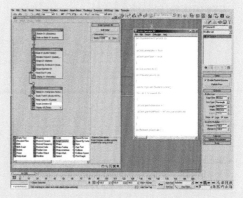

Information: Again, another basic script. This one also deals with the scale value of the particles; however, this time it sets the internal pCont.particleFloat value to the value of the scale of each particle (looped as before). This internal value will be referenced in the next operator via Script Wiring. If you'd like to know more about this script, consult the "Scripting Particle Flow" section in the MAXScript Help that comes with 3ds Max, and includes a complete breakdown of every single line of text.

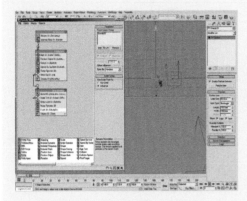

17 Add a Force operator to the event and add the Gravity01 Space Warp to its Force Space Warps list. Right-click the Force operator and select Use Script Wiring. A new Script Wiring rollout appears; enable Influence.

Information: By enabling these two features within the Force operator, we can utilize the pCont.particleFloat value set earlier in the Script operator to derive the influence of the Force operator on the particle. That is to say that the smaller the particle, the smaller the value set within pCont.particleFloat, and therefore the smaller the Influence value assigned to that particle.

18 Add a Force operator to the event and add the Wind01 Space Warp to its Force Space Warps list. Set the Influence % value to 750. Add another Force operator to the event and add the Drag01 Space Warp to its Force Space Warps List. Set its Influence % value to 350.

Information: The Wind Space Warp simply adds some additional turbulence to the entire system, simulating generic sea motion which will break up the effect somewhat. The Drag Space Warp is introduced to add some subtlety to the system so as to remove any harshness to the motion and to smooth it out a touch. Each Space Warp has been introduced within its own Force operator so that its Influence value can be tweaked independently.

19 Instance the entire Large Bubbles event to create a new event and label this new event Small Bubbles. Wire the input of this new event to the output of the Scale test in the Large Bubbles event. Remove the Speed operator and Scale Test from the Small Bubbles event and add a Shape Instance operator to the top of the event. Click on the button in the Particle Geometry Object group and choose the Small_Bubble_Reference object in the scene.

Turn off Scale% and Acquire Material in the Shape Instance operator. Select the Large Bubbles event, right-click and select Properties. In the resulting dialog panel, turn off Renderable and click OK to confirm and close. NOTE: Depending on your version of 3ds Max and your setup, you may need to enable By Object in this panel first.

Information: As the particle motion is derived from the particle scale, we can use the entire event again to drive the smaller particles without having to set any additional properties! However, we obviously need to remove the Speed operator as the speed has been killed in a previous event before the particles were split off into their different scale events, and the Scale Test was removed because we don't need to test for particle scale in this event. We've disabled the Scale %, else we'll reset the particle's Scale value back to 100, which we don't desire as it'd override the value set within the first Script operator. Acquire Material has been disabled purely for safety in case any material will be assigned to the referenced object later on (either intentionally or by accident) as we want the Bubble material to handle everything in the system. We've made the Large Bubbles event non-renderable as this will be handled by the Blobmesh object, which we'll create shortly.

20 Right-click the Play Animation icon, and in the resulting dialog turn off Real Time. Click OK to accept this. With the system now set up, it's time to run the simulation; however, ensure you saved the scene before you do this. Click the Play icon and watch the simulation run through.

Information: This step is purely for safety. If the particles suddenly stop being displayed or the system hangs for a while, there will be a problem with the Keep Apart operator, which causes one or both sets of particles to disappear at render time (the Viewport Integration Step settings are the same as those of the Render's, so whatever result you got in the Viewport you should get in the Render). If there's a problem in playing the simulation in the Viewport, return to frame 0 and set a new seed in the Position Object operator, and run the simulation again. If you're still having problems (it's due to the way Keep Apart works, and therefore a necessary evil), reduce the amount of particles in the Noise Controller we set up earlier.

PART FOUR: Finally we'll surface the relevant particles before setting up additional volumetrics and a touch of color correction before rendering.

21 With the simulation working, create a new Blobmesh object in the Top Viewport. Set its Evaluation Coarseness to 10 for Render and Viewport. Enable Off In Viewport (due to particle count and update times) and click on the Pick button. Choose the PF Source 01 icon in the scene.

Information: We don't need to see the geometry of Blobmesh in Viewport, though you can turn it on if you wish, but it'll slow down your system further you go. You may also want to increase the Relative Coarseness value for Viewport, but be aware that the Relax modifier we'll add in the next step can influence the lower polygon version more than the default value we've set in this tutorial, giving an incorrect representation of the result at render time. The Relative Coarseness value is set quite high as the main detail is being handled by the Small Bubbles event; however, in the accompanying tutorial (number 24 in this book), the Blobmesh object has a more refined Relative Coarseness value due to we needing all the particles surfaced and therefore retaining the details.

22 In the Blobmesh object's Particle Flow Parameters rollout, turn off All Particle Flow Events and click on the Add button. Highlight the PF Source 01 and then Large Bubbles option in the resulting dialog panel and click OK to accept. Next, add a Relax modifier to Blobmesh and set its Relax value to 1.

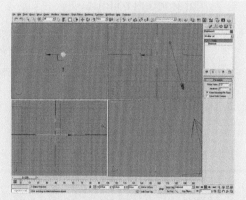

Information: Here we need the Large Bubbles event to be treated by the Blobmesh object, and so the All Particle Flow Events has been disabled and a specific event was called into Blobmesh. The Relax modifier is used to reduce the "blobby" feel of the default Blobmesh result and to smooth out the geometry.

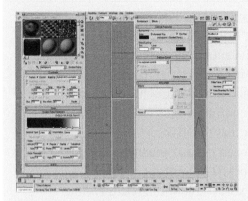

23 Assign the Bubble material to the Blobmesh01 object in the scene. Create a Gradient Ramp map in a free sample slot in the Material Editor. Label it Background. In the Coordinates rollout, enable Environ and set the Mapping to Cylindrical Environment. Set the W Angle value to 90 to rotate the gradient vertically. Set the flag at position 0 to RGB 0,8,15 and the one at position 50 to RGB 0,35,73. Add flags to positions 65 (RGB 0,55,117), 75 (RGB 10,103,155), and 87 (RGB 30,195,228). Open up the Environment and Effects panel and instance this map into the Environment Map slot in the Common Parameters rollout.

Information: This Gradient Ramp map is designed to simulate the underwater environment, giving the bubble geometry something to reflect and refract against. The RGB values in the gradient are simply derived from the source reference material.

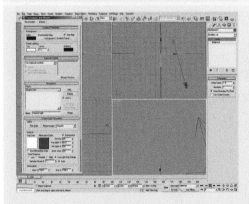

24 In the Atmosphere rollout, add a Volume Light Atmospheric Effect. In the resulting Volume Light Parameters rollout, click the Pick Light button and select the Fspot01 light in the scene. Enable Exponential and set the Density value to 0.5.

Information: The Volume Light effect generates the God Rays, which have been generated from the Noise map we set up earlier. We've dropped the Density

to a really low value so that the end result is subtle and not overpowering, akin to the reference material. Even though these volumetrics will be reflected and refracted in the bubble geometry, the main highlight is being driven via a combination of the Fspot and Omni lights in the scene; the Omni light is introduced to exaggerate the highlight. As the geometry in the scene is transparent, there are no surfaces in the scene that have their diffuse values brightened by additional lighting. Should you introduce such objects, then it'd be worthwhile to restrict this Omni light so as to illuminate only the bubble geometry by modifying its Exclude list, else the additional objects would become overly illuminated and/or their highlights blown out!

25 To add some contrast and detail, navigate to the Effects tab of the Environment and Effects panel. Add Brightness and Contrast effects and set Brightness to 0.45 and Contrast to 0.9. Add a Color Balance effect and set the Magenta/Green field to 15 and the Yellow/Blue field to −10. Enable Preserve Luminosity. Add a Film Grain effect and set its Grain to 0.3.

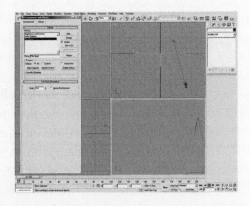

Information: Here we're simply adding some additional post-processing prior to rendering, such as increasing the contrast, a touch of color correction, and a bit of film grain to simulate photographic media. Normally this process is done in one's favorite compositor so as not to destroy the original render with post-processing; it has been introduced in this tutorial simply to give an indication of what tweaks we can do to enhance the scene, but I'd seriously suggest you add these effects in a compositor if only you've and/or know how to use one.

26 Open up the Render Setup panel and navigate to the Indirect Illumination tab. Turn off Enable Final Gather and render off the sequence. NOTE: You may need to change the Frame Buffer Type to Integer (16 bits per channel) from Floating-Point (32 bits per channel) depending on your 3ds Max version in order for these render effects to work correctly.

Information: We don't need Final Gathering enabled in this scene due to the type of material used. If you find that reflections and refractions aren't as detailed as you expect, try increasing the Maximum value in the Samples per Pixel group in the Render Setup panel's Renderer tab.

Taking it further

The end simulation does work well especially with the scripted forces affecting the particles, although it can take quite a long time to render. Unfortunately, this is due to the Blobmesh object in the scene which takes a fair amount of time to calculate particle surfacing, but is a necessary evil at this present time. To speed up render times, you may want to try restricting the particles that Blobmesh can use by tweaking the Scale test values so that more particles are sent to the next event where they aren't affected by Blobmesh. Also, you may want to have some particles being "blown off" the larger mass. This could be achieved by a simple Age test set to Event Age which pipes the particles to another event. This event could then randomly Spawn smaller particles which are then piped to the event that handles particles at less than 100% size, while the remaining larger particles are sent back to their original event using a Send Out test. Obviously you'd need to re-wire things a little; for example, you couldn't have the Speed operator there because as soon as they arrive back to the event they'd immediately stop! To solve this, extract this operator to another event so that the Speed operator kicks in before the particles arrive at the main event.

We're missing some additional details – this can be found in the next tutorial: Large Bubbles. Try incorporating this additional system into the present tutorial; to make life a touch easier, I purposely designed the tutorials with the same scene scale and similar values so that incorporating them shouldn't be too much of a task, though you'll need to ensure the systems interact with each other, specifically the particles in this stream should attempt to rejoin the larger bubbles in the other system akin to those in real life (much like the turbulent displacement effect).

Incorporating the existing Keep Apart operators will help here, but as stressed before, always ensure you performed the simulation to test the stability of the Keep Apart operators; the more you throw at them, the more they've a chance of falling over.

It may also be worthwhile to incorporate the Underwater tutorial in the supplementary book to this scene, which will yield a pretty cool result, especially if incorporated with volumetric "God Rays" emitted from the surface. Obviously you may need to tweak the settings such as material colors and/or scale to match the scene, but the end result will be worth it overall.

Additionally, try adding some particle debris to swim in front of the camera. This effect is pretty much essential to give the impression of camera motion should you decide to add any, else it may appear as if the bubbles are moving around erratically as there's nothing else in the scene (presently) apart from the volumetric rays to determine the position and/or orientation.

Finally, you may want to add some additional deformation to the geometry so as to simulate the deforming surfaces mentioned in the "Analysis" section. To achieve this, try using a Mesher Compound Object instead of rendering the particles themselves, and apply a Noise modifier to the geometry. This will cause the geometry to wiggle and deform as it travels up, giving the impression that the water is deforming the bubbles.

14 Large bubbles

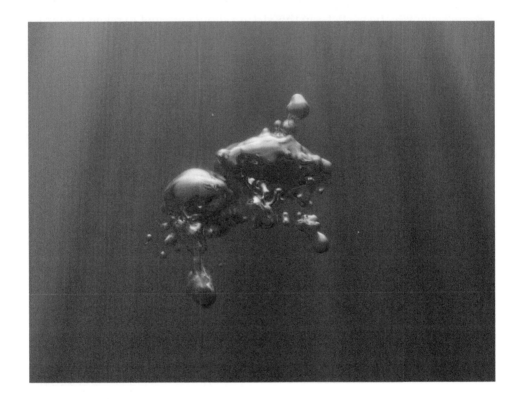

Introduction

In this tutorial we're going to create a couple of large bubbles rising up through an underwater environment from beneath the camera. For those who have just finished the Bubbles Stream tutorial, they'll notice some similarity in the "Analysis" and "Taking it further" sections; this is totally intentional as the two scenes could be merged together to create one big system and also utilize the same scene environment, albeit with few small changes such as light position. Saying that, the entire system is different; it gives a good example of how the scale of an effect has a direct influence on how the system is constructed.

Analysis of effect

(a) The unique formation of these types of bubbles takes on the sliced hemisphere effect as the bubbles interact with water, with water pushing out and flattening the bubble shape to result in a nice smooth surface at the top of the hemisphere and a noisy underside. (b) Due to the friction and motion of water, air often gets "torn off" the surface of this hemisphere, which is largely dependent on the size of the main bubble hemisphere and the rate of change of direction. This tearing process tends to occur mainly at the edges of the hemisphere bubble, and due to water displacement as the bubble rises, the torn-off bubbles get rapidly sucked back up towards the middle of the underside of the main bubble; their rising motion is actually faster than the motion of the original bubble! (c) Things we really need to concentrate on here are the motion of the bubbles in relation to each other and the way air refracts the surrounding material (water). Air fights against water, which not only sculpts its surface as it travels but also causes internal turbulence, making the bubbles attract each other. This in turn causes the unique "dancing" motion as bubbles circle each other and collide to form larger bubbles. (d) The other unique property here is the way the bubbles are shaded which, again, is one among the factors that needs to be emulated exactly, else the end result won't look convincing. The surface of the bubble material acts akin to that of the sea surface when viewed from underwater – the depth is reflected on the underside, yet the surface is visible through the material and distorted by the medium.

The main trick in this system is to ensure the rising large bubbles keep their unique hemisphere shape but emit particles based on external influence (motion and water turbulence). This obviously will be produced using Particle Flow; however, the system is

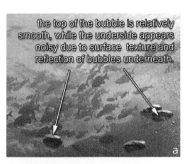

the top of the bubble is relatively smooth, while the underside appears noisy due to surface texture and reflection of bubbles underneath.

Image courtesy Leonard Tan

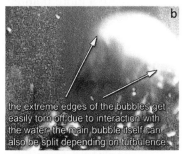

the extreme edges of the bubbles get easily torn off due to interaction with the water; the main bubble itself can also be split depending on turbulence.

Image courtesy Leonard Tan

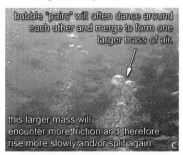

bubble "pairs" will often dance around each other and merge to form one larger mass of air.

this larger mass will encounter more friction and therefore rise more slowly and/or split again

Image courtesy Leonard Tan

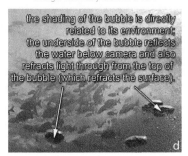

the shading of the bubble is directly related to its environment; the underside of the bubble reflects the water below camera and also refracts light through from the top of the bubble (which refracts the surface).

Image courtesy Leonard Tan

different from that in the previous tutorial. Because of the nature of this effect, we want a lot more interaction from the smaller bubbles with the larger rising bubbles, chasing and merging with them, thus affecting their shape. This can be produced with multiple Keep Apart operators: one set to attract the main mass of air as it rises through water and the other to attract the smaller "torn off" bubbles back to the main mass and to interact with each other, creating a more turbulent and chasing motion akin to the reference material. The main mass of air will be produced from a single particle, which spawns multiple particles as it travels. These particles will then be affected with random horizontal speeds to create the shape of the main air mass before being scaled down to create a more pointed edge and finer bubbles. These particles will be tested for direction change using a Speed test, checking to see if the change in motion/direction warrants them to be torn off the main mass of particles; if so then they're attracted to each other and the main air mass. There are also Space Warps affecting the entire system, adding to the turbulent motion of the particles and also deforming the shape of the main air mass. Additionally, we need to be sure of getting the material look right. To achieve the correct appearance of bubbles, we're going to resolve to a bit of mathematics; however, it's quite simple and doesn't require excessive material setup like the Underwater tutorial in the supplementary book. The way a transparent object is made to appear is largely dependent on two things: the material it's made up of, and the material in which we're viewing the object; as the 3ds Max manual states: "In the physical world, the IOR results from the relative speeds of light through the transparent material and the medium the eye or the camera is in. Typically this is related to the object's density; the higher the IOR, the denser the object." In this case, we're viewing air from within a water environment. Typically, IOR values are based on the fact that we're viewing the object in air (IOR value of 1.0003). Obviously, in this circumstance, it's the other way around. Therefore, we need to work out the resulting IOR value of the bubble, and it isn't 1.0003. Typically, the correct way to work this out is to divide the medium we're viewing by the medium we're in; therefore, the correct value should be: 1.0003 (air)/1.33 (water) = 0.7521, which is the value we should dial into our IOR setting. For more information on this, search for IOR Interface in the 3ds Max Help file. This time, unlike the previous tutorial, we're going to surface the entire system with a Blobmesh Compound Object. Unfortunately, this also means that render times will increase, but the effect will be worth it. Again, unlike the previous tutorial,

we aren't going to resort to scripting so as to affect the particles based on scale values; however, should you want to incorporate this, see the "Taking it further" section for more information.

Walkthrough

PART ONE: Loading the start scene and setting up the Force Space Warps to be exerted on the bubble particles, and changing the renderer to mental ray before setting up its properties.

1 Open the *14_Large_Bubbles_ Start.max* file that accompanies this tutorial and accept any unit change that may pop up. In the Top Viewport, create a Gravity Space Warp and rotate it 180 degrees so that it's pointing upwards instead of downwards. Create a Wind Space Warp in the Top Viewport and set the Strength value to 0.1. In its Wind group, set the Turbulence value to 1, Frequency to 5, and Scale to 0.03. Add a Drag Space Warp to the Top Viewport as well. Set its Time On to −100 and Time Off to 1000.

Information: Make sure you accept the unit change dialog panel to ensure we're all working with the same unit values. We're going to deal with procedural maps; so if you're using a different unit setup, then our results may differ and cause problems further down the line. The Gravity Space Warp is introduced to pull the particles upwards to the "surface"; this will be controlled by a Script Operator later on, so the Wind Space Warp is introduced to add some additional velocity and overall turbulence. However, to control all these Space Warps, an additional Drag is included to dampen their effect. We set the Time On value to −100 so as to get the particles already established by the time we join the scene at frame 0, so therefore we need the Space Warp

to work in frames leading up to frame 0. We've set the Time Off value to a high number, just in case we decide to extend the duration of the sequence! These Space Warps will play a large part in simulation later on, causing the particles to move and interact with each other, which may bring instability to the system; pay close attention to the "Information" section in step 18 for more information on this.

2 Open the Render Setup panel and expand the Assign Renderer rollout in the Common tab. Change the renderer of the Production and Material Editor to mental ray Renderer. Close the panel and navigate back to the Material Editor. In a new sample slot, create a new Glass (physics_phen) material and label it Bubble.

Information: By default, the scene's renderer is set to Scanline; in order to use the advanced mental ray materials, we've to change the renderer over to mental ray to gain access to the materials. The Glass (physics_phen) material does exactly what we expect, though we need to change a few properties first.

3 Set the Light Persistence value to white by setting its RGB value to 1,1,1 (mental ray setting, not standard 0–255 value). Set the IOR value to 0.752 (we lose the last 0.0001 value due to the text entry box clipping that value).

Information: By default, the Light Persistence value has a slightly-off white

color, which can get quite intense depending on the thickness of the object. Setting the color to white ensures air is clear in our bubbles! The IOR value is the result of the calculation we arrived at in the "Analysis" section earlier – IOR of air/IOR of water.

PART TWO: Next we'll set up the caustic God Rays projector map before setting up the particle system.

4 Create a new Noise map in a free sample slot and label it God Rays. In the Coordinates rollout, set Source to Explicit Map Channel. Set Noise Type to Turbulence. Set Size to 0.1, High value to 0.75, and Low to 0.1. Set Default Tangent For In/Out Keys to Linear (located next to the Key Filters button at the bottom of the 3ds Max interface), go to frame 200, turn on Auto Key, and set the Phase value to 2. Turn off Auto Key and go back to frame 0. Instance this map into the Projector map slot in the Fspot01 light.

Information: This may drive the color, appearance, and motion of the light rays (often called God Rays) emanating from the water surface. These have been included simply for the bubbles to reflect and refract, adding realism to the scene. If they weren't present, then the overall resulting scene may have looked a little dull. NOTE: It's extremely important to make sure you return to frame 0 after setting the keyframes. This is because you aren't designing a particle system mid-sequence, which will take a while to update and/or may cause 3ds Max to hang. We're using a linear keyframe type so that the motion of the rays starts and stops linearly, else we may have a ramp up or ramp down in motion, which would be unrealistic!

5 Select the PF Source 01 icon in the scene, and in the Modifier tab in the Command bar, click on Particle View. Turn off the System by clicking on the light bulb icon in the PF Source 01 event. Drag out a Birth operator to the Particle View event display to create a new event, wire the output of the PF Source 01 event to the input of this new event, and label the event Bubble Path Birth01. In the Birth operator, set the Emit Start and Emit Stop values to −20 and set Amount to 1.

Information: We've disabled the particle system straightaway as we'll be adding a Spawn test later on based on particle travel distance. As we're dealing with a negative frame value for particle birth, these spawned particles will spawn themselves and so on and so on, resulting in a system hang. Turning off the system at this stage is the safest. We only need a single main particle per bubble to be emitted (the other main bubble will be set up later on in another event as it will have some different properties). Note that we're using Phantom in the root Render operator as we don't need to see the particles at render time, but they need to be calculated by the renderer so that the Blobmesh that we'll add later on can derive the particle scale and position values from the system. We've set the Emit Start and Emit Stop values to −20 so that the particles (and therefore the bubble shape) are established before we join the scene at frame 0, else we'll see the system draw out the bubble shape, which we obviously don't want!

6 Add a Position Icon operator to the Bubble Path Birth01 event. Add a Shape operator to the event and set its Shape to Sphere. Set the Size value to 1.5 cm. Add a Scale operator to the event and set its Scale Variation to 25 for all three axes. Add a Force operator and add the Gravity Space Warp to its Force Space Warps list. Set this operator's Influence % value to 150.

Information: The Shape and Scale operators set the size of the particles which, in turn, will drive the Keep Apart operators we'll add later on. These values have a direct effect on their motion. The Gravity Space Warps force the particles to rise towards the surface.

7 Add another Force operator to the event and add the Wind01 Space Warp to its Force Space Warps list. Set this operator's Influence % value to 750. Add another Force operator to the event and add the Drag01 Space Warp to its Force Space Warps list. Set this operator's Influence % value to 1500.

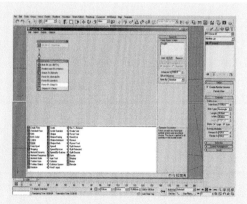

Information: The Space Warps have been added to the Force operators individually so that their default values can be amended independently. The Drag Space Warp adds a touch of damping to the overall effect of Gravity and Wind, and so the motion is more graceful as opposed to exaggeration.

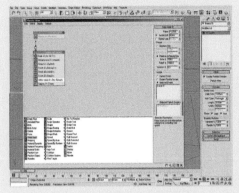

8 Add a Keep Apart operator to the event and set its Force value to −10 cm. Set Accel Limit to 2 cm. Choose Relative to Particle Size and set the Core % value to 100 and the Falloff % value to 1000. In the Scope group, choose Selected Events. We'll return to this operator later on to choose the desired events once they're created.

Information: This Keep Apart operator will force a single "drawing" particle to interact with the other drawing particle we'll add later on by duplicating this event. Obviously this event hasn't been created yet, so we can't fill in the rest of the information in the Keep Apart operator!

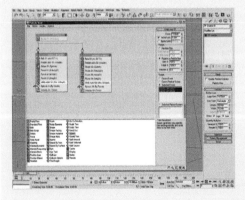

9 Add a Spawn test to the event and set it to By Travel Distance. Set Step Size to 0.05 cm and set the Offspring value to 3. Instance the entire Bubble Path Birth01 event and wire the input of this new event to the output of the PF Source 01 event. Make Birth, Position Icon, and Spawn unique. In the (instanced) Keep Apart operator's Scope group, highlight the Bubble Path Birth01 and Bubble Path Birth02 events in the Selected Events list.

Information: The Spawn test is the main reason why we turned the system off, else the spawned particles will themselves spawn the additional particles per frame that are stuck in this event until they're piped out, resulting in an exponential increase and possibly a crash. The event has been instanced, but we want some unique properties set to create a smaller bubble later on in the

sequence, making these specific operators unique. Now that we've got the other event duplicated, and we can fill in the rest of the Keep Apart operator's parameters.

10 In the Bubble Path Birth02 event's Birth operator, set the Emit Start and Emit Stop values to 40. In the Position Icon operator, change the Seed value by clicking on the New button in the Uniqueness group so that the particle is born from a different location. In the Spawn test, set Step Size to 0.125.

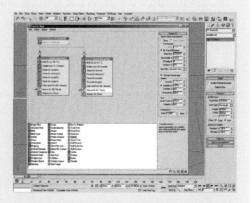

Information: The Birth operator's values have been changed so that a second particle is born later on in the sequence (as mentioned before). The Position Icon's Seed value is changed to ensure a new bubble is born in a different location on the PF Source 01 icon. If you encounter problems with simulation later on, check the "Information" section in step 18 as previously mentioned. The Spawn test's Step Size is increased so as to reduce the amount of particles as this branch's bubble may be smaller and, therefore, need lesser particles.

11 Drag out a Speed operator to create a new event and wire the input of this new event to the output of the Spawn in the Bubble Path Birth01 event. Label this new event Bubble Shape01. Set the Speed value to 50 cm and Direction to Random Horizontal. Add a Scale operator to the event. Set Type to Relative First, and in the Animation Offset Keying group, set Sync By to Particle Age.

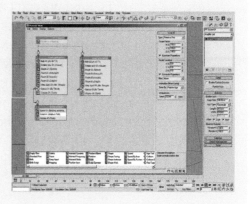

Information: The Speed operator has a main function of giving the large bubble its overall shape, spreading out the spawned particles, with the Scale operator animated (in the next step) to create a reduction in size at the end, and creating smaller particles that can be torn off the main mass. Sync By is set to Particle Age as the particle age is reset for spawned particles that come out of the Spawn test into this new event.

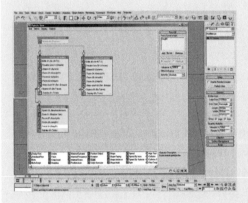

12 In the Default In/Out Tangents for New Keys flyout next to the playback controls, set the tangent to an ease-out curve as illustrated. Enable Auto Key and go to frame 20. Set Scale Factor to 0 (it's applied to all axes by default) and turn off Auto Key. Go back to frame 0. Instance the Gravity and Wind Force operators from the Bubble Birth Path01 event into this event. Copy (not instance) the Force operator that contains the Drag Space Warp to this event and set the Influence value to 3000.

Information: Because we don't want a linear bubble shape, the Scale operator's animation has a touch of ramping in its design, creating a bit of a curve in the mass of particles that are spread outwards. We go back to frame 0 to ensure any properties we'll add to our particle system later on don't take an age to update because we're further in the sequence. We want similar motion properties of our bubble shape as the particle that is drawing it out, hence instancing the Force operators across. The Drag Space Warps' Force operator has had its Influence value increased to create a quick slow-down of the accelerated particles so that they don't spread out too far, forming the bubble shape!

13 Add a Scale test to the event, and in its Test True If Particle Value group, choose Is Less Than Test Value. Set Test Value % to 70. Instance this entire event and wire the input of this new event to the output of the Spawn test in the Bubble Birth Path02 event. Make the Speed operator in this new event unique and set its value to 30 cm. Change the Display operator's Type to Geometry to see the particles in action and turn the particle system back on.

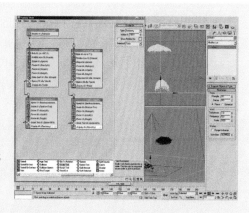

Information: The Scale test checks to see if the particles have reduced enough in size to be passed to the next event to perform the tearing check. This is to ensure the tearing check is performed only on particles towards the edge of the bubble (smaller scale values), not in the middle (larger scale values). The new Bubble Birth Path02 event is identical to the original; however, the Speed value is reduced, resulting in a reduced "throw" of particles and, therefore, a smaller bubble size. We can now enable the system and see how the mass of particles produce a rough bubble shape that we'll refine next.

14 Ensuring you're at frame 0 (for safety), instance the Scale and all the Force operators in the Bubble Shape01 event to the Particle View event display to create a new event and label the event Bubble Tear Check. Wire the output of the Scale tests in the two Bubble Shape events to the input of this new event.

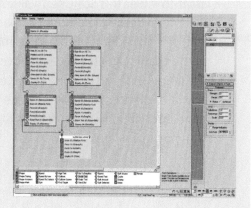

Information: We want the particles to continue scaling down, instancing the Scale operator into this new event. We also want them to continue their motion; therefore, the Force operators are added.

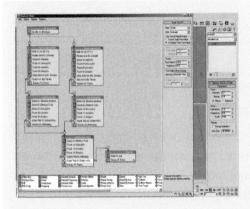

15 Add a Speed test to the event and set it to Steering Rate. Set Test Value to 250. Add a Scale test to the event, and in the Test True If Particle Value group, choose Is Less Than Test Value and set Test Value % to 15. Drag out a Delete operator to the Particle View event display to create a new event and wire the output of the Scale test to the input of this new event.

Information: The Speed test is set to Steering Rate, which checks for the rate of change of direction. If the particles have a sudden change of direction over the threshold value we've set, then they're passed to the next event. If not, then they continue scaling down (and are continuously tested for direction change) until they reach a certain scale value. Once this value is reached, they're piped out to an event that deleted them. NOTE: This Scale value determines how sharp the edge of the main bubble mass is. You may want to lower this Scale test value to refine the edges, though you may want to increase the amount of particles that are spawned by the Spawn test, else the edge of the bubble mass may become fragmented. We're aware that it can also have an adverse effect on simulation as it'll increase the amount of particles in the system for the Keep Apart operator (that we'll add later on) to handle. Again, see the "Information" section of step 18 for more information on fixing the system if simulation fails due to any tweaks you may make later on.

16 Instance the Scale and all three Force operators in the Bubble Tear Check event to the Particle View event display and label the new event Bubble Edge Torn. Wire the output of the Speed test in the Bubble Tear Check event to the input of this new event. Add a Scale test to the event, and in the Test True If Particle Value group, choose Is Less Than Test Value and set Test Value % to 50 and

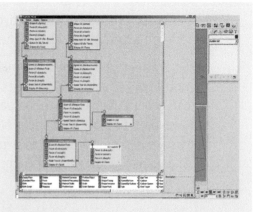

Variation % to 10. Instance all three Force operators in the Bubble Edge event to the Particle View event display and label the new event Torn Bubbles. Wire the input of this new event to the output of the Scale test in the Bubble Edge Torn event.

Information: Here we've chosen few particles that have been torn off the main mass; however, they're still being influenced by the same forces, so it won't become apparent that they have been "extracted" from the main mass until they reach a certain size and are passed to the next event. This is done so that they don't start dragging behind the main mass until they get closer to the edges of the main bubble mass, a kind of "holding" event if you'll! The lower the Scale value, the smaller the resulting torn-off bubbles.

17 Make the Force operator with the Drag Space Warp unique and set its Influence value to 2000. Add a Keep Apart operator to the event. Set the Force value to −10 cm and the Accel Limit value to 300 cm. In the Range group, choose Relative To Particle Size and set the Core % value to 100 and Falloff % to 300. In the

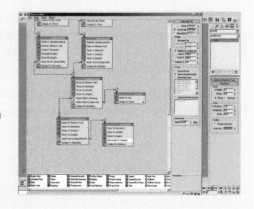

Scope group, choose Current Particle System so that the particles in the system are attracted to each other.

Information: This event is the main crux of simulation – the way the torn-off bubbles react to each other and the main air mass. By adding these specific groups, we're forcing the particles to form larger bubbles and to try to travel back to the main bubble. Unfortunately, this is where the stability of the system is in problem as the Keep Apart operator tends to fall over when dealing with large amounts of particles with numerous forces applied, which this system does.

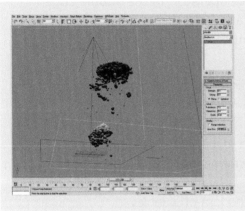

18 Right-click the Play Animation icon, and in the resulting Time Configuration dialog, turn off Real Time. Click OK to accept this. With the system now set up, it's time to run the simulation; however, ensure you saved the scene before you do this. Click the Play icon and watch the simulation run through. Check the "Information" section underneath if the system hangs or if any particles (e.g., the trailing particles) suddenly disappear.

Information: This step is purely for safety. If the particles suddenly stop being displayed and the system hangs for a while, there's a problem with the Keep Apart operators, which will cause particles to disappear at render time (the Viewport Integration Step settings are the same as those of the Render's, so whatever result you got in the Viewport you should get in the render). If there's a problem playing the simulation in the Viewport, quickly return to frame 0 (it may take a few seconds to update and go back to frame 0) and set a new seed in the second Position Object operator and run the simulation again. Be fully aware that you may need to run this several times until you get a Seed value that works – it took me about 12 goes to get a value that didn't fail … I also resorted to moving the Wind Space Warp to a different location,

which obviously affects the particle distribution shape. Unfortunately, there are several compounding effects that determine failure – CPU type, Memory, Space Warp positioning, etc.; so from now on our results may slightly differ. If you're still having problems (it's due to the way Keep Apart works and therefore a necessary evil), increase the value in the Spawn test's Spawnable % field, though this will obviously result in gaps visible in the main air bubble mass. Additionally, you may want to change the Keep Apart operator's Range group setting to Absolute Size. This results in the system being more stable at the expense of the particle's scale values not being taken into consideration. Therefore, you'll have to drop a generic size value, say 0.5 cm with a Falloff of 2.5 cm; 50% of the original size of the main parent particle (0.5 cm) representative of the Scale test's value used; and 500% of the size of 0.5 cm being 2.5 cm, akin to the 500% value used in the Falloff % field. One other thing you can try is to restrict the events that the Keep Apart operators use. Really sorry about this particular step, but it's the limitation and stability of the Keep Apart operator that lets us down here ….

PART THREE: Finally we'll set up surfacing using Blobmesh and refine its geometry to create a smooth surface before adding final tweaks and render effects.

19 With the simulation working (eventually!!), create a new Blobmesh object in the Top Viewport. Set its Evaluation Coarseness to 3 for Render and Viewport. Enable Large Data Optimization and Off In Viewport (due to particle count and update times) and click on the Pick button. Choose the PF Source 01 icon in the scene. Next, add a Relax modifier to Blobmesh and set its Relax value to 1 and Iterations to 2.

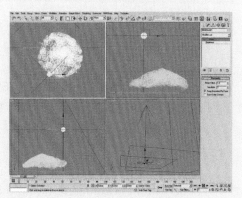

Information: We don't need to see the geometry of Blobmesh in the Viewport, though we can turn it on if desired, but it'll slow down the system the further we go. It's a more refined Relative Coarseness value due to we needing all the particles surfaced and therefore retaining the detail. You may also want to increase this value for the Viewport, but be aware that the Relax modifier will influence the lower polygon version more than the default value we've set in this tutorial, giving an incorrect representation of the result at render time. Large Data Optimization deals with higher amounts of meta surfaces (2000+), which our system can easily produce in a more efficient manner. The Relax modifier is used to reduce the "blobby" feel of the default Blobmesh result and to smooth out the geometry.

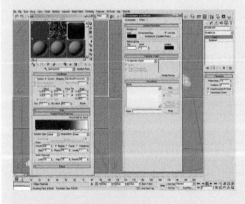

20 Assign the Bubble material to the Blobmesh01 object in the scene. Create a Gradient Ramp map in a free sample slot in the Material Editor. Label it Background. In the Coordinates rollout, enable Environ and set Mapping to Cylindrical Environment. Set the W Angle value to 90 to rotate the gradient vertically. Set the flag at position 0 to RGB 0,8,15 and the one at position 50 to RGB 0,35,73. Add flags to positions 65 (RGB 0,55,117), 75 (RGB 10,103,155), and 87 (RGB 30,195,228). Open the Environment and Effects panel and instance this map into the Environment Map slot in the Common Parameters rollout.

Information: This Gradient Ramp map is designed to simulate the underwater environment, giving the bubble geometry something to reflect and refract against. The RGB values in the gradient are simply derived from the source reference material.

21 In the Atmosphere rollout, add a Volume Light Atmospheric Effect. In the resulting Volume Light Parameters rollout, click on the Pick Light button and select the Fspot01 light in the scene. Enable Exponential and set the Density value to 0.5.

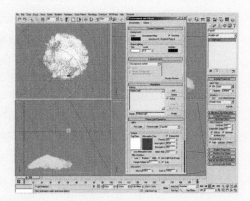

Information: The Volume Light effect generates the God Rays, which are themselves generated from the Noise map we'd set up earlier. We've dropped the Density value to a really low value so that the end result is subtle and not overpowering, akin to the reference material. Even though these volumetrics will be reflected and refracted in the bubble geometry, the main highlight is being driven via a combination of the Fspot and Omni lights in the scene; the Omni light is introduced to exaggerate the highlight. As the geometry in the scene is transparent, there are no surfaces to have their diffuse values brightened by additional lighting. Should you introduce such objects, then it'd be worthwhile to restrict this Omni light to illuminate only the bubble geometry by modifying its Exclude list, else the additional objects may become overly illuminated and/or their highlights blown out!

22 To add some contrast and detail, navigate to the Effects tab of the Environment and Effects panel. Add a Brightness and Contrast effect and set Brightness to 0.45 and Contrast to 0.9. Add a Color Balance effect and set the Magenta/Green field to 15 and the Yellow/Blue field to −10. Enable Preserve Luminosity. Add a Film Grain effect and set its Grain to 0.3.

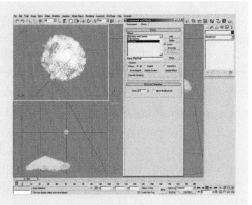

Information: Here we're simply adding some additional post-processing prior to rendering, such as increasing the contrast, adding a touch of color correction, and a bit of film grain to simulate photographic media. Normally this process would be done in our favorite compositor so as not to destroy the original render while post-processing … it has been introduced in this tutorial simply to give an indication of what tweaks we can do to enhance the scene, but I'd seriously suggest you add these effects if you've a compositor and/or know how to use one.

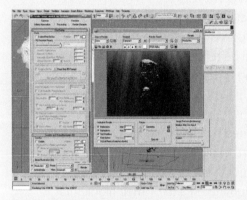

23 Open the Render Setup panel and navigate to the Indirect Illumination tab. Turn off Enable Final Gather and render off the sequence.

Information: We don't need Final Gathering enabled in this scene due to the type of materials used. If you find that reflections and refractions aren't as detailed as you expected, try increasing the Maximum value in the Samples per Pixel group in the Render Setup panel's Renderer tab.

Taking it further

The end simulation does work well, but it can take quite a long time to render; it's this Blobmesh object in the scene that takes a fair amount of time to calculate particle surfacing, but is a necessary evil at this present time (there seems to be a lot of those in this scene!!). To speed up render times, you may want to try increasing the Evaluation Coarseness values to reduce the calculation times, then add more geometry back by adding a Meshsmooth modifier. This will result in a close estimation of the original settings and yield a better result than simply increasing the Evaluation Coarseness and reducing the amount of influence the Relax modifier has.

We're missing some additional detail – this can be found in the previous tutorial: Bubble Stream. Try incorporating this additional system into this tutorial; to make life a touch easier, I purposely designed the tutorials with the same scene scale and similar values, so incorporating them shouldn't be too much of a task. However, you'll need to ensure the systems interact with each other, specifically the particles in this stream should attempt to rejoin the larger bubbles in the other system akin to those in real life (much like a turbulent displacement effect). Moreover, you may need to adjust the original size of the particles so they appear more accurate to their size; the Bubbles Stream system, for example, could have its Shape operator values reduced so that it looks correct in the same scene as this system, but bear in mind that this will have an effect on the particle's motion, so you'll have to tweak the settings in the merged system to accommodate.

Incorporating the existing Keep Apart operators will help here, but always ensure you performed the simulation(s) to test the stability of the Keep Apart operators; the more the particles you tend to throw at them, the more the chance they've of falling over, as you've possibly found in this already particle-heavy system due to the amount the Spawn tests generated.

As mentioned in the last tutorial, it may also be worthwhile to incorporate the Underwater tutorial available in the supplementary book to this scene to yield a pretty cool result, especially if incorporated with volumetric God Rays emitted from the surface. Obviously you may need to tweak the settings such as material colors and/or scale to match the scene, but the end result will be worth it overall.

Again, as mentioned before, try adding some particle debris that swims in front of the camera. This effect is pretty much essential to give the impression of camera motion, should you decide to add any, else it may appear as if the bubbles are moving around erratically as there's nothing else in the scene (presently) apart from the volumetric rays to determine the position and/or orientation.

Finally you may want to add some additional deformation to the geometry to simulate additional rippling across the surface of the bubbles as they travel through water. To achieve this, try applying a Noise modifier to the Blobmesh geometry. This will then cause the geometry to wiggle and deform as it travels up, giving the impression that water is deforming the bubbles.

15 Galaxy

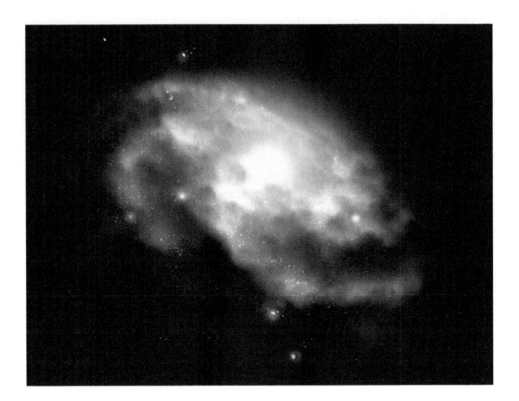

Introduction

In this tutorial we're going to create an effective galaxy distribution
system and shade it accordingly using references from the original Hubble
photography. First we'll design the base particle system distribution by
simulating the rotational and gravitational attractions of each element with
Particle Flow operators before locking off the system by sampling it with
a Mesher Compound Object. This will then be used within an additional
system to place the particles so that we can fly through the system.

Analysis of effect

(a) Okay, first things first: Galaxies take on all kinds of shapes and sizes, plus a fair few of them are angled from our point in our own galaxy; so the majority of reference I've obtained is based around similar formations. I'd seriously suggest you read on their formation before proceeding with this tutorial so that you'll have a greater insight into their distribution, how and why they're shaded the way they're (i.e., how the images are generated), and how galaxies interact with other stellar phenomena. Putting it bluntly, I'm not a scientist! The distribution of sample images included with this book consists of the "generic" spiral galaxy formation. To generate this type of effect, we must first understand how the "particles" are distributed so that we can replicate it in real life. Think logically – matter attracts matter through gravity which in turn attracts even greater masses, creating the central core which, due to gravitational attraction, causes the galaxy to spin, drag matter towards the central core, and tear off parts creating detail and these long trails; that is to say, there are defined cloud arms trailing out from the central core of mass of stars. (b) These trails aren't necessarily refined; there's additional detail within their shape producing additional branching from each arm to converge with adjacent arms. Within this main (bluish) cloud mass contains the main bulk of stars, most of which are shaded blue akin to the cloud matter; however, these have their own distribution pattern with clumps of stars being apparent. (c) Additionally, red clusters of stars (or other matter – again, I'm not a scientist!) also appear apparent, yet larger and more sporadic than the blue star clusters. Within each arm of the galaxy contains additional finer detail; this consists of darker dust cloud matter which breaks up the uniformity of the galaxy shape, yet it tends to surround each arm and the main outer edges. (d) Side-on we see the galaxy is quite thin at the center in comparison to the outer rim, with the volumetric-esque glow appearing slightly squished.

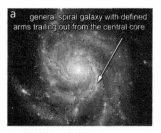

Image courtesy NASA, ESA, and The Hubble Heritage (STScI/ AURA)-ESA/Hubble Collaboration

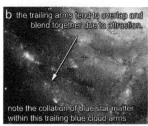

Image courtesy NASA, ESA, and The Hubble Heritage (STScI/ AURA)-ESA/Hubble Collaboration

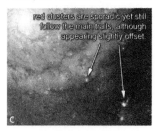

Image courtesy NASA, ESA, and The Hubble Heritage (STScI/ AURA)-ESA/Hubble Collaboration

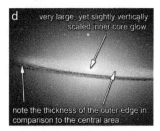

Image courtesy NASA, ESA, and The Hubble Heritage (STScI/ AURA)-ESA/Hubble Collaboration

We see the outer edge is defined by a layer of dust cloud which is prominent through the galaxy, right to the core as apparent in this image.

To create the same kind of distribution within 3ds Max, we should emulate the same kind of gravitational attraction between particles as within an actual galaxy. Obviously we need billions of years to produce this, so by using a Vortex Space Warp we can make the main mass of particles appear to spin. Gravitational attraction between the particles can be tackled on two fronts – one for the main distribution of arms, and the other for localized attraction. Both of these can be simulated by using multiple Keep Apart operators – one for the main arm distribution (instanced across all systems) and the other for local attraction (unique for each system). Obviously this is going to be a distribution system, so we need to snapshot it at a certain point so that we can fly through the galaxy; we could add Age tests to the system so that the particles are piped out to another event where their speed is killed and the particles made renderable. However, this will result in high cache sizes (we'll cache the system for ease of playback later on), plus whenever we make a tweak to the renderable section of the system, the cache will fail. Also, it'd have to be recalculated at render time anyway, should you decide to send the lot down to a render farm! The best way is to simply snapshot the mesh at the end of the sequence using a Mesher Compound Object, duplicate the Mesher (for safety), and collapse it down to an Editable Poly. Then, thanks to the nice little Birth Script (originally written by Jefferson D. Lim (aka "Galagast"), we can place particles over the collapsed object's vertices (the script generates one particle per vertex), thereby making them renderable and locked in situ. The materials are quite basic, generated by procedural maps for the facing particles we'll use. Finally we'll add a touch of volumetric lighting, one to cover the entire galaxy and another to brighten up the core.

At this stage, before we even start the scene, it's to be mentioned that this setup will take a while to simulate, so ensure you've got a pot of fresh coffee (an animator's muse!) to hand. If you've got a low-spec machine, then you may want to reduce the amount of particles in initial simulation, but bear in mind that this may have an adverse effect on the distribution pattern and also the end particle densities for each system. Additionally, be aware that, due to the amount of opacity-mapped particles coupled with the fact that there are volumetrics present in the resulting scene, it may take up to 20 minutes for a PAL resolution frame to render (based on a dual 2.4 GHz machine with 2 Gb RAM) by which time we'd get halfway through the pre-set camera move (looking directly through the clouds). Rightly, with that in mind, let's begin.

Walkthrough

PART ONE: Loading the initial scene and setting up the initial Space Warps required for particle distribution.

1 Open the *15_Galaxy_Start.max* scene and accept any file unit change if prompted. In the Top Viewport, create a Vortex Space Warp at the origin of the scene (XYZ coordinates 0,0,0). In the Front Viewport, relocate this Space Warp 5000 units vertically upwards so that its resulting coordinates are at 0,0,5000. Navigate to the Modifier tab and set the Space Warp's Time Off value to 10 000. In its Vortex Shape group, set Taper Length to 0. In the Capture and Motion group, set Axial Drop to 0 and its corresponding Damping value to 0. Set Orbital Speed to 2 with a Damping of 1. Set Radial Pull to 1.5 with a Damping of 10.

Information: As we're dealing with particle systems and procedural maps, it's important we all work with the same unit scale, else your results may differ from mine! The startup scene has a few items already established, namely some Particle Flow icons, which we'll use to set up the simulation system later on, and a Camera that has a pre-set animation flying through the galaxy system. The Vortex Space Warp is what controls the rotation of the distribution system; it's centered in the scene so that we don't get any shearing of the animation and that the galaxy simulation rotates around the origin. It's then relocated up in the Z-axis so that the particles we'll create momentarily are affected by the entire Space Warp; if it's left at the origin, then there's chance that only the bottom half would be affected as designed since the Vortex only rotates the particles at full force along its stem when there's no Taper Length or Axial Drop value (we don't want the particles to move down through the vortex!). The settings we used will produce a quick rotational motion so that the particles distribute evenly and quickly through

the simulation, yet aren't spread out too finely; there's a nice collection of particles around the core, thanks to the Radial Pull. We've increased the Time Off value to 10 000 just in case we decide to extend the length of the simulation (see the "Taking it further" section for more information on this). The main simulation particles are emitted from the flat disc icons (akin to the reference material), while the stars themselves are born from the vertically scaled spherical icons so that they can be distributed in three dimensions throughout the galaxy system.

2 In the Top Viewport, create a Wind Space Warp at the origin. In its Force group, set its Strength value to 0. In its Wind group, set Turbulence to 1 and Scale to 0.01.

Information: This Space Warp has been introduced purely to break up the dust clouds we'll add later, resulting in a more natural distribution. We've set the Strength value to 0 as we don't want the dust clouds to travel along the icon arrow, just get affected by turbulence only.

3 Still in the Top Viewport, create an Omni light at the origin and label it Omni_White_Core. Ensure Shadows are disabled. Set its Multiplier value to 30, and in its Decay group, set Type to Inverse Square. Set its corresponding Start value to 20. In the Far Attenuation group, enable Use and Show and set

the Start value to 20 (the same as the Decay Start value) and the End value to 1000.

Information: The Omni light not only illuminates the central particles but also serves as the white central core volumetric. We're using Inverse Square Decay to achieve a nice realistic falloff, ensuring the central core is nice and "hot" while the light trails off through the system until it hits the Far Attenuation End value (which prevents further calculation in 3ds Max). The Shadows are disabled so that it saves rendering time, plus the Volumetric effect we'll add later on would be occluded by the shadows.

4 Copy the Omni_White_Core_ Vol light and label the clone Omni_Galaxy_Cast. Set its Multiplier value to 75 and its color to RGB 187,158,116. Set the Decay Start and Far Attenuation Start values to 60 and set the End Far Attenuation value to 2000. Copy this light and label the new light Omni_Cream_ Core_Vol. Set its Multiplier value to 100 and the Decay Start and Far Attenuation Start values to 30. Set the Far Attenuation End value to 1200. In the Front Viewport, vertically scale down this light to 50% as illustrated.

Information: Similar deal as before, the first light creates additional illumination only with a nice beige/cream hue (RGB values sampled from the reference material), whereas the second light acts as illumination and another volumetric light (which we'll set up at the end of the tutorial), which is vertically scaled down akin to the reference material.

PART TWO: With the Space Warps set up, we'll now go into Particle View and start designing our system.

5 Go to the Graph Editors menu and select Particle View. Drag out a new Birth operator to the Particle View event display and label the new event Blue Cloud Sim. Wire the input of this event to the output of the PF Source Blue Cloud Simulation event. In the Birth event, set the Emit Stop value to 200 and Amount to 4000.

Information: As the root events have already been set up, it's now a simple task of creating the simulations. As we're dealing with a 200-frame sequence, that's what we'll dial into the Emit Stop value. The 4000 particle amount is emitted over this period. Again, if you decide to extend the length of the animation, then these values will need to be amended (along with the other particles systems we'll create shortly).

6 Add a Position Icon operator to the new event. Add a Shape operator to the event and set its Shape type to Vertex. Add a Force operator to the event and add the Vortex01 Space Warp to its Force Space Warps list. Add a Keep Apart operator to the event and rename it KA_BlueCloudClumping. Set its Force value to −100 and Accel Limit to 2000. In the Range group, set Core Radius to 1 and Falloff Zone to 100.

Information: We're using a Vertex shape type as we need to only have vertices present in our snapshotted geometry; these resulting vertices are the positions from where the renderable particles will be emitted. If we use other particle shape types, then this would result in additional vertices being generated which will in turn generate additional particles in the distribution systems, which is undesirable. This initial Keep Apart operator simply collates the particles into bunches as they spin around the vortex. These bunches will be stretched out into the tendril arms, which will be created next.

7 Add another Keep Apart operator to the event and rename it KA_ Galaxy_Trails01. Set its Force value to −100 and Accel Limit to 5000. In the Range group, set Core Radius to 5 and Falloff Zone to 300. In the Display operator, set Type to Dots and set the swatch color to a light Blue for reference. Right-click the Play Animation icon, and in the resulting Time Configuration dialog, turn off Real Time and Loop. Click OK to close the dialog. Save the scene and click the Play Animation icon to run the simulation.

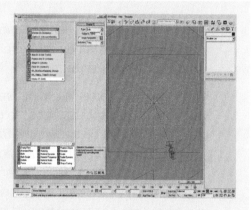

Information: This Keep Apart operator has a large Falloff Zone value which affects a large radius of the particles, attracting them and, as they spin, creating the tendril arms. If you wish to redesign the shape of the galaxy, it's this operator you need to amend, specifically this value. We've changed the Display operator to Dots so that we can see all the particles clearly in the Viewport and how they collate when performing the simulation. We saved the scene beforehand (this is advisable every time you perform a simulation) purely for safety. This system will then be cached into the Cache modifier so that you can simply scrub through the sequence later on. The Time Configuration settings have been changed so that we can see every frame update in the simulation, and that it plays through only once; we don't need the sequence to constantly loop.

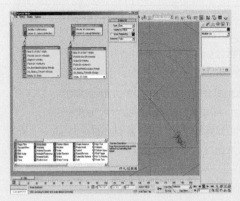

8 Go back to frame 0 (very important!) and instance the Blue Cloud Sim event and label the new event Blue Stars Sim. Wire the input of this new event to the output of the PF Source Blue Small Stars Simulation event. Make the Birth and Display operators unique. In the Birth operator, set Amount to 10 000. Make this new event's KA_BlueCloudClumping operator unique and rename it KA_BlueStarsClumping. We'll set the Scope group once the other influential event is created. In the Display operator, make the swatch color darker blue.

Information: Same deal as before, though this time we're emitting from one of the scaled spherical icons to get a 3D distribution of particles within the cloud. We need to go back to the frame, else the new system we're setting up will attempt to update as we perform any setting change. The first Keep Apart operator's values haven't been amended as it needs to interact with another event which we'll set up next. Even though the values are the same as the other Keep Apart operator in the previous event (i.e., we haven't changed their numerical values), the sheer amount of particles will result in a different clumping effect when the simulation is performed ... but don't do that just yet!

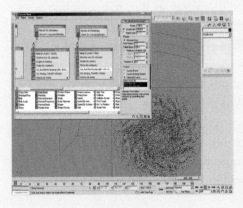

9 Instance this event and wire its input to the output of the PF Source Blue Large Stars Simulation event. Rename the event Blue Large Stars Sim. Make the Birth operator unique and set Amount to 200. In the KA_BlueStarsClumping operator, choose Selected Events in the Scope group and select the Blue Stars Sim and Blue Large Stars Sim events as illustrated. Save the scene and click on the Play Animation icon.

Information: As the KA_BlueStarsClumping operator is instanced across from the previous event, changes in the Scope parameters in this operator are also applied to the other event, which enables them to interact. NOTE: This simulation will take longer to perform than before due to the increased particle counts. Additionally, you may find your machine performing badly after this stage due to the amount of cached particles in memory. In this case, you'll have to turn off the Cache operators (also turn off the other systems apart from the one you're working on) and then run the sequence to test the simulation; however, don't forget to re-enable it later on. Be warned though that even if you turn off the Cache operators you'll still need to perform the overall simulation later on so that you get to the end distribution state. This will obviously take a fair while by which point the time duration set in your Autosave would elapse, therefore the Autosave will kick in, forcing the particle systems to recalculate again, resulting in an endless loop of simulations! To get around this, temporarily disable the Autosave feature (Customize -> Preferences menu) before you run the final simulation, and in the resulting dialog, navigate to the Files tab and turn off Autosave. Don't forget to turn it back on once you've locked down the simulations with the Mesher Compound objects! For those with enough RAM, they needn't worry as the Cache will update the particle systems immediately without having to resimulate. Whew. Okay, next step.

10 Again, go back to frame 0 and instance the Blue Large Stars Sim event to create a new event and label the new event Red Large Stars Sim. Wire the input of this new event to the output of the PF Source Red Large Stars Simulation event. Make the Birth operator unique and set Amount to 400.

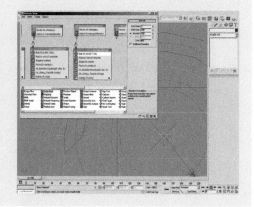

Information: Here we've set the same properties as of the Blue Large Star Sim event, yet we're simply reducing the amount of particles present in this new system so that they collate better (as there's less to interact with), akin to the reference material.

11 Make the KA_BlueStarsClumping event unique and rename it KA_RedStarsClumping. In this operator, set the Accel Limit value to 20 000 and choose Current Event in the Scope group. Make the Display operator unique and set the swatch color to red. Click on the Play Animation icon again to cache the simulation for this event.

Information: We need to affect only these particles with one another (with respect to clumping), so the Scope is changed back to Current Event. Again, the Display operator's colors have been changed so that the particles are apparent in the Viewport.

12 Back at frame 0, instance the event again and label the new event Dust Sim. Wire the input of this new event to the output of the PF Source Dust Simulation event. Make its Birth operator unique and set the Birth operator's Amount value to 10 000. Make this event's KA_RedStarsClumping operator unique, rename it KA_DustClumping, and set its Accel Limit value to 2000.

Here we're going to use similar properties as the initial cloud simulation so we can instance across majority of the settings; however, we need more particles so the Birth operator is made unique and the Amount value cranked up! As before, the clumping value is amended.

13 Add a Force operator beneath the Keep Apart operators as illustrated, and add the Wind Space Warp to its Force Space Warps list. Set the Influence value to 3000. Make the Display operator unique and set its swatch color to dark grey. Click on the Play Animation icon to run this final simulation.

Information: By adding the Force operator (and thereby the Wind) we can distribute the dust particles throughout the system more naturally, which will break up any large dark patches and stretch them out a little like tendrils, akin to the reference material.

14 Again, due to heavy particle counts, you'll notice a large slowdown in the simulation as we get further into the sequence, so now is the time to have a bit of a break! If you've turned off the Cache modifiers or other systems, you'll need to resimulate these, which will add to the time. Again, if you're dealing with a low spec machine and have the Cache modifiers disabled, ensure you've temporarily turned off Autosave!

Information: Well, the step pretty much explains everything here. Time for a coffee!

PART THREE: With the simulations complete and cached, we'll sample them at the end of the sequence with multiple Mesher Compound Objects so that the distribution is now locked in situ.

15 At frame 200 and in the Top Viewport, create a Mesher Compound Object. Relocate this object to the origin. Label this object Mesher_Cloud_Blue. In the Modifier tab, click on the Pick object button and choose the PF Source Blue Cloud Simulation icon in the scene. This would be difficult as the scene may be so busy, if so then (with the Pick object button depressed) press H or click on the Select By Name icon on the toolbar and choose the correct item. Copy the Mesher_Cloud_Blue object and rename the copy Mesher_Cloud_Blue_C. NOTE: Ensure you label this object exactly the way it will be referenced in a script later on.

Information: The original Mesher Compound Object simply references the particle system's resulting geometry and generates a mesh; however, as we're using Vertex as the Shape Type, only the vertices will be generated, so you wouldn't see anything in the Viewport (but they're there!). As this Compound Object updates at every frame as we scrub through the animation, we need to snapshot this at frame 200; this can be achieved by cloning the object (for safety) and then

16 Ensuring you're still at frame 200, right-click this object and in the Convert To menu choose Convert to Editable Poly. Ensure you choose the correct option here as we'll be using a script to reference poly commands; these commands won't work if you choose Editable Mesh.

Information: By collapsing the geometry down to an Editable Poly at frame 200, we've captured the vertex distribution state, which will be used in another particle system later. Now we need to perform the same operation on the rest of the systems.

17 At frame 200 and in the Top Viewport create a Mesher Compound Object. Relocate this object to the origin. Label this object Mesher_ Small_Stars_Blue. In the Modifier tab, click on the Pick object button and choose the PF Source Blue Small Stars Simulation icon in the scene. Clone this Mesher Compound Object as before and label it Mesher_Small_ Stars_Blue_C. Right-click this object and in the Convert To menu choose Convert to Editable Poly.

Information: Same as before, we're simply producing a vertex geometry cloud at frame 200 and then collapsing it down so it doesn't update when we play through the animation (required when we make our system renderable later on).

18 Still at frame 200 and in the Top Viewport create another Mesher Compound Object. Relocate this object to the origin. Label this object Mesher_Large_Stars_Blue. In the Modifier tab, click on the Pick object button and choose the PF Source Blue Large Stars Simulation icon in the scene. Clone this Mesher Compound Object as before and label it Mesher_Large_Stars_Blue_C. Right-click this object and in the Convert To menu choose Convert to Editable Poly.

Information: … and again, but this time with Large Blue Stars ….

19 Still at frame 200 and in the Top Viewport create yet another Mesher Compound Object. Relocate this object to the origin. Label this object Mesher_Large_Stars_Red. In the Modifier tab, click on the Pick object button and choose the PF Source Red Large Stars Simulation icon in the scene. Clone this Mesher Compound Object as before and label it Mesher_Large_Stars_Red_C. Right-click this object and in the Convert To menu choose Convert to Editable Poly.

Information: … yet again …! One more to go ….

20 Still at frame 200 and in the Top Viewport create the final Mesher Compound Object. Relocate this object to the origin. Label this object Mesher_Dust. In the Modifier tab, click on the Pick object button and choose the PF Source Dust Simulation icon in the scene. Clone this Mesher Compound Object as before and label it Mesher_Dust_C. Right-click this object and in the Convert To menu choose Convert to Editable Poly.

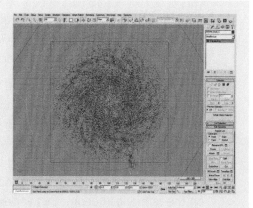

Information: Whew … done! Now that we've all the reference geometry set up, we can start setting up the renderable system.

PART FOUR: With the reference geometry collapsed, we can now start designing our renderable particles.

21 Turn off all the particle systems as we no longer require them and clear their caches. Go back to frame 0. Hide the uncollapsed Mesher objects as we no longer need to use them (but they're just there for safety in case we want to resimulate later on). Add a new Empty Flow to the event display (its icon will, by default, be placed at the origin) and label the new system PF Source Galaxy. Ensure it's turned on. Select

this event and set its Upper Limit in the Particle Amount to its highest value (50 000 000). Set the Render Integration Step to Frame. Drag out a Birth Script operator to the event display to create a new event, label the event Blue Cloud Renderable, and wire the input of this event to the output of the PF Source Galaxy event. In the Birth Script operator, click on

the Edit Script button. In the resulting Birth Script editor, select all the text and delete it. Next, load the *15_Galaxy_Birth.ms* script included with this tutorial, kindly provided by Jefferson D. Lim (aka "Galagast").

Information: You've had turned off Autosave in a previous step, so once you go back to frame 0, turn it back on. Okay, this script is pretty straightforward; all it does is call in the collapsed geometry and assign it to a variable name that can be used within the script. This is then checked to see if particles have been assigned to it; if not then it runs through a loop NumVerts times (the amount of original particles) and adds a particle based on the referenced geometry's vertex position. It then loops back and repeats the process until all the vertices are assigned. The Upper Limit value has been increased to ensure we don't run out of particles in the system! The Integration Step has been amended for the Render option as we won't deal with moving particles, so particle position accuracy isn't vital. NOTE: Ensure you remove the original Birth script text before loading the script, else the script will simply be added to the existing one.

22 Next we need to uniquely edit the text in the script so that it references each object individually and stores this object name within a variable so that it can be used within the main script. Replace the text *my_mesh* throughout the script with *cloudblue* and replace *$mesh_name* with *$Mesher_Cloud_Blue_C*. Go to File -> Evaluate All to run the script.

Information: We renamed the text items in the script so that each script will have a unique name for each distribution, else other copies of the script would overwrite the position data and distribute the particles incorrectly. On evaluating the script, the particles should immediately update. If you've any errors, check the variable names you've edited to ensure you've replaced them *exactly* and not missed any; try using the Replace feature in the Birth Script editor if you're unsure.

23 Add a Shape Facing operator to the event. Click on the None button in the **Look At Camera/Object** group and select the Camera01 object in the scene. Enable **Use Parallel Direction**. In the **Size/Width** group, set the Units value to 300 and Variation % to 25. In the **Orientation** group, choose Random. Next, add a Material Static operator to the event. Finally, in the Display operator, set Type to Geometry, so that we can see the particles in the Viewport, and set Visible % to 1. Set its color swatch to light blue.

Information: For this system we're using facing particles to create the cloud effect, which we'll set up in the Material Editor later on. Parallel Direction is used to get all the particles facing the same way. This prevents any unwanted particles from spinning when the camera is animated and also reduces particle/particle intersection. Random has been chosen as the Orientation type to break up any uniformity in the particle material we'll assign later on. We've dropped the Visible % value down to 0.1 so that we see only a small amount of particles in the Viewport (the Viewport % value in the Particle Flow icon will have no effect here), but you'll still get 100% of the particles at render time. The Display operator's color is simply for Viewport reference, and won't affect the colors at render time.

24 Copy the Blue Cloud Renderable event and label the new event Blue Stars Renderable. Replace the Shape Facing operator with a Shape operator and set its type to Sphere. Set Size to 2. Add a Rotation operator to the event and add a Scale operator. In the Scale operator, set Scale Variation to 100 for all three axes. In the Birth Script operator, open the script editor

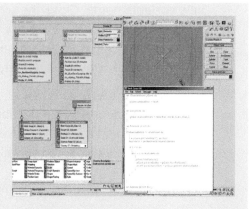

and replace the *cloudblue* variable with *bluesmallstars* throughout the script and *$Mesher_Cloud_Blue_C* with *$Mesher_Small_Stars_Blue_C* so that the collapsed geometry would be referenced by this new variable name. Close the script. In the Display operator, set its color swatch to darker blue. Wire the input of this new event to the output of the PF Source Galaxy event and check the Viewport to ensure the particles are distributed correctly.

Information: Here we're using simple spherical particles to simulate our stars. As there's no scale variation in the Shape operator, we need to add a Scale operator to the event. We renamed the text items in the script so that each script will have a unique name for each distribution, else other copies of the script would overwrite the position data and distribute the particles incorrectly.

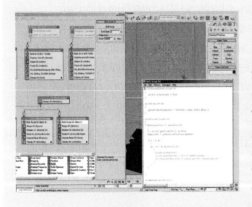

25 Copy this event and label the new event Large Blue Stars Renderable. In the Shape operator, set Size to 5. In the Birth Script operator, open the script editor and replace the *bluesmallstars* variable with *bluelargestars* throughout the script and *$Mesher_Small_Stars_Blue_C* with *$Mesher_Large_Stars_Blue_C* so that the large blue stars' collapsed geometry would be referenced by this new variable name. Close the script. In the Display operator, set the Visible % value to 100. Wire the input of this new event to the output of the PF Source Galaxy event, and check the Viewport to ensure the particles are distributed correctly.

Information: As before, we've edited the script so that it'd reference to the correct geometry for distribution, and also amended the size of the particles to a higher value. We've also amended the Visible % value back to 100 so that we can see all the particles in the Viewport as there aren't many.

26 Copy this event and label the new event Large Red Stars Renderable. In the Birth Script operator, open the script editor and replace the *bluelargestars* variable with *redlargestars* throughout the script and *$Mesher_Large_Stars_Blue_C* with *$Mesher_Large_Stars_Red_C* so that the large red stars' collapsed geometry would be referenced by this new variable name. Close the script. In

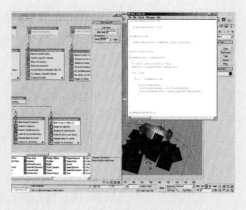

its Display operator, set its color swatch to red. Wire the input of this new event to the output of the PF Source Galaxy event, and check the Viewport to ensure the particles are distributed correctly.

Information: Same deal as before, we've referenced a different distribution object in the scene and given it a unique variable name in our script.

27 Finally copy the Blue Cloud Renderable event and label the new event Dust Cloud Renderable. In the Birth Script operator, open the script editor and replace the *cloudblue* variable with *dustclouds* throughout the script and *$Mesher_Cloud_Blue_C* with *$Mesher_Dust_C* so that the dust cloud's collapsed geometry would be referenced by this new variable name. Close the script. In the Shape

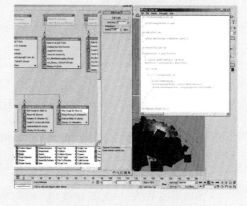

Facing operator, set the Units value to 200. In the Display operator, set the color swatch to dark grey. Wire the input of this new event to the output of the PF Source Galaxy event and check the Viewport to ensure the particles are distributed correctly.

Information: This time, as we already have the facing particles set up (albeit with a few amendments), we can reference it across from the first placement system and then tweak the script suitably. This dust needs to be slightly smaller than the main blue clouds, so therefore we've amended its Units value to 200. Again, as there are a lot of particles in this system, the Visible % value is dropped to 1 so that we can see updates faster in the Viewport (set in the previous cloud event).

PART FIVE: With the renderable particles established, we'll now design and assign materials to the particles before setting up the volumetrics to simulate the galaxy's core.

28 Open the Material Editor. Add a Blend material to the first available sample slot and label it Blue Cloud. Go to this material's Material 1 slot and label it Blue Cloud Bright. Set the Diffuse color to RGB 100,125,155 and set Self-Illumination to 100. Set Opacity to 0, and in the Extended Parameters rollout, set Advanced Transparency Type to Additive.

Information: We're going to use multiple materials to shade the main blue clouds: one to additively brighten up the overlapping particles with the surrounding areas being dust clouds. This dust cloud material will also be used to shade the dust cloud system later on. Here we're simply coloring the particles blue and setting up additive transparency. Opacity is set to 0 so that when we mix this value with a map we'll design next the strength of the map's influence isn't too high.

29 Add a Mask map to the Opacity slot and label it Cloud & Stars Mask. Add a Speckle map to the Map slot and label it Cloud & Stars. In the Coordinates group, set Source to Explicit Map Channel. Set Size to 6 and click on the Swap button. Set the Color #1 swatch to RGB 170,170,170. In the Coordinates rollout, set U Offset to −0.7 and V to 0.95 to center a nice cloud pattern in the sample slot.

Information: The Mask map will be used to mask off the Speckle map and its sub-map so that there isn't any edge clipping on the facing particles. We're using Explicit Map Channel as the mapping type so that what we see in the Material Editor is what we get when applied to the particles. This also ensures the particle texture doesn't swim as we animate through the galaxy system at render time. The Offset values have been changed simply to get a nice pattern at the center of the sample slot.

30 Add a Splat map to this map's Color #2 slot and label it Stars. Set Source to Explicit Map Channel and set Size to 3. Set the # Iterations value to 7. Set the Color #1 swatch to black and Color #2 to RGB 55,55,55.

Information: This Splat map is used here to add some additional finer detail to the blue clouds by raising the opacity of the material a touch.

31 In the Cloud & Stars Mask map, add a Gradient Ramp map to the Mask slot and label it Cloud Mask. Set the Flags at positions 0 and 50 to white and the one at 100 to black. Add a flag to position 90 and set it to black. Relocate the flag at position 50 to position 60. Set Gradient Type to Radial. In the Noise group, set Amount to 0.19, Size to 4.4, and enable Fractal. In the Blue Cloud Bright material, set the Opacity map slot's (not the main Opacity value) Amount value to 8.

Information: This Gradient Ramp map prevents the Speckle map and its Splat sub-map from clipping the edges of the facing particles, else you'd possibly see edge artefacts at render time. To break up any uniformity in the gradient, we've added a touch of noise, but not too much, else clipping would occur in this map also! Opacity value has been dropped to 8, resulting in only 8% of the map's RGB value being used as the material's opacity. This is, therefore, mixed with the original Opacity value (zero) which would result in very low opacity overall; however, due to the large amount of particles in the system and the fact that we're using additive transparency, this low value works, else we'd end up with a system that is too opaque and too bright.

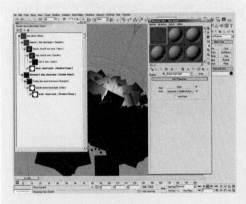

32 Add a Double Sided material to the Blue Cloud's Material #2 slot and label it Blue Cloud Dust. Set the Translucency value to 50. In the Facing Material, set the Diffuse color to RGB 48,37,35 and label this material Blue Cloud Dust Brown. Add a Mask map to the Opacity slot and label it Brown Cloud Mask. Instance the Cloud Mask (Gradient Ramp) map to this new Mask map's Mask slot.

Information: This Double Sided material is a nice way to create back-lit objects. Using a technology akin to translucency shaders we'd find elsewhere in 3ds Max (though working on flat geometry), it uses the illumination on one side of the material to brighten up the side in shadow. This pass-through "illumination" is controlled by the Translucency value; 50 is a mid-range value though increasing or decreasing it will favor the Facing material or Back material, respectively. This works well for us as we're dealing with a central light, and the particles in front of us will constantly be illuminated from the core, so we need to see some shading through the material. As this material automatically converts one-sided objects to two-sided ones (as is its description!), we don't need to enable 2-Sided in the material. As we're dealing with the same cloud shape, we can simply reference the maps set up in the Blue Cloud Bright material, but for starters we need the Gradient Ramp map in there.

33 Copy the Cloud & Stars map to the Brown Cloud Mask map's Map slot and label this copy Brown Cloud Opacity. In this new copy, remove the Splat map from the Color #2 slot and set the Color #1 swatch to white. Instance the Blue Cloud Dust Brown material to the Back Material slot in the Blue Cloud Dust material. At the top level of the Blue Cloud material, instance the Cloud & Stars Mask to its Mask slot.

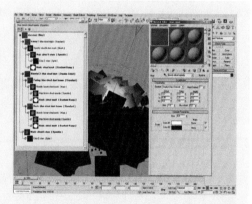

Information: … though we don't need the Splat map in this material as we don't want dark dusty stars! As the same material needs to be passed through to the other side of the particle, the material is instanced to the Back Material slot. By instancing the opacity map of the Blue Clouds Bright material to the Mask slot of the Blue Cloud (Blend) material, this ensures the center of the resulting material is blue and the outer areas have a faded dust cloud texture (driven by the Mask slot's RGB values).

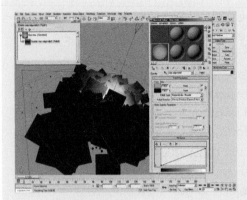

34 In a new Material Editor sample slot, label the material Blue Stars. Enable 2-Sided, set the Diffuse color to RGB 37,90,169, and set Self-Illumination to 100. In the Extended Parameters rollout, set Advanced Transparency to Additive. Add a Falloff map to the Opacity slot and label it Stars Edge Falloff. Set the Front color to RGB 150,150,150 and the Side color to black.

Information: This material is pretty straightforward; a self-illuminated material is set to 2-Sided to increase brightness at its core when used with additive transparency. To enable this, a Falloff map is added to the Opacity slot to fade off opacity at the edges of the geometry, resulting in a brighter center.

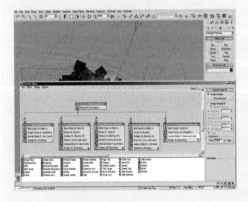

35 Copy this material and label the new copy Red Stars. Set its Diffuse color to RGB 200,60,50. Finally instance the Blue Cloud material to the Material Static operator in the Blue Cloud Renderable event; the Blue Stars material to both Blue Stars event's Material Static operators; the Red Stars material to the Material Static operator in the Red Stars Renderable event; and the Blue Cloud Dust (the Double Sided Material nested within the Blue Cloud material) to the Material Static operator in the Dust Renderable event.

Information: A bit long step, but pretty self-evident. Here we're simply duplicating the Blue Stars material and changing the color before assigning the relevant materials to their respective Material Static operators in the particle system. As the dusty cloud material is already established, thanks to its use within the Blue Cloud material, we can just reference it from there, but we can instance it out to a new sample slot if we can't grab it from within the Blue Cloud material – navigate to the top of the Blue Cloud material and drag the Material 2 slot to a free sample slot in the Material Editor and ensure you choose Instance when prompted. This can then be easily dragged into the correct Material Static operator and/or amended easily, if desired, later on in the Material Editor.

36 Open the Environment and Effects panel and add a new Volume Light Atmospheric Effect. Rename it Volume Light-Cream Core. In its Lights group, click on the Pick Light button and choose the Omni_Cream_Core_Vol light. Enable Exponential and set Density to 3 and Max Light % to 100. Set the Fog color to RGB 187,158,116.

Information: Here we're simply setting up the fogging effect to emanate from the central core. In order that the cream color shines through, we'll set this up first before adding the white hot core volumetric. Density has been dropped to 3 as we don't need the effect to be too overpowering, and the Max Light % value has been increased to 100 so that it doesn't clamp off at 90%. The Fog color was simply derived from point sampling a color from the reference material – the best source for sampling colors!

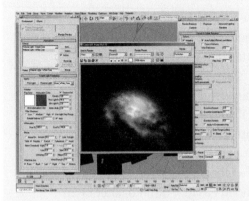

37 Add a new Volume Light Atmospheric Effect and rename it Volume Light-White Core. In its Lights group, click on the Pick Light button and choose the Omni_White_ Core_Vol light. Enable Exponential and set Density to 3. Finally render off the sequence from the Camera01 Viewport.

Information: The final step here is to perform a similar operation as done for the white core volumetrics. This time we don't need to set any additional colors as the default color is already set to white. Finally we can render off the sequence … but read the "Taking it further" section's first statement before you proceed as it might save you a bit of hair loss in the long run …!

Taking it further

Okay, first things first: as mentioned earlier, this baby is going to take an absolute age to render out. Sorry, but that's the case with opacity-mapped particles and volumetrics. So how can we speed up things a touch? One way to get around it is to kill anti-aliasing and filtering in the render, which should result in render times halving, though this is at the expense of the smaller stars scintillating. To fix this, you could render out each element as a separate pass and then recomposite in your favourite compositor; for example, render the cloud layers out individually with no anti-aliasing (it makes little difference) and the stars with anti-aliasing to remove scintillating.

Additionally, depending on how your camera moves, be on the look out for the facing particles rotating. With subtle moves (like in a sequence in the base scene) we should be fine; however, should you decide to go to extremes and look directly underneath the galaxy system or orbit the system, this will force the particles to turn to face the camera, which may cause the particles to spin and the galaxy clouds to rotate furiously or flip 180 degrees! To get around this, amend the animation so that these areas are avoided, and/or amend the Orientation group setting in the Shape Facing operators depending on the animation. Again,

be subtle with the animation; this is a very large object, so try to be graceful with your camera work.

If you need a more realistic shot, try repositioning the camera way back in the scene and render off with a very large lens size. Don't forget that all the reference we've seen has been taken with a very tight zoom, so virtually all perspective would be lost. Have a go at mimicking this and see what results you get!

You may also want to change the simulation to get a more defined galaxy shape – the longer you run the simulation, the more the particles it attracts; extend the length of the sequence and run the initial distribution systems independently to see what you get. To add even more variation, try tweaking the instanced Keep Apart operator as this derives the strength of the galaxy's spiral arm attraction – higher Falloff values result in larger clumping while lower values yield more detail. Entirely up to you! You may, however, want to throw more particles into the system; try extending the length of the sequence to 1000 frames and, with a bit of maths, dial in the particle amount values for each one (i.e., times the existing value by 5) to get the same result. Obviously this will have a bigger effect on rendering times, plus you'll also need to re-setup the Mesher and collapsed Mesher objects so that the renderable system is distributed over your new simulation results.

Depending on the amount of particles you throw at it, and how you get the systems to interact, the system may fail; this is due to one of the Keep Apart operators having a "bit of a mard" (as we English like to say) and sending the particles out to infinity. Unfortunately, this is a flaw in this "brute force" operator; try setting new seed values in the Position Icon operator and resimulate and/or reduce the particle system a touch.

Finally try increasing the amount of star clusters and add more veins to the dust clouds to add more detail. This can be achieved with an additional system having more Wind influence, coupled with some spawning to create the tendril smoke effect that the dust clouds have. Have a look at the Cigarette Smoke tutorial in the supplementary book for more information on mixing multiple Wind Space Warps to create a more natural distribution.

By the time this book hits the shelves, the Creativity Extension for 3ds Max 2009 will already be out which gives you access to the Initial State operator. This, therefore, makes the Script and Mesher setups redundant as the initial particle positions can be set up with the Initial State operator(s); however this script/ Mesher setup is still included in this tutorial due to the fact that not everyone may be on the 3ds Max subscription program and, therefore, (currently) won't have access to this operator.

16 Ray of dusty light

Introduction

In this tutorial we're going to create a sunbeam effect from an off-camera light source. Normally we'd resort to using simple volumetrics for this type of effect, but due to the sheer proximity of dust, one could see the individual particles. This being the case, we need some high Depth of Field effects; to accomplish this, we'll unlock a mental ray shader and use it to create the Bokeh lens effect before rendering.

Analysis of effect

(a) Bokeh effects are present in all photography; some are subtle while some are more prominent. A portrait with a blurred background, for example, will show this effect in the out-of-focus areas; it's how light is directed through the lens derived from the shape of the lens and aperture. This type of sunbeam effect is mainly prominent in poorly lit environments with a single shaft of light streaming through; however, the Bokeh lens effect is only visible in these rays with a pretty exaggerated depth of field. This can normally be achieved with a macro lens, shooting almost directly along the ray so that the dust particles are illuminated by the backlit sun. The prominence of the effect is also directly related to the size of the aperture of the camera, which also has an effect on the Bokeh shape; wider apertures (lower f-stop values) result in more circular patterns, while smaller apertures (higher f-stops) produce more defined hexagon shapes due to the shape derived from the lens which is being occluded by the internal blades. (b) Depending on the lens and/or its manufacturer, these may be angled and/or curved to reduce any artefacts in photography. Saying that, stylized Bokeh effects can be produced by using a template over the lens for some pretty interesting effects! Additionally, depending on the grade of the glass and its manufacturer, you may also see chromatic aberrations in the resulting image. This is due to light being fractured into its red, blue, and green components and received by the CCD, resulting in a form of ghosting; however, not all purple fringing is caused by this effect – often it's the case of a poor-quality CCD which can't focus small rays of light (e.g., from highlights) onto the relevant color receptor, thus resulting in a false color. (c) The dust

a the Bokeh effect in action - note the out of focus shapes of the light through the tree.

ello burdz

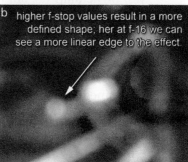

b higher f-stop values result in a more defined shape; her at f-16 we can see a more linear edge to the effect.

c the dust particles are most visible when viewed along the beam, towards the light source.

d note that even in this image with a slower shutter speed, particles outside the beam are not visible.

itself, however, is quite basic in its motion, yet graceful unless exaggerated by external forces; there appears to be one large motion covering the majority of the mass with smaller turbulent areas within the bulk of particles. The particles themselves, however, are only visible within this beam; they aren't apparent, either in photography, footage, or indeed to the naked eye (well, not as much anyway) unless they're highlighted by bright light. (d) That is to say that the particles outside of this beam become virtually invisible, so we've a nice effect of the particles entering the beam, swirling around, and fading out as they exit, often out of focus.

In 3ds Max we don't natively have a filter to create this effect. Or do we? Well yes, we actually do, but it's actually disabled by default, buried deep within the *architectural_max.mi* file; you can find its details within the mr Arch and Design Viz Shaders documentation included with the software. A quick editing of this .mi file will result in the shader becoming available as a Lens shader accessible either via the Material Editor or in the Lens slot in the Camera Shaders group in the mental ray's Renderer tab. A good thing about this shader is that you not only can design the shape to suit your end effect but also animate it as desired. However, in this case, we're going to forego all that and design one of our own, which will incorporate a touch of a fake chromatic aberration effect by a simple bitmap edit. The dust itself is simply a basic particle system with two subtle Wind Space Warps, one to drive the overall turbulence and another just to give some smaller internal motion. These particles will reference geometry in the scene, which will be designed with basic modifiers to simulate small dust. Again, these needn't have to be complex to get the desired effect. The particles will be illuminated with a single intense Spotlight which cuts through the particle cloud. The particles themselves will be shaded with a two-sided material that simply has a Falloff map assigned to the Opacity slot set to Light/Shadow so that when the particle is in shadow it becomes transparent (otherwise we'd have black floating particles in our environment!). The environment itself is a simple .hdr bitmap taken from the standard 3ds Max map repository that ships with the software.

Okay, now it must be said that I've tried to sneak this one in. Technically, it isn't really air but particulate matter which is affected by air turbulence, though it isn't really the air motion we're trying to simulate but the particulate

matter and a camera effect. Saying that, I felt the need to incorporate this effect into the book as the light beam visibility effect is quite unique and the end results are very effective, yet there are some issues which will be covered in the "Taking it further" section.

Disclaimer: Amending the *architectural_max.mi* file is part of this tutorial you do at your own risk. The publishers, their associates, former room-mates, the author, the contributors, or anyone they know can't be held responsible if you mess up in editing the file without making a backup beforehand!! Right, with that bit of legal jargon out of the way, let's move on.

Walkthrough

PART ONE: First we'll unlock the Bokeh shader by editing a mental ray text file before checking it out in a blank scene.

1 Firstly enable the Bokeh shader. In Windows Explorer, navigate to your default 3ds Max 2009 installation folder and go to the *\mentalray\ shaders_standard\include* folder (normally located in *C:\Program Files\ Autodesk\3ds Max 2009\mentalray\ shaders_standard\include*). Copy the *architectural_max.mi* file to another location.

Information: Okay, this step is very important. This file links up a fair amount of shaders within 3ds Max, so ensure you backup the original file. Drop a copy of it on your desktop or elsewhere you can restore the file from later on.

2 Move this .bak file out of this folder to a safe location for backup. Open your favourite text editor (Notepad will do) and load the *architectural_max.mi* file. Navigate down this file until you reach:

```
gui "gui_mia_lens_bokeh" {
    control "Global" "Global" (
        "uiName"   "Arch: DOF/Bokeh",
        "hidden"
```

Comment out the "hidden" statement by placing a # in front of the first quotation mark, resulting in:

```
gui "gui_mia_lens_bokeh" {
    control "Global" "Global" (
        "uiName"   "Arch: DOF/Bokeh",
        #"hidden"
```

Save the file.

Information: By adding the # symbol in front of the "hidden" statement, we're simply commenting out that particular line, thus enabling the Bokeh shader. Again, I stress that neither the publisher nor I take responsibility of 3ds Max's stability by editing this file. In a worst case scenario, restore the original file from the backup you've made! Sorry for the legal jargon, but had to mention it!

3 Next, restart 3ds Max and switch to the mental ray Renderer. Open the Render Setup panel and navigate to the Renderer tab. Scroll down to the Camera Shaders group and click on the Lens slot's None button. In the resulting Material/Map Browser dialog, the Arch: DOF/Bokeh shader should be present. If not, double-check the *architectural_max.mi* file to verify you've edited it correctly and/or restore the original file and try again.

Information: You should now see the Bokeh shader present in the shader list either in the Material Editor or in this Lens slot; however, as it's a mental ray shader, it's only present when using the mental ray renderer.

PART TWO: Next we'll load the start scene and add Space Warps and lights before designing our particle system.

4 Open the *16_Bokeh_Sunbeam_ Start.max* file included with this tutorial and accept any file unit change if prompted. In the Top Viewport, create a Wind Space Warp and label it Wind_Small. In its Force group, set its Strength value to 0. In its Wind group, set Turbulence to 1 and set Scale to 0.02. Create another Wind Space Warp in the Top Viewport and label it Wind_Large. Again, set its Strength to 0 and Turbulence to 1. This time set the Scale value to 0.005.

Information: We must use the same unit setup so that your inputs will give the same results as this tutorial. As we're dealing with "physical" cameras, we need to deal with real-world units. The initial Wind Space Warp creates a small turbulent wind pattern, thanks to its Scale size, whereas the second one creates a larger pattern. This may be confusing as the Scale values seem to conflict this; basically the smaller the Scale value, the larger the wind shape.

5 In the Left Viewport, create a Target Spot Standard Light and drag it out as illustrated so that light can pass right through the Particle Flow icon; the light should be roughly 1000 mm to the left of the origin and about 150 mm high. Position its target approx. 200 mm to the right of the origin and about 57 mm below the origin (coordinates 0, −200, −50). Set its Multiplier value to 7, expand the Spotlight Parameters rollout, and turn on Show Cone. Set the Hotspot/ Beam value to 1 and the Falloff/Field value to 3.

Information: This light will be used to illuminate the dust particles. It's been positioned such that it cuts right through the icon so that particles can travel in and out of its beam. We've cranked up the Multiplier value so that the light is very intense and that the Bokeh effect we'll add later on is pretty prominent in the resulting render. The Hotspot/Beam and Falloff/Field values are set very low as we just need a thin ray of light passing through the particles.

PART THREE: Next we'll create basic debris templates to shape the particles in our system like dust particles.

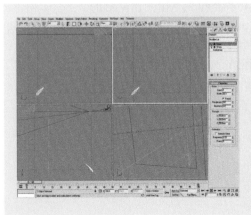

6 In the Top Viewport, create a Geosphere primitive and label it Debris01. Set its Radius to 0.5 mm and set Segments to 2. Add an XForm modifier and go to its Gizmo sub-object level. Vertically scale down the Gizmo in the Left Viewport to 50%. Add a Noise modifier and set the Seed value to 1. Set Scale to 36, enable Fractal, and set Strength to 50 mm for all three axes.

Information: We've added an XForm modifier to squish the geometry down, resulting in flatter flakes; it's easier to apply it this way rather than in the particle system, plus the Optimize modifier we'll add later on can take this deformation into account.

7 Add an Optimize modifier and set the Face Thresh value to 8. Copy this object three times and set the Noise modifier's Seed value in each new copy to 2, 3, and 4 respectively. Select all four Debris objects and navigate to the Hierarchy tab. In the Move/Rotate/Scale group, click on the Affect Pivot Only button and click on the (now visible) Center to Object button. Click on the Affect Pivot Only button again to deselect it. Link the Debris02, Debris03, and Debris04 objects to the Debris01 object.

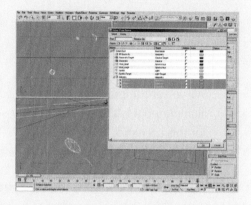

Information: We've used an Optimize modifier to reduce the geometry count so that the memory overhead is reduced (they're going to be rendered out pretty small anyway!) when referencing the geometry in the particle system. We've also created copies of the original and amended the seeds so that we've a few different particle shapes to work with, and they're linked to the initial debris object as this object will be referenced within the particle system and call on its "children" as other particle shapes within the same system. The pivot points have been relocated so that they spin around their center; because of the Noise modifiers, the geometry has been relocated away from the original pivot point, else it'd result in the particles spinning around thin air!

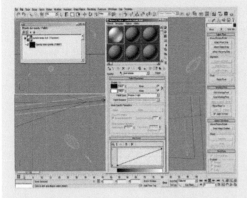

8 Next, go to the Material Editor and label a Standard material Particle Beam Dust. Enable 2-Sided and set the Diffuse color to white. Add a Falloff map into its Opacity slot and label it Dust Opacity. Change its Falloff Type to Shadow/Light.

Information: This is a basic dust material with the main crux of it being in the Opacity map so that the unilluminated particles are rendered out as transparent. We've set the material to 2-Sided so that the internal back faces are also illuminated, resulting in a kind of pseudo translucency effect that works well for this scenario.

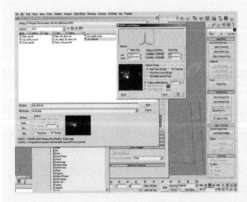

9 Add a Bitmap map to a free sample slot in the Material Editor and load the *Loft_Med.hdr* file included with 3ds Max (in the *\maps\HDRs* folder in the default installation directory location – e.g., within Program Files, not within your 3ds Max user folders in My Documents folder). On loading, in the Internal Storage group, choose Real Pixels (32 bpp) and click OK to close this dialog.

Information: Here we're simply setting up the background map for rendering later on. We're using the *stick.hdr file* as the background as it'll show up the particles nicely due to it being an internal scene with bright windows. We're using a 32-bit image in case we may want to add photographic exposure later on (see the "Taking it further" section for more information).

10 In the resulting Bitmap map, label the map Environment, and in the Coordinates rollout, choose Environ. Choose Cylindrical Environment from the Mapping menu. Set U Offset to 0.62. Open up the Environment and Effects panel and instance this map to the Environment Map slot in the Background group.

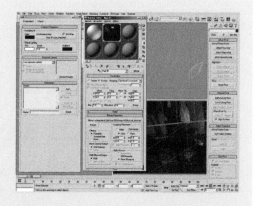

Information: We've simply offset the map horizontally so that the resulting camera view has the window in the bitmap just off frame, akin to the positioning of light we've added to our scene. The Camera01 Viewport has already been pre-set to update with the background environment image.

11 Next, enter Particle View by accessing it via the Graph Editors menu. Drag out a Birth operator to the event display to create a new event. Wire the input of this new event to the output of the PF Source 01 event. Set the Emit Start and Emit Stop values to −100 and Amount to 10 000. Add a Position Icon operator to the event.

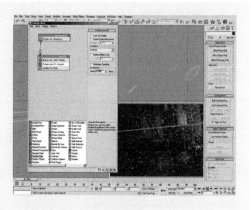

Information: The Emit Start and Emit Stop values have been set back to −100 so that the Wind Space Warps we'll add shortly can have time to ramp up their motion, and so it doesn't look as if the particles are speeding up in the resulting render; they're already at speed, thanks to the 100-frame buildup.

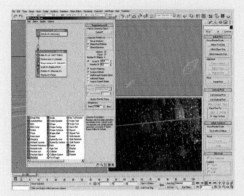

12 Add a Shape Instance operator to the event. In this operator's Particle Geometry Object group, click on the button and select the Debris01 object in the scene. Turn on Object and Children in the "Separate Particles for" group. Set the Scale % value to 25 and Variation % to 25. Add a Scale operator to the event and set its Type to Relative First. In the Scale Variation group, set the X, Y, and Z values to 50. Add a Rotation operator to the event.

Information: Here we're referencing the source geometry in the scene and using its children as different particle shapes as mentioned earlier. Even though we've a subtle scale variation set in the Shape Instance operator, we've added another Scale operator that inherits this original scale value and applies another variation to it, adding more of a natural breakup in scale size. The Rotation operator has been added just to initially offset the particles before they start spinning, which we'll add next.

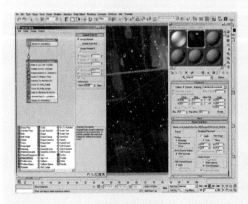

13 Add a Force operator to the event and add the Wind_Small Space Warp to its Force Space Warps list. Set its Influence value to 1. Add a Force operator to the event and add the Wind_Large Space Warp to its Force Space Warps list. Set its Influence value to 1. Add a Spin operator to the event and set its Spin Rate and Variation to 75. Finally add a Material

Static operator to the event and instance the Particle Beam Dust to the material slot in this new operator. Change the Display operator's Type to Geometry to see the particle shapes in action!

Information: As we're dealing with small slow-moving particles, we don't expect the Force operators to have much influence. Obviously this value could be animated later on if you want to simulate someone walking across the ray of light and disturbing the particles! The Spin operator simply creates a subtle turning motion to break up any uniformity of the effect, and will result in a nice change in intensity in the Bokeh effect for each particle as it turns and as the light catches its different surfaces shaded with the Material Static operator.

PART FOUR: Finally, with the particle system and light set up, we'll set up and assign the Bokeh lens effect.

14 Open the Render Setup panel and change Renderer to mental ray Renderer. Navigate to the Renderer tab and add an Arch: DOF/Bokeh to its Lens slot in the Camera Shaders group. To access this shader's parameters, instance this shader to a free sample slot in the Material Editor.

Information: Here's where we access the main effect. As we can't view the properties of this shader from within the Render Setup panel, we've to instance this shader across to the Material Editor. Ensure you actually instanced it across and not just copied it, else any settings we make will have no effect on the end result!

15 In the Arch: DOF/Bokeh shader in the Material Editor, set Focus Plane to 130 mm. Set Radius of Confusion to 3 mm and Samples to 64. Enable Use custom Bokeh map and click on the Browse button at the bottom of the Arch: DOF/Bokeh Parameters rollout. Choose the five-sided *rgb.tif* file included with this tutorial (there's a .psd file for you to construct your own if you desire!). Finally render off the sequence. This may take a while due to the background image being blurred, so see the "Taking it further" section for more information.

Information: We've increased the Samples value to 64 as the Radius of Confusion (the size of the camera's "iris") will spread out the resulting particles; you could set the Radius of Confusion value higher for a larger Bokeh effect; however, this would result in a more grainy Bokeh effect, in which case you should increase the amount of samples. Alternatively, you may increase the amount of samples in the Render Setup panel's Renderer tab. The bitmap file we loaded is simply a cutout five-sided shape with a small color wheel effect in the middle; try creating your own custom shapes in Photoshop (or equivalent) using the .psd template provided. Try removing the color element within the file and see how the resulting render will look like, or try painting your own. Remember to keep this file relatively low in size to save memory and, therefore, render time. Alternatively, try foregoing the file approach and use the Bokeh shader's own blades setup!

Taking it further

This scene, with all the settings used, may take a while to render especially if you're dealing with a lower spec machine and/or are rendering out with a large canvas size, and decided to increase the amount of samples to improve render quality. The reason why this sequence takes so long is the particles being so small that it obviously results in sampling issues unless we crank up the amount

of samples either in the Bokeh shader or in the Render tab. Either way, it's going to take a while if you've got large particle counts or decided to up the Radius of Confusion. Actually, if you decide to bring down this value, these tiny particles won't be as diffused; therefore, you can afford to drop the amount of sampling.

At this point, we need to discuss a bit of camera theory; the shader that we've used simply determines the depth of field and isn't directly tied to the mr Photographic Exposure Control tool; however, with a bit of working out, we can derive the correct correlation between the two if you wish to get technical. The Radius value in the Arch: DOF/Bokeh shader deals with real-world/scene units, which represents the radius of the camera's iris which in turn relates directly to the camera's f-stop value. The diameter of the iris (radius value × 2) can be determined by dividing the focal length by the f-stop value; therefore, the relationship can be defined as:

(Radius × 2) = focal length/f-stop

or

Radius = (focal length/f-stop)/2

Therefore, you can derive the correct Radius value from your mr Photographic Exposure Contol values or vice versa when dealing with Photometric lights.

One other way to decrease render times is to bin the background image straightaway and composite it using your favourite compositor. Actually, I'd seriously advise you to render off in passes as it's good to get into the habit of doing this. I know I keep mentioning it, but there's only little you can do in 3D without wasting time – it's so much easier to tweak the settings than have to go back into the 3D package and re-render. A case of this point is the Taken Further scene available with this tutorial, which includes a simple volumetric light. Obviously with the Arch: DOF/Bokeh shader applied, it'd take a while to render off, so this effect is simply rendered in layers (background, particles, volumetric) and composited afterwards. If you've got a copy of Combustion, the workspace file is included for you to play with, along with the rendered assets, though you may need to point Combustion to the files when loading the workspace file.

It has to be mentioned (at this late stage!) that this type of effect is normally produced as a post-process applied in a compositor (you could even batch-job the sequence in Photoshop!); however, getting the overlapping depth effects is a bit of pain; so rendering it off here is a viable solution, just not a very fast one if you crank up the quality. Saying that, if you'd no knowledge of any compositing package, seriously, now is the time to start. Well, after you've finished this page and read the Appendix.

Try changing the design of the Bokeh template to suit your needs; girlfriend/boyfriend's birthday? Change the template to a love heart, change the color of the template to red and hey presto! Instant Hallmark moment! You may also want to add particulate matter to the grass scenes to simulate pollen dispersal – this effect would work very well in scenes like these. Just as when we originally had lens flares in our scenes, sky light rigs, HDRI, and final gathering, personally, I can see Bokeh and real-world camera effects being the next stage of "detail" that we enthusiastically add to our renders. It just makes things, well, nice.

I also have to mention that by amending the *architectural_max.mi* to unlock a shader not officially supported by Autodesk, you've now damned your 3ds Max scenes to come out with tons of depth of field, which will result in higher render times, more caffeine, and lack of sleep. Therefore, your current spouse will now leave you for a compositor*.

Sorry about that . . . Happy rendering!

*or an editor.

Appendices

■ The next step and further reading

■ Plugin solutions

The next step and further reading

I'd recommend you take a camera with you even when you're out on a normal day so that you can take a picture of that amazing sunset or pollution haze, depending on where you live. As before, collect as much reference material as possible should you wish to recreate it in 3D in order that you have a better understanding of the effect when you get the images back to the studio. Also, take a pencil and paper out so that you can make notes about the effect while you are viewing it. Alternatively, if you've a small digital video camera, you could just give a quick running dialog of the effect on what is happening. You may look like an idiot, but if it can help you re-create that effect better later on, five minutes of strange looks are worth it!

Above all, have fun! 3D is simply another medium that an artist can work with and, like working with brush, paint, and canvas, it takes time to hone your skills. Persevere and you'll succeed. Hopefully, by the time you get to this part, you've had a firm grasp on what to look for and how to break down and analyze your own reference material, and that when you're out on your travel, you'll start to view the world through a different set of eyes.

There are numerous 3ds Max books out there; some great, some not so great (I hope you class this one in the former category!), but, to my knowledge, there isn't any which solely covers the natural elements. Therefore, my main suggestion would be not to go out and spend a fortune on books, but to go out and observe the natural world in all its beauty. Yes, we've some reference material supplementing this book in electronic format, but there is only so much I can shoot and source in the allocated time I've had to produce this book. Take a camera or video camera and shoot as much reference materials of an effect as you can. If you've the opportunity, shoot in different lighting conditions, different times of the day, different exposures and so on. By analyzing all these scenarios, you'll start to understand what generates the effect, how it behaves, and how you can recreate it.

For further reading, I'd suggest you get your hands dirty and read up on the science behind creating these natural effects. Granted, some of them may be

right over your head (a lot of it is way over mine), but nevertheless it does make for interesting read. I'd also suggest you look at a lot of landscape photography books, simply to expand your horizons and to view places you've never visited; Yann Arthus-Bertrand's *The Earth from the Air*, for example, is an exceptional work and is very highly recommended.

Computational Fluid Dynamics – John D. Anderson
Elementary Fluid Dynamics – D.J. Acheson
Turbulent Flows – Stephen B. Pope
Geophysical Fluid Dynamics – Joseph Pedlosky
A First Course in Fluid Dynamics – A.R. Paterson
An Introduction to Fire Dynamics – Douglas Drysdale
A Professional's Guide to Pyrotechnics: Understanding and Making Exploding Fireworks – John Donner
Principles of Fire Behavior – James G. Quintiere
Blaze: The Forensics of Fire – Nicholas Faith
Introduction to Mathematical Fire Modelling – Marc Janssens
Volcano (Eyewitness Guide) – Susanna Van Rose
Understanding Flying Weather – Derek Piggott
Atmosphere, Weather and Climate – Rodger Barry
Introductory Oceanography – Harold V. Thurman and Elizabeth A. Burton
Fundamentals of Physics and Chemistry of the Atmosphere – Guido Visconti
A Short Course in Cloud Physics – R.R. Rogers and M.K. Yau
The Blue Planet – Andrew Byatt, Alastair Fothergill, Martha Holmes and Sir David Attenborough
Cloud Dynamics – Robert A. Houze
The Colour Encyclopedia of Ornamental Grasses: Sedges, Rushes, Restios, Cat-tails and Selected Bamboos – Rick Darke
Grasses, Ferns, Mosses and Lichens of Great Britain and Ireland – Roger Phillips and Sheila Grant
Grasses (New Plant Library) – Jo Chatterton and Trevor Scott
Form and Foliage Guide to Trees and Shrubs – Susin Chow
The Watercolourist's A–Z of Trees and Foliage: An Illustrated Directory of Trees from a Watercolourist's Perspective – Adelene Fletcher
World's Top Photographers: Landscape – Terry Hope
First Light: A Landscape Photographer's Art – Joe Cornish
Large Format Nature Photography – Jack Dykinga

Plugin solutions

Even though this book has been designed to get you to use your knowledge gained in the "Analysis" sections in the areas of 3ds Max so that you don't have to use a plugin, at times you'll have to either get your hands dirty, or code a script or plugin yourself to do the job, or buy one of the excellent off-the-shelf plugins. Here I've mentioned a few of the plugins and third-party solutions out there; bear in mind that some additional plugins may be released new and/or some withdrawn after the time I wrote this to the time you're reading it. I've only mentioned products that are currently available for license and not those in-house developed as these are often kept close to the studio's chest! There are also several freeware and open source projects out there which give excellent terrain generation and mesh output for importing into 3ds Max.

Afterburn – www.afterworks.com

This plugin needs no introduction and is often the one I'd turn to at a moment's notice due to the sheer range of effects that can be created with it. I could waffle on and on about its features, but there's no point as you've more than likely seen its results in several feature films ranging from *Armageddon* to the *Matrix* series. Hats off to Kresimir for continuously developing this product although the competition has faded away.

Krakatoa – www.franticfilms.com

Voxel-based point rendering and particle caching system from the VFX house Frantic Films. Reportedly used in feature films such as *Superman Returns* (Krypton destruction sequence) among others, it enables the user to expand on 3ds Max's particle limitations by layering multiple caches on top of each other, plus the ability to change features such as color, etc., without having to re-render. Genius!

Aura – www.chaosgroup.com

The next-generation system from Chaos Group, producing fluidic voxel effects for complex fire and realistic smoke.

Flowline – www.flowlines.info

Originally designed as an in-house tool by the German VFX house Scanline, Flowline has recently been tried and tested in production to give excellent results for fire, water, and other fluid-based effects. Presently (at the time of writing) it's not available as an off-the-shelf solution, but here's hoping!

Real Flow/Real Wave – www.nextlimit.com

As 3ds Max currently has no native fluid dynamics system, Real Flow is an alternative offering the ability to import scene data from 3ds Max and apply almost any fluid-based system ranging from the pouring liquids to the floods, and with the inclusion of Real Wave, we can simulate large bodies of water and have breaking waves, splashes, and the like with relative simplicity.

Glu3D – www.3daliens.com

Another fluid-based system, however, within the 3ds Max Viewport and integrated within Particle Flow, making it an ideal solution for 3ds Max pipelines and for those who don't want to keep exporting mesh data to external programs. Also, it's a very nice alternative to the Blobmesh Compound Object type.

Dreamscape – www.afterworks.com

Another plugin from the developers of Afterburn, you can expect the same kind of exceptional quality. The sea shaders are exceptional and can simulate deep oceans, foamy peaks, large bodies of water, and sub-surface effects quickly and easily. You can even throw objects onto the surface and have them interact with it, or even propel them across the surface, creating wakes as they move. Not only does Dreamscape produce water effects, it also has a very nice terrain designer and new materials which allow us to create a variety of terrain effects. Perfect for creating mountainous terrain! The beauty of this is that we can also render off the terrain as a voxel, which means there's virtually no geometry; so it renders an exceptionally high quality terrain in a fraction of time it'd take to render off the mesh equivalent. We can also design a wide range of cloud effects and use Afterburn technology to produce 3D volumetric clouds which converts the normal 2D cloud layer into a 3D volumetric; perfect for backlit sunset effects!

Index

2D cloud layer, 310
3D distribution of particles, 270
3ds Max, 97, 132, 208, 212, 233, 240, 294, 309, 310
3ds Max's particle limitations, 309
3ds Max Help file, 223
3ds Max interface, 227
3D volumetric clouds, 310

Accel Limit, 233
Accel Limit value, 100, 101, 272
 negative force and high, 101
Adaptive Coarseness values, 18
Adhered fragments, 43
Advanced Effects group, 228
 Fspot01 light's, 228
Advanced Rendering Options, 107
Adverse effects, 225
Afterburner, 60, 61, 62, 79
 analysis of effect, 61
 cone and thrust beam, 63
 expressions set up, 74
 initial lights set up, 67
 intensity of, 79
 internal lighting, 77
 numerous lights for, 62
 "trademark" effect of, 61
 volumetric lighting, 64
 volumetrics set up, 72
Afterburn technology, 310
Age tests, 264
Aggregate particles, 91
Aggregation process, 84, 97, 111
Air, 223, 227
 IOR of, 227
Air/bubble interaction, 136
Air bubble mass, 257
Air bubbles, 108, 227
 collapsed, 108
 frozen, 108
Air particles, 97

Air resistance, 139
Air turbulence, 292
Angle grinder, 43
Angle grinder effect, 42
Angle Snap value, 194
Angle value, 180
Animation Offset Keying group, 102
Arch and Design (mi) material, 96, 98, 105, 113, 114, 117, 119, 208, 217
Arctic scene, 191, 202
Armageddon, 309
Array tool, 74
Assign Controller, 229
Assign Renderer rollout, 226, 246
Atmosphere, 207
 size of, 207
 surface material, 207
Atoll, 177, 181
 formation, 177
Atoll Island Mix map, 184, 188
Atoll Shape, 180, 181, 185
Atoll Terrain Bump map, 188
Attenuation boundary, 77
Attenuation color, 69, 70, 71
Attenuation values, 66
Autosave, 271, 278

Background image, 105
Backlit sunset effects, 310
Back material, 285
Beer, 114
Beer_Surface, 119, 127
Beer materials, 115
Beer surface geometry, 115
Beer Surface material, 120
Beer to Glass Interface, 120
Bend modifiers, 23, 24, 180
 combination of, 180
Bezier Float controller, 229
Billboard particles, 18
Birth operator, 11, 34, 48, 89, 228, 268, 270

Birth Rate, 223
Birth Script, 264, 278
Birth Script operator, 279, 281
Bitmap map, 98, 109, 213
Blend material, 116, 117, 118, 119, 282
 glass condensation, 118, 119
Blobmesh, 104, 111, 124, 125, 223, 237,
 248, 257, 258
 clone of, 125
 collapsed, 111
 default, 237
 geometry of, 237, 258
Blobmesh_Droplets, 124, 125, 127
 collapsed object, 124, 125, 127
Blobmesh_Icicles, 103
Blobmesh01 object, 238
Blobmesh Compound Object, 3, 5, 85, 91,
 98, 100, 103, 115, 123, 133, 144,
 231, 244, 310
 surfaced with, 123
Blobmesh geometry, 261
Blobmesh object, 7, 8, 92, 124, 125, 137,
 235, 236, 237, 240, 257
 uncollapsed, 125
Blobmesh object Icicles, 104
Blobmesh operator, 14
Blue Cloud Bright material, 285
Blue Cloud Dust material, 285, 286, 287
Blue Cloud Renderable event, 279, 281, 286
Blue clouds, 282
Blue Cloud Sim, 268, 270
Blue Large Stars Sim, 270, 271, 272
Blue Stars material, 286
Blue Stars Sim, 270
Blur offset value, 109
Blur value, 161, 170
Bokeh effect, 291, 296, 301, 302
Bokeh lens effect, 290, 291, 301
Bokeh map, 302
Bokeh shader, 293, 294, 295, 303
Bokeh shape, 291
Booleaned geometry, 126
Boolean operations, 115, 125, 126, 129
Bottle_Boolean_Subtraction object, 125
Bottle_Droplet_Emitter, 122
Bottle_Droplet_Emitter object, 123
Bottle Condensation, 118
Bottle Condensation Mask map, 121

Bottle model, 115, 125
Bottle object, 116, 117
Bounce value, 157
BRDF (bidirectional reflectance distribution
 function), 214
BRDF rollout, 107
Brightness, 239
Bubble_Stream_Emitter, 226, 230
Bubble_Stream_Emitter object, 231
Bubble Birth event, 228, 232
Bubble Edge event, 255
Bubble Edge Torn event, 255
Bubble Emitter Map, 225
Bubble Falloff map, 146
Bubble formation, 97
 internal, 97
 water, 97
Bubble geometry, 238, 239, 259
 deformation, 241
Bubble material, 222, 228, 235,
 238, 258
 surface of, 222
Bubble motion, 228
 simulation, 222, 223
Bubble particles, 224
 emission, 222, 223, 225
 influence of force operator on, 234
 larger, 240
 main turbulent motion of, 233
 motion of, 225, 226, 231, 232
 scale value of, 226, 233
 smaller, 240
Bubble Pop Influence event, 141, 142, 143
Bubble popping, 149
Bubble Reflection Falloff Control, 146
Bubble rippling, 145
Bubbles, 111, 222, 223, 228, 231, 232, 235,
 237, 241, 243, 244, 255, 261
 collapsed, 111
 "dancing" motion, 222
 deforming, 241
 edges of, 255
 hemisphere, 243
 interacting with water, 243
 internal, 111
 IOR value of, 223, 244
 large, 231, 235, 241
 "torn off", 243

size of, 222
small, 231, 235, 237
unique property, 243
Bubbles Stream tutorial, 242
Bubble stream:
analysis of effect, 222
Bubble Stream Emitter, 225
Bubble Tear Check event, 255
Bulbous mesh, 92, 145
Bump Amount value, 189
Bump map, 129, 170, 177, 189, 208,
212, 217
Bump Map slot, 188
Bump Mixer map, 201
Bump slot, 199
Bump texture, 108
Bump value, 108

Cache modifiers, 269, 273
Cache operators, 271
Caches, 309
Camera Shaders group, 292, 294, 301
Camera theory, 303
Cap Holes modifier, 15
Caustic effect, 128
Caustics, 127, 128
Cell Characteristics group, 106
Cellular map, 22, 27, 28, 30, 32, 98,
106, 107, 129, 190, 193, 200
color distribution in, 28
color strength of, 32
Cellular sub-map, 32
white areas of, 32
Chaos Group, 309
Child stream particles, 37
Chromatic aberration effect, 292
Cloud effects, 279, 310
Cloud Mask, 284
Clusters, 233
Coarseness value, 124, 258
viewport evaluation, 124
Collation, 111, 114
Collision accuracy, 87
Collision detection, 111
Collision test, 11, 38, 50, 90, 91, 163, 164
Color Balance, 239
Color Correction map, 208, 213
Color swatch, 106, 107

Common Parameters rollout, 238
Condensation, 114, 115, 122, 128, 130
collation of, 113, 114
Condensation droplets, 122
Condensation map, 128, 129
Condensation material, 118
green glass, 118
Cone, 61, 63, 72, 80
attenuation feature to, 63
orange licks of flame, 80
Contrast effects, 239
Control Gradient Ramp Map, 121
condensation Blend, 121
Controller, 229, 230
noise, 229
Coplanar faces, 129
Coplanar polygons, 126
Cora:
Darwinian explanation of, 178
Coral formations, 178
Core radius, 90, 100, 101
low, 101
Cracks, 97
ice, 97
Current Particle System, 100, 233
Cut-off threshold, 222
Cylindrical Environment, 238

Daylight system, 201
Debris objects, 297
Debris surfaces, 58
non-renderable particles, 58
Debris system, 111
Default In/Out Tangents, 102
Default Tangent, 227
Default value, 237
Deflector01 Space Warp, 164
Deflector geometry, 129
Deflectors, 46
Deflector Space Warp, 86
Delete Mesh modifier, 29
Delete operator, 11, 12, 47, 49, 53, 54, 91
Delete Particles, 123, 230
Denser light, 71
Density multiplier value, 179
Density value, 238
Depth of Field (DoF), 105, 107, 110, 111
parameters rollout, 110

Dialog panel, 229
Diamond-esque linear shape, 97
Diffuse Bitmap map, 212
Diffuse color, 117, 121, 122
Diffuse map, 46, 206, 208
Diffuse slot, 188
Direction-orientated operators, 141
Directional force, 137
Direct light, 74, 210
Displace modifier, 24, 28, 155, 160, 192,
 194, 196
 map into, 28
Display operator, 231, 269, 270,
 272, 279
Division Colors group, 106
Double Sided material, 285
Drag01 Space Warp, 234
Drag Space Warp, 224, 245, 249
 Force operator, 252
 Time Off value, 224
Droplet geometry, 125, 129
 collapsed, 125
 intersecting, 129
 shape of, 127
 small kinks, 124
Droplet interface, 129
Droplets, 115, 118, 123
 size, 123
Droplet to Glass Interface, 121
Droplet Water, 120
"Dry desert" effect, 200
Dummy object, 78, 210, 211
Dust, 290
 sheer proximity of, 290
 unilluminated particles, 298
Dust cloud material, 282
Dust particles, 291, 296
Dust Renderable event, 286
Dust Sim, 272

Edge Mask map, 170
Editable Poly, 264, 275
Emission points, 21, 22, 24, 25
 particles, 24
 particles to spread outwards, 25
 renderable surface, 22
Emissions, 21, 22
Emit Start values, 299

Emit Stop value, 8, 99, 123, 228, 299
 birth operator's, 123
Emitter geometry, 230
Emitter material, 223
Emitter Objects List, 230
Enable Final Gather, 240
Engine, 61
 internal illumination of, 61
Engine object, 78
Engine Vector, 73
Environment and Effects panel, 239, 287
Environment map, 98
Environment Map slot, 110, 238
Evaluation Coarseness, 236
 for Render and Viewport, 236
Evaluation Coarseness values, 104, 124
Explicit Map Channel, 169, 227, 283
Explosion Lifespan event, 55
Expression controllers, 72, 73

F-Stop value, 110, 303
 adjusting, 110
Face Thresh value, 105, 297
Facing material, 284, 285
Falloff effect, 18
Falloff map, 16, 19, 184, 199, 200, 208, 212,
 286, 292, 298
Falloff value, 90, 126, 211, 289
Falloff Zone, 101
Falloff Zone value, 269
Farasan Islands, 190
Far Attenuation group, 65, 66, 77, 216
Far Attenuation value, 64, 267
Feedback loop effect, 153
Feedback loop system, 175
Film Grain effect, 239, 259
Filtering, 288
Filtering group, 149
Find Target particles, 38
Finer waveform, 135
Fire, 17, 60
 shape of, 17
Fire effect, 4
Flame, 4, 5
 brightness of, 5
 Keep Apart operator, 8
 motion of, 4
 waveform pattern, 4

Flame geometry, 17
Flame kicks, 80
Flame Large Influence event, 12
Flame material, 16
Flame particles, 9, 10, 12, 17
 color and shape, 18
 emission, 11
 falloff effect, 18
 issue of disappearing, 14
 Keep Apart operator, 10
 larger influence on, 12
 speed of, 18
Flame shape, 3, 9
Flatter areas, 197
Float Expression controller, 72
Float List, 229
Fluid-based effects, 310
Fluid-based system, 310
Fluid dynamics, 3, 4, 19
Fluid dynamics system, 310
Fluidic voxel effects, 309
Focal length, 303
Fog color, 70, 287
Fog parameters, 16
Force operator, 11, 47, 140, **234**, 254,
 268, 273, 300, 301
Force operator strength, 223
Force Space Warps, 94, 98, 100, **224**, 245,
 273
Force Space Warps list, 234
Force value, 85, 100, 233
Fractal-esque patterns, 97
 cloudy, 97
Frame value, 160
Free Direct light, 210
Freezing, 97, 112
Freezing water, 97
Frequency value, 230
Fresnel-type effect, 68
Fresnel reflections, 107, 117, 119
Front Viewport, 265, 267
Frosting effect, 107, 108, 111
Fspot, 239
Fuel, 17

Galaxy:
 analysis of effect, 263
 creating the simulations, 268
 design and assign materials, 282
 facing particles, 279
 fogging effect, 287
 Mesher Compound Objects, 274
 omni light, 267
 Particle View, 268
 renderable particles, 277
 setting up the initial Space Warps, 265
 taking it further, 288
 walkthrough, 265
Galaxy distribution system, 262
Gas-fuelled fire, 4
Gaseous fire, 18
General Maps rollout, 107
Geometry, 237
Geometry count, 297
Geosphere geometry, 11
Geosphere primitive, 6, 209, 296
Gizmo Sub-Object level, 127, 225
Glass, 129
Glass/beer interface, 115
 IOR value of, 115
Glass Condensation, 116
Glass material, 117, 118, 119
 designed, 117
Glass texture, 129
 deformation in, 129
Global Illumination (GI) rollout, 128
Glossiness, 98
Glossiness map slot, 106, 118
 refraction group's, 106
Glossiness value, 118
Glossy effects, 117
Glow effect, 58
Glow element, 56
Glow Element rollout, 56
Glow Render Effect, 44, 47, 58
God Rays, 227, 228, 238, 247, 259, 261
 volumetric, 241
God Rays projector map, 247
Gradient Ramp map, 67, 68, 69, 119, 122,
 133, 147, 148, 158, 165, 177, 179,
 180, 181, 183, 184, 185, 188, 189,
 208, 211, 225, 226, 238, 258, 284, 285
 designed, 238
 phase value in, 147
Graph Editors, 268
Gravity01 Space Warp, 163, 234

Gravity Space Warp, 45, 47, 86, 100, 156, 224, 245
Green Glass material, 121
Ground Collision event, 52, 53, 54, 55

Hail aggregation, 94
Hail patterns, 83
Hailstones, 84
Half Frame, 87
Higher resolution image, 58
Hubble images, 207
Hubble Space Telescope, 207

Ice, 97, 101, 106, 107, 108
 collations of, 101
 pure and dirty, 106
 real IOR value for, 107
 surface texture, 97
Ice Aggregation, 111
Ice crystallization, 83
Ice formation, 84, 104
 blobby, 104
Ice formation patterns, 83
Ice material, 85, 92
 mental ray shader for, 92
Ice particles:
 emitter, 86
 using Phantom, 87
Ice structure, 97
Icicle Bump Speckle Small map, 109
Icicle construction process, 111
Icicle Draw, 99
Icicle drawing system, 103
Icicle formation, 96, 97, 105
 shielded, 97
 simulation, 100, 103
Icicle geometry, 96, 98, 105, 112
Icicle Impurity Color map, 106
Icicle Refraction Glossiness, 106
Icicles, 97, 99, 101, 102, 104, 109, 110, 111
 collating, 97
 constructed, 111
 detrimental effect on, 107
 reflections and refractions, 110
 refraction Glossiness map, 107
 simulated, 111
 width of, 102
Icicle Scale, 102

Illumination, 199, 285
Image Motion Blur, 18, 57
Index of Refraction, 223
Indirect Illumination tab, 240
Integration Step, 278
Internal pCont.particleFloat value, 233
Inverse Square Decay, 64, 267
IOR Interface, 223
IOR value, 113, 106, 107, 115, 117, 120, 121, 125, 129, 227, 244, 247
 incorrect, 125
 interface between glass and liquid, 121
 interface between liquid and glass, 120
Islands, 177
Iterations value, 104

Jet Beam light, 67
 projector map to, 67

KA Flames, 8
KA Turbulence, 10
KA Turbulence operator, 13
Keep Apart operator, 9, 10, 13, 14, 17, 84, 85, 89, 100, 101, 103, 112, 133, 139, 223, 233, 241, 264, 268, 269, 270, 273
 particle system in, 101
 stability of, 241
Keep Apart operator's Force value, 90
Killer event, 53, 54
Krypton destruction sequence, 309

Landscape (lume) map, 168, 171, 201
Large Blue Stars Renderable, 280
Large bubbles, 132, 142, 143, 242, 256, 261
Large Influence system, 13
Large Red Stars Renderable, 281
Larger rising bubbles, 244
Laser scanning information, 208
Lens Effects Parameters rollout, 56
Lens shader, 292
Light beam visibility effect, 293
Light Persistence value, 227, 246
Light rays, 228
 color, appearance, and motion of, 228
Light scattering, 97
Light scattering effect, 133, 147
Linear bubble shape, 252
Local Axis Co-ordinates, 104

Loose Sparks event, 51, 52
Luminance colors, 192
Luminosity slot, 18

Mach Disk elements, 74
Mach Disks, 61, 62, 67, 71, 77
 core of, 62
 intensity of, 62
 volumetric effect, 71
Mach Disk Vector, 75
Mack Disks, 72
Magenta/Green field, 239
Main controller, 229
Map Condensation Blend Control, 119
Map Icicles Bump Indentations, 108
Map information, 27
Mars:
 atmospheric effects, 215
Mask map, 283, 284
Material Dynamic operator, 47, 52, 163
Material Editor, 121, 225, 238, 282,
 283, 286, 287
Material modifier, 126
Material Static operator, 33, 228, 286
Matrix series, 309
Max Distance value, 107
MAXScript, 233
Mental ray, 110, 116, 227
Mental Ray's Daylight and environment
 systems, 193
Mental Ray's Daylight system, 191
Mental Ray Landscape (lume) shader, 193
Mental ray Renderer, 105, 149, 294,
 295, 301
Mental Ray shaders, 199, 290, 295
Mental ray tab, 127
Mesher Compound objects, 241, 264,
 271, 274, 275, 276, 277
Mesh Select modifier, 27, 198
Metal, 43
Metal ball, 3
Metal pipe, 48
Mix Map, 67, 182, 183, 200, 201
Motion, 231
 particle, 231
Motion Blur parameters, 56
Motion blurring, 40
Motion Blur value, 41

Mountain weathering:
 analysis of effect, 154
 constructing the particle system, 162
 feedback effect, 157
 setting up the Space Warps, 155
 walkthrough, 155
Mr Physical Sky map, 173, 174, 203
Multi-Pass Effect group, 110
Multi-Pass Motion Blur, 59
Multi/Sub-Object material, 120, 121, 127
 droplets, 121, 127
Multiple-pass motion blur, 18
Multiplier controller, 75, 76
MultiRes modifier, 125

NASA, 213, 217
Natural effects, 307
Near Attenuation group, 65, 66
Nitrogen bubble, 107
 illusion of, 107
Noise, 229
Noise Amount, 159, 180, 185
Noise Controller, 62, 78, 223, 229, 230, 236
 particles in, 236
Noise Float, 230
Noise group, 226
Noise Map, 68, 98, 108, 109, 118, 122, 179,
 189, 190, 200, 223, 227, 238, 247, 259
Noise modifiers, 105, 193, 197, 198,
 200, 241, 261, 296, 297
Noise Position controller, 78
Noise value, 181
Noise wave, 230
Normal Map, 208, 212, 214, 217
Nozzle contracts, 80
NURBS surface, 208
NVIDIA plugin, 208

Object Motion Blur, 18, 47, 57, 58, 59
Object Properties, 127
Off-camera light source, 290
Offset values, 283
Omni counterpart, 76
Omni lights, 63, 67, 74, 77, 179, 208,
 215, 216, 239, 259, 266
Opacity map, 146, 285, 298
Opacity slot, 298
Opacity value, 284

Opaque Shadows, 128
Optimize modifier, 27, 98, 105, 297
Oren-Nayar-Blinn shader, 32, 183, 193, 199
Output Amount value, 47
Output map, 29
Overlapping depth effects, 303

Pacific Ocean, 178
Park Explosions event, 54
Particle's Scale value, 235
 method for setting, 225
Particle accuracy, 27
Particle age, 252
Particle Age map, 46, 165
Particle age value, 142
Particle Beam Dust, 301
Particle counts, 111, 112
Particle distribution, 226
Particle droplets, 122, 128
 smoothing, 127
Particle effects, 111
 to simulate nitrogen collation, 111
Particle emission value, 230
Particle Flow, 223, 265, 296, 310
Particle Flow Parameters rollout, 237
 blobmesh object's, 237
Particle Flow system, 99, 111, 125
Particle Geometry Object group, 235
Particle motion, 235
Particles, 37, 39, 99, 100, 101, 103, 104,
 111, 232, 263
 collapsed geometry, 104, 105
 faceted geometry, 105
 geometry intersections, 111
 removes, 39
 size of, 104
 spawned, 101
 speed of, 37
 surfaced geometry, 103, 104
Particle scale values, 225, 232
Particle Size, 231, 233
Particle surfacing, 240
Particle system, 97, 101, 103, 104, 111, 115,
 122, 124, 225, 228, 229
Particle system mid-sequence, 228
Particle Value group, 232
Particle View, 228, 230, 268
Particle View event display, 99, 102, 228, 232

PCont.particleFloat value set, 234
Percent Snap Toggle, 225
PF Source, 01 event 101, 124
PF Source, 01 icon 99, 229, 236
PF Source, 01 root event 228
 output of, 228
PF Source Flames, 8
PF Source Flames root event, 9
PF Source Turbulence, 10, 12
Phantom, 7, 248
Phase value, 228
Photographic Exposure Control, 303
Photographic media, 239
Photometric lights, 303
Photoshop plugin, 211
Pixel group, 240
Plane primitive, 179
Planet, 207, 210
 direct light, 210
Planetary surface, 206
Planet map, 192
Planets, 207
 photos of planets, 207
Play Animation icon, 143, 236
Plugins, 309
Polygon elements, 111
Polygon mesh, 92
Polygons, 27, 28
 face Thresh value, 27
 selection of, 28
Poly Select modifier, 126
Position Controller, 73
Position Icon's Seed value, 251
Position Icon operator, 8, 88, 89, 143, 268
Position List controller, 78
Position Object operator, 14, 34, 37, 40,
 230, 236
Position Transformation coordinates, 73
Preserve Luminosity, 239
Production and Material Editor, 226
Projector map, 208
Pseudo translucency effect, 298
Pulsing animation, 78
Pulsing effect, 79
Push modifier, 26, 145, 196

Radial gradient, 226
Rate animation, 138

Rate controller, 229
Ray scattering, 107
Raytrace map, 17, 148
Raytrace material, 16
Real-World Scale, 158
Real Flow, 310
Reddening effect, 211
Red Large Stars Sim, 271
Red Stars Renderable event, 286
Reference materials, 98, 99, 104, 107,
 108, 111, 117, 120, 128, 307
Reflection Glossiness map slot, 118
Reflection group, 106
Reflections, 107
Reflectivity, 119
Reflectivity value, 106, 117
 high, 106
Refraction, 97
 icicles, 106
 of ice, 97
Refraction Color, 98, 106, 117
Refraction Color map slot, 106
Refraction glossiness, 96, 111
Refraction Glossiness map, 107, 110,
 118, 129
Refraction Glossiness values, 113
Refraction groups, 106, 107, 117, 119,
 120, 121
Refractions, 106, 118, 119
Relative Coarseness value, 237
Relax modifier, 15, 25, 91, 104, 124, 145,
 193, 196, 198, 237, 258
Relax value, 237
Renderable surface, 22
Renderer, 59, 227
 scene's, 227
Renderer tab, 240
 render Setup panel's, 240
Rendering, 260
Render Integration Step, 277
Render parameters, 127
Render Quantity Multiplier values, 99
Render Setup panel, 39, 92, 93, 226,
 240, 301
Render times, 137, 256, 303
Repulsive collisions, 139
RGB Level value, 110
RGB settings, 169

RGB values, 106, 107, 108, 118, 169, 227,
 238, 258, 284
Rim Light Effect, 199, 200
Rolls Royce and Pratt & Whitney, 62
Rotation operator, 38, 279, 300
Roughness value, 79, 105

Scale Factor group, 102
Scale operator, 34, 100, 102, 123, 252, 254,
 279, 300
Scale test, 232, 253
Scale threshold, 232
Scale value, 105
Scale Variation group, 102
Scanline, 59, 227
Scanline renderer, 44
Scatter Compound Object, 111
Scattered light diffusion, 131
Scene Motion Blur, 18
Scenes, 202, 211, 215, 260
 blobmesh object in, 260
 daylight lights in, 202
 direct light in, 215
 dummy object, 211
 mars object in, 215
Scripting Particle Flow, 233
Script operator, 223, 224, 231, 232, 233
Script Operator panel, 231, 233
Script Wiring, 233
Script Wiring rollout, 234
SDeflector, 5, 6, 11, 87, 91
SDeflector Space Warp, 6
Sea motion, 234
 simulating, 234
Sea surface, 222
Seed particles, 88, 89, 92, 94
Self-Illumination, 183, 184, 199, 215
Self-Illumination map slot, 47
Self-Illumination slot, 199
Shadow Map, 64
Shape Facing operator, 279, 281
Shape Instance operator, 235, 300
Shape Mark operator, 44, 48
Shape operator, 8, 11, 12, 34, 49, 100, 231,
 268, 279
 particles, 34
Shape size, 7
Shock Diamonds, 61

Small_Bubble_Reference, 225
Small_Bubble_Reference object, 235
Small Bubbles event, 141
 force operators in, 141
Smaller bubbles, 132
Smaller resolution sequence, 58
Smoothing Groups, 127
Smooth modifier, 98, 105
Snow aggregation, 192
Snowdrift_Terrain's modifier, 196
Snowdrift Terrain, 199
Soap bubble, 131, 132
 animated texture, 149
 background map to, 149
 color change, 132
 distribution pattern, 135
 particles shape and scale, 138
 physical size of, 132
 shape of, 136
 simulation, 144
 Space Warps, 134
Soft Selection rollout, 126
Solar Flare tutorial, 21
 ultraviolet, 21
Solid beam, 69
Source Color influence, 57
Space Warps, 6, 135, 234, 225
Spark Explosions event, 54
Spark particles, 46
Sparks, 42, 43, 55
Sparks material:
 color distribution, 47
Spawn Rate, 101
Spawn test, 35, 36, 37, 50, 52, 101, 102,
 112, 250, 254
 child particles generated by, 36
 multiple particles, 35, 36
 stream Emitters event, 37
Special Purpose Maps rollout, 108
Speckle/Noise map combination, 109
Speckle map, 98, 108, 109, 283, 284
 larger Size value for, 109
Speed operator, 86, 88, 89, 100, 123, 137,
 232, 240, 252
 influence value of, 100
Speed operator's Direction, 163
Speed test, 254
Speed value, 231, 232

speed operator's, 232
Spin operator, 301
Splat map, 118, 283, 285
Split Amount test, 51, 52
Sporadic cellular texture, 27
Sporadic patterns, 97
Spotlight, 77, 79
Standard Flow, 137
Standard Scanline renderer, 149
Standard Shape operator, 225
Static particles, 102
 spawned, 102
Steering Rate, 254
Stream of emissions, 22
 using Additive Transparency, 22
Streams, 22, 25, 41, 261
 angles, 22
 particles in, 41
 sheer number of, 25
Stream Spread Offset event, 36
 child particles in, 36
Strength field, 230
Strength value, 98, 224
Stucco map, 108, 182
Sub-Object Face selection, 29
Sub-surface effects, 310
Sunbeam effect, 290, 291
Sunlight, 210
Sun spot, 21
 ferocity of, 21
Superman Returns, 309
Surface Color Control map, 32
Surface Color Mix map, 32
Surface deformation, 27
Surface geometry, 116
 beer, 116
 bottle, 116
Surface Geometry list, 231
Surface indentations, 108
Surface operator, 231, 232
Surface Speed material, 30
Surface Target Selection map, 29
Surface texture, 22, 98, 109
 ice, 98
 sporadic, 98

Target Spot Standard Light, 296
Target test, 38

Teapot geometry, 95
Tearing check, 253
Terrain, 197
Terrain displacement map, 189
Terrain effects, 310
 high quality, 310
Terrain geometry, 155, 157,
 159, 166
Terrain weathering system, 153
Tessellation Method group, 209
Test Value, 232
Texture map, 129, 186, 187
 baked, 129
Threshold value, 105, 254
 low, 105
Thrust jet, 61
Time Configuration settings, 269
Tiny bubbles, 133
Top Viewport, 265, 266
Torn-off bubbles, 244, 255, 256
Track View, 228, 229
 selected, 229
Transform Position Controller, 75
Translucency value, 284
Transparency, 119
Transparency value, 106, 117
Transparent material, 223
Transparent shadows, 127, 128
Travel Distance, 101
Turbosmooth modifier, 15, 18, 127
Turbulence, 99, 108, 222, 224, 227, 234
 internal, 222
Turbulence value, 98, 224
Turbulent effect, 13, 176
Turbulent motion, 4, 5
Turbulent refined patterns, 5

UDeflectors, 46, 155
UDeflector Space Warp, 157
Underwater, 223, 241
Underwater environment, 238
Use Real-World Scale, 225
Use Script Wiring, 234
UVW Map modifier, 145
UVW Mapping modifier, 24

Vertex distribution state, 275
Vertex selection, 126

Vol. Select modifier, 27, 29
Volcanic terrain, 178
Volume Light Atmospheric Effect, 238,
 287, 288
Volume Light effect, 238, 259
Volume Select modifier, 197, 198
Volumetric cylinder, 66
Volumetric effect, 267
Volumetric Light effects, 70
Volumetric lights, 216
Volumetric rays, 241, 261
Volumetrics, 236, 239
 reflected, 239
 refracted, 239
Vortex Shape group, 265
Vortex Space Warp, 264, 265

W Angle value, 119
Water, 97, 222, 227, 241, 243
 aggregation of frozen, 97
 dragged, 97
 freezing, 97
 friction and motion of, 243
 IOR of, 227
Water-based bubbles, 131
Water-esque material, 120
Water/glass interface, 115
Water droplets, 97, 112,
 114, 115
 collation of, 114
 IOR of, 115
Water effects, 310
Water particles, 130
Weathering effects, 154, 162
White color, 227
 slightly-off, 227
Wind01 Space Warp, 234
Wind Space Warps, 5, 6, 85, 86, 98, 99,
 100, 110, 134, 224, 234, 245, 266,
 273, 292, 295

XForm modifier, 24, 26, 115, 127, 225,
 296, 297

Yellow/Blue field, 239
YouTube, 62

Zero-value keyframes, 138

Printed and bound by CPI Group (UK) Ltd, Croydon, CR0 4YY

23/10/2024

01778251-0001